50 Years with The Beatles

TIM HILL

Photographs by the *Daily Mail*

ATLANTIC WORLD

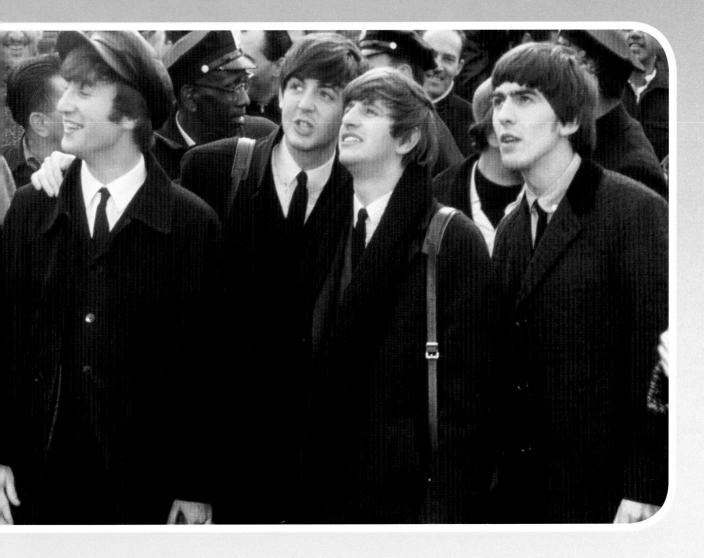

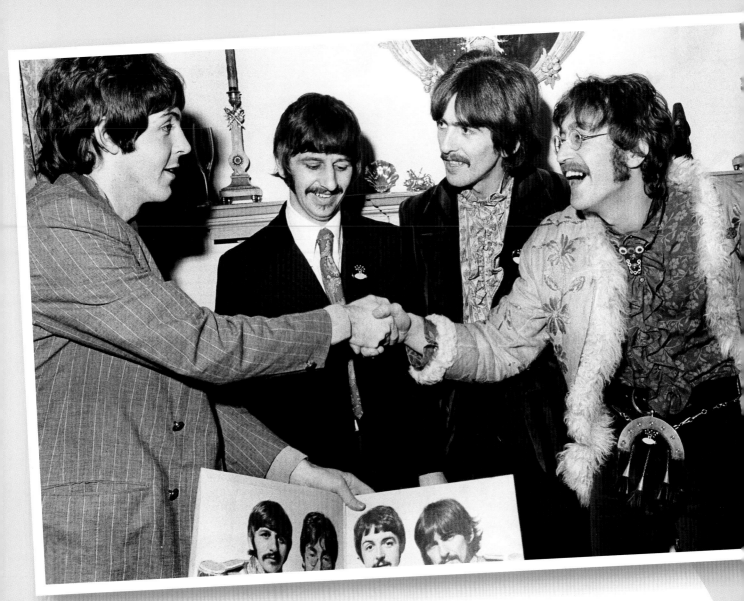

Contents

50 Years with
The Beatles

To MARY with love

FR/ MUM > DAD
CHRISTMAS 2013

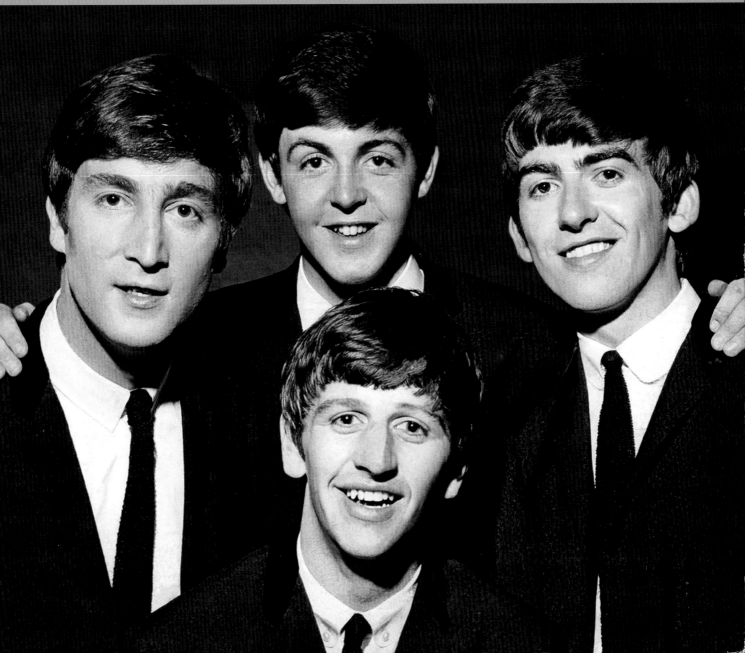

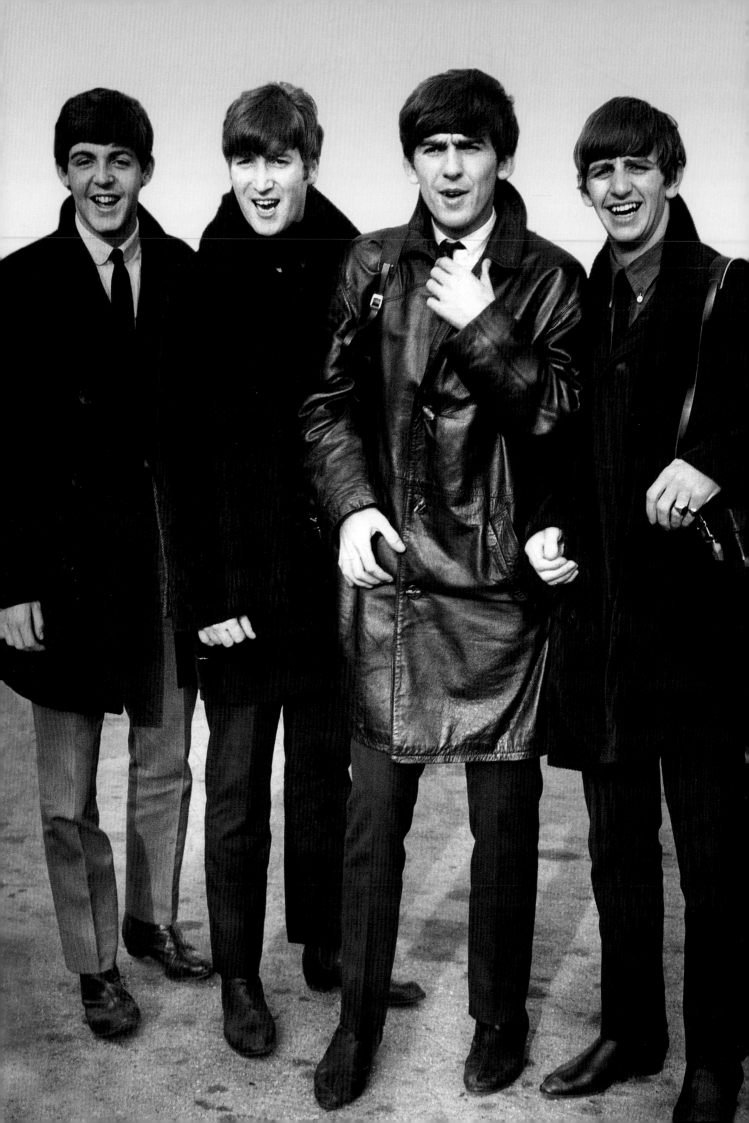

Defining an era:
Four lads who shook the world

"We had nice ordinary ambitions really, just to be recording artists." Aside from the fact that describing the Beatles as "just recording artists" is like calling Shakespeare "just a scribbler", Paul's reflection on the Beatles' pre-fame objectives shows that they didn't look beyond getting a record deal. They knew they were good — their fiercely loyal Liverpool fans and faithful Hamburg following attested to that. But superabundance of talent was one thing; convincing A & R men was another. One major label took a look and decided to pass. Hardly surprising, then, that there was no master plan to change the face of popular music, rewrite the record books or influence just about every major artist in this corner of the galaxy. Yet that is precisely what happened. The Beatles defined an era. The "Swinging Sixties" played out to the accompaniment of their music. Beatles songs cut across age, class and geographical boundaries like no other band in no other age. A pop sensation became a cultural phenomenon.

How was it done? Even Brian Epstein thought the clock was ticking apace, that fan fickleness and changing taste would soon bring it all to a juddering halt. And it might have happened had the Beatles stood still. But they quickly outgrew the breezy, personal pronoun-filled boy-girl songs, and shed the cheeky Moptop image that helped push the decibel needle off the scale. They grew as artists, and the fans matured with them. Eleanor Rigby picked up her rice a mere two years after money couldn't buy us love. The same gap separated the "pure genius" of "In My Life" — epithet courtesy of White Stripes founder Jack White — and "She Loves You" riding high at the top of the charts. Brian Wilson virtually gave up the creative ghost after hearing *Sgt. Pepper*, while Eric Clapton felt he was intruding on hallowed ground when invited to Abbey Road to play on "While My Guitar Gently Weeps". Just some of the legends lining up with the rest of us to pay homage to the greatest band that ever plugged in a guitar or crashed a hi-hat. The Beatles reinvented the pop idiom, and in the process inspired not just adoration and respect but awe and reverence.

Beatles music remains as fresh, vibrant and innovative as the day it was pressed, a peerless legacy for existing fans to revisit and new ones to discover

"When you get to the top," wrote poet Philip Larkin, "there is nowhere to go but down." The Beatles, he went on, were an exception to that rule. "There they remain, unreachable, frozen, fabulous." The passage of time has served only to enhance their reputation, to confirm that genius has no expiry date. It is over forty years since they went their separate ways, yet Beatles music remains as fresh, vibrant and innovative as the day it was pressed, a peerless legacy for existing fans to revisit and new ones to discover. This book, with fabulous classic and rare photographs from the archives of the *Daily Mail,* comprehensively charts the heady days when they were Fab.

Foreword
by Robert Whitaker
Beatles' official photographer

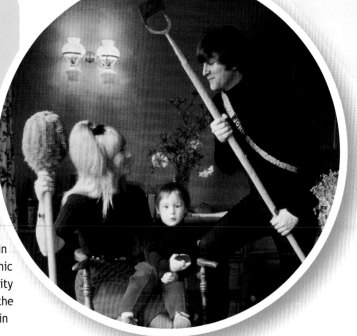

My first encounter with the Beatles was in 1964. I was in Melbourne, Australia, where I had my own photographic studio. I was almost twenty-five years old, enjoying city life with friends that included a number of leading lights in the Australian arts scene. I was asked to photograph Brian Epstein for a newspaper interview. Thousands of people crowded round the Beatles' hotel but we managed to fight our way in. At the end of the interview Brian, curious about the results, asked me if he could see the photographs I had taken. Then he introduced me to the Beatles who were just down the corridor in their own lounge. They were looking at presents given by their fans and every so often they would go to the window and wave to the crowds.

Next day I went back with two large prints of Brian. In the darkroom I had introduced a decorative wreath in the background around his head. He was knocked out by what he saw and asked to view more of my work. The same afternoon, Brian called me with an invitation to accompany him to the Beatles' concert at the Festival Hall and photograph them on stage. Finally, he asked me if I would be interested in him managing me as a photographer back in the UK. Later that year I accepted his offer.

Over the next few years I photographed the Beatles all over the world. I watched and captured them on film as they performed countless times to millions of screaming fans who were crazy about them and their music, their energy and enthusiasm for life.

I think the years of learning the entertainment business the hard way, with five or six hour back-to-back sessions onstage in Hamburg, made the Beatles consummate performers in a traditional sense, which is maybe why their variety shows and movies seemed to come so naturally to them. I watched them give their polished stage shows all over the world and their act rarely changed. It bored me eventually and it obviously bored them — especially when their performance couldn't be heard over the screams of the audience.

My pictures often have a theme that can be unlocked with a visual key that's visible in the photograph. On the one hand, not taking conventional photos may have narrowed the market for my pictures, on the other hand, the unusual staging I created was not only what the Beatles enjoyed and wanted, it also fed the mood of the picture editors and their readers at the time. And those photographs are still very much in demand.

The pictures I took of John and Cynthia at Kenwood (above and page 82) were picked up by newspapers all over the world: there had never been coverage like it. I got the inspiration from a book my grandmother gave me in 1955 called *The History of the Camera in Australia*. It included many photographs of early Australian life and that's exactly how I saw John — as a pioneer. All the photo sessions were creative in their own way and I enjoyed each of them. I remember my first shoot in studios in Farringdon Road — I travelled there, down the Strand, with the Beatles in their Rolls-Royce with everyone looking. For the second studio session I did with them, at Sherriff Road in Hampstead, I had some help from friends at the Royal Academy and we set up this sort of Pop Art stage with strips of different colours and shiny foil. The idea was to create a levitation effect with the boys but we didn't have enough time to achieve that and the session ended with the guys wrapping themselves in polythene, then breaking up big pieces of polystyrene in what Professor David Mellor of Sussex University called the Auto-destruct Session.

The most creative experience I had with the Beatles was in the Tokyo Hilton: we couldn't get out because of the fans. The local promoter asked them to do something for charity; he gave them paper and paints to create a poster. They put a lamp with a circular base in the middle of the paper and each of them took a corner and created their piece of art, each in his own style. When they finished, they took the lamp away and signed their autographs in the central space. It really was a spontaneous work of art.

I felt closest to John: we both had philosophical and artistic ideas about things other than music. Was he a genius, were the others? Lennon and McCartney together achieved outstanding creative success, but when you end a creative partnership it's hard to get the same quality and I think that shows, not just in the individual work of Paul and John after the split but in all of the individual solo careers. In my opinion the greatest genius of the Beatles was in what they did together.

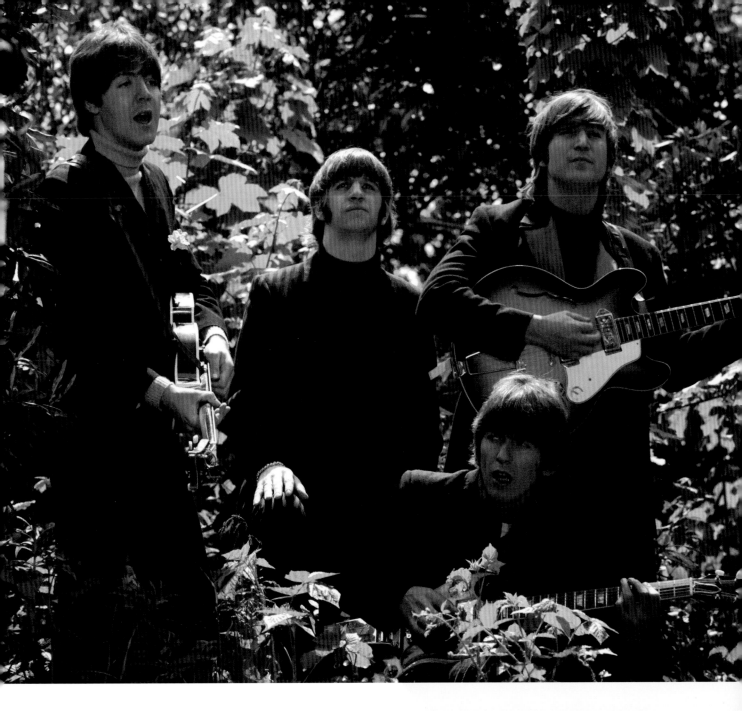

I see the Beatles as a product of their time, but it's obvious that they brought with them a new age with completely changed music and values. The young generation, sick of the gloomy postwar society, were ready for the colour and energy of rock 'n' roll. The Beatles had that a-plenty; at first that energy was raw and unsophisticated but as the tedium of live performance hit, they turned their talent to composition and innovation in the recording studio. I'm not alone in thinking they changed the world; they certainly changed mine. I look back with great pride and pleasure to the work I did with them in the photographic studio and, very often, on location. While no one can take away from the Beatles their great talent, they were able to connect with some of the most creative people of their age and gain impetus for their ideas. This added greatness to natural talent: think of the list— George Martin, Klaus Voorman, Peter Blake, Brian Epstein himself, and many more.

My last trip with the Beatles was on the fated Far East tour in 1966: the photos I took on the plane after the chaotic departure from Manila are deceptive in every sense, with the Beatles playing cards during the flight after the frightening parting display put on by the Filipino crowds — the only time I heard them being booed. I had been driven to the airport with a pistol pointed at me. You got used to the drama. The Beatles got off the flight at Delhi and I flew on to Athens. I never saw them together again in person or photographed them as a group after that.

The collection of words and images compressed into these pages reflects the overwhelming decade of the Beatles' career as a band. In that brief time they exceeded the output and success of most artists' entire careers, yet they continued solo careers while their classic albums and compilations kept them at the top of the charts. While little can compare with the sheer exhilaration of the 1960s, I hope you get a feel of those adrenalin-rich days as you read the pages that follow.

Robert Whitaker

Roll Over Beethoven

The 1960s belonged to the Beatles. They were here, there and everywhere, a ubiquitous presence on the cultural landscape

The 1960s belonged to the Beatles. They were here, there and everywhere, a ubiquitous presence on the cultural landscape, scene-makers and scene-stealers. A decade earlier, the four were growing up in the city of Strawberry Fields and Penny Lane; kids, like any other, searching for identity as they dealt with the usual preoccupations and pressures: family, school, adolescence.

Materially, John had the best of it. From the age of five the young working-class hero's home was a pleasant semi-detached house in a leafy Liverpool suburb. Emotionally, the picture was less rosy. The comforts of Menlove Avenue, where his Aunt Mimi and her husband acted in loco parentis, couldn't compensate for the absence of his natural parents. His merchant seaman father wouldn't reappear in his life until the Beatles were the biggest draw on the planet. His mother, Julia, was killed in a road accident just as they were becoming reacquainted, leaving 17-year-old John doubly bereft.

From an early age Lennon thought he was marked out for greatness — either that or an asylum. He was bright but not studious, pugnacious with punier specimens, using his quick-wittedness to outsmart those bigger than he. He had a fertile imagination, a rebellious streak and a keen sense of the absurd. All were on show in the *Daily Howl*, a paper the young Lennon circulated among his Quarry Bank schoolmates. It was full of cartoons, caricatures and Edward Lear-style nonsense verse of the kind that would appear in his later published works. He would remain an inveterate scribbler, but in his mid-teens he was bitten by the rock 'n' roll bug. "Nothing affected me till Elvis," John would say, though when he formed his first band it was a skiffle combo, not least because washboards and tea-chest basses were a cheap and cheerful route to performing on stage. With an inexpensive acoustic guitar and a few banjo chords under his belt, the latter courtesy of his mother, John was up and running with the Quarry Men.

Paul McCartney made his first public appearance at Woolton Hospital, where his mother, Mary, was a midwife. In his youth Paul was keener on the big band sound and show tunes, the influence of his trumpet-playing father, Jim. But he, too, was carried away by the twin seductions of guitar and skiffle. On July 6, 1957 Paul went along to Woolton Village Church Garden Fete at the suggestion of his Liverpool Institute pal Ivan Vaughan, who had been at elementary school with the 16-year-old fronting the band providing the entertainment. Paul was more interested in the chance of picking up girls than listening to the Quarry Men, but the two youngsters did meet. Paul impressed John with his ability to tune a guitar and knowledge of song lyrics, as well as his playing. Lennon was torn between wanting to improve the band and inviting a possible rival leader to join. He opted for improvement; Paul was in.

Getting George Harrison on board was harder. Paul sang the praises of the guitar-playing friend with whom he shared a bus journey to the grammar school they attended. John regarded George, three years his junior, as a young whippersnapper, an annoying hanger-on, but once again, talent won out. George's ability to play the rock number "Raunchy" unerringly helped seal the deal. His lead playing was better than Paul's, and John relented. By February 1958 three-quarters of the Beatles' line-up was in place.

Over the next 18 months the group found it tough going. The competition was stiff and plentiful, gigs hard to come by. The Quarry Men did cut their first record in this period however, paying 17s 6d for the privilege of committing "That'll Be The Day" to acetate. On the flipside was a song called "In Spite Of All The Danger", credited to Harrison and McCartney, though much later Paul said it was his composition, George's shared billing down to a guitar solo. This was illuminating on two counts: it showed their enthusiasm for writing their own material, and that they had no idea of how music publishing worked. In their naivety they thought music floated in the ether and couldn't be owned like a normal consumer item. That lack of worldliness would have major repercussions a few years later, when ownership of the gold-dust Beatles songbook was at issue.

John & Paul were collaborators-in-chief, the two teenagers showing a flair for composition

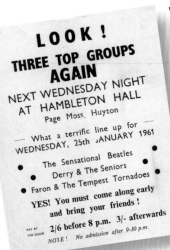

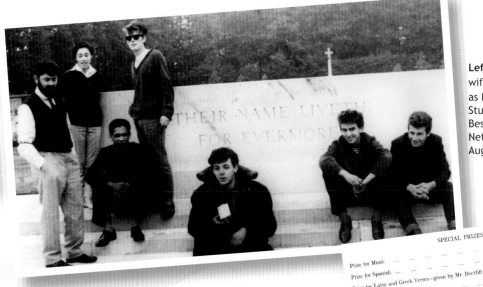

Left: (l to r) Promoter Allan Williams, his wife Beryl, Harold Phillips (also known as Lord Woodbine, a calypso singer), Stuart Sutcliffe, Paul, George, and Pete Best at the Arnhem War Memorial in the Netherlands, en route to Hamburg in August 1960. John took the photograph.

THE CITY OF LIVERPOOL

LIVERPOOL INSTITUTE HIGH SCHOOL

SPEECH DAY

TUESDAY, DECEMBER 15th, 1959

The PRIZES will be Distributed
and the ADDRESS given by

THE RIGHT HONOURABLE
VISCOUNT LEVERHULME, T.D., B.A., J.P.

Chairman: Professor R. A. MORTON, Ph.D., D.Sc., F.R.I.C., F.R.S.

SPECIAL PRIZES

	... D. Norris	
Prize for Music	... J. D. Lunt	
Prize for Spanish	... R. T. Crofts	
Prize for Latin and Greek Verses—given by Mr. Bentliff	... J. P. McCartney	
Prize for Art	... F. J. McKie	
Prize for French—given by the French Consul		

John had offered the bassist slot to another friend at the same time

The Quarry Men

John and Paul were collaborators-in-chief, the two teenagers showing a flair for composition. In the periods when the Quarry Men were a functioning band in name only, Lennon and McCartney focused on writing, skiving off school and spending their days coming up with melodies and filling exercise books with lyrics. As they sparked off each other, the duo thought that if they couldn't make it as performers, perhaps they could write for big-name stars. These brainstorming sessions helped forge a bond between them, and that deepened when Lennon lost his mother in 1958. Mary McCartney had succumbed to breast cancer two years earlier. "I think it helped our intimacy and our trust in each other," said Paul of the twin tragedies and how they strengthened fraternal ties.

By the spring of 1959, the Quarry Men were stumbling along and could easily have folded. George had become a sometime member of another band, the Les Stewart Quartet, and it was this connection that gave John's group a welcome boost. The Les Stewart Quartet was booked to open a new coffee bar, a converted basement in a large Victorian property in West Derby. Mona Best opened The Casbah not simply for commercial gain or to provide kids with a place to hang out. She was ambitious for her unassuming 17-year-old son Pete, and saw the new venture as a way of promoting his career. John, Paul and George helped decorate the place before its grand opening on August 29, though only George should have been on stage on the big day. An internal bust-up left the Les Stewart Quartet depleted, and at George's suggestion, John and Paul rode to the rescue.

The Quarry Men, plus Les Stewart bass player Ken Brown, became The Casbah's resident band, though Brown was soon shown the door after he received his gig fee despite being too unwell to perform, a clear breach of natural justice to the other three. It was also the parting of the ways for the Quarry Men and The Casbah, but regular work had buoyed their spirits and persuaded them to keep going. The worst was behind them: 1960 was to be a turning point in their burgeoning careers.

Beetle Sutcliffe on bass guitar

In January of the new year the group became a four-piece again as John's best friend from art college, Stuart Sutcliffe, was recruited to play bass. Sutcliffe was a gifted artist but was no great addition to the rhythm section. His place in the band rested on Lennon's endorsement and the fact that an art prize put a down payment on a Hofner President bass guitar. Indeed, John had offered the bassist slot to another art student friend at the same time: whoever got hold of an instrument first was in. Paul would have been horrified at such selection criteria – a mate with the right gear – but John was the leader, the hiring and firing in his gift.

Sutcliffe improved over time, and it is a popular myth that he always played side-on to the audience to mask his lack of ability. Even so, his guitar work didn't progress beyond a rudimentary level. Not that John seemed to care. His friend looked the part of a rock 'n' roller, which was more than enough. Even John, who could be cocky and surly with those around him, looked up to Stuart. Paul, who had no such personal connection with the bassist, wanted to ditch a group member who could potentially hold them back. For now, though, he had to bide his time.

Sutcliffe may not have contributed much musically, but he is credited with suggesting that the group change its name along insect lines, a nod towards the much-revered Crickets. It was the Beetles first; several permutations were tried before they settled upon the Beatles that summer. Sutcliffe was also the conduit to Allan Williams, the next important figure in the Beatles' story. Williams owned the Jacaranda coffee bar and was also a small-time promoter. Sutcliffe, who patronized the Jacaranda, approached Williams touting for business, which led to the band's first pro tour – criss-crossing Scotland backing Johnny Gentle – and the first of five trips to Hamburg.

Days before the newly constituted Beatles set off for Germany on August 16, 1960, they solved their long-term rhythm section problem after paying an impromptu return visit to the Casbah. There they found Pete Best on drums in the resident band, which was on the verge of splitting. There was a hasty audition, but with Hamburg looming there was hardly a decision to be made. The helter-skelter trip round Scotland, and arduous sets up to eight hours long in seedy Hamburg clubs disabused the Beatles of any notion that being a working band was a glamorous pursuit. But hour after hour of beer and Preludin-fuelled stage work honed their live act and made them into a tight professional unit. "Mach schau!" Hamburg club owner Bruno Koschmider would yell, and make a show they certainly did.

One Ringo Starr was also in Hamburg in the autumn of 1960. Richard Starkey grew up in straitened circumstances in Dingle, one of Liverpool's most impoverished areas. He too experienced early family dislocation – his parents split up when he was three – and Ritchie, as he was known, also had to contend with a string of ailments that severely disrupted his schooling. Affable and popular, Ritchie also found an outlet in skiffle-band membership, choosing drums over the usual cheap-and-cheerful instruments. By 1960 he was Liverpool's premier drummer, plying his trade with Rory Storm and the Hurricanes, at the time a bigger name than the Beatles on Merseyside. There was both fraternization and rivalry between the groups, who shared the onerous workload at the Kaiserkeller club.

The residency ended on a sour note when boss Bruno Koschmider cut up rough after he found the Beatles jamming at a rival nightspot, the Top Ten. After a run-in with the police, all made it back to England except Stuart Sutcliffe, who chose to remain with girlfriend Astrid Kirchherr. She and Klaus Voormann were part of an intellectual set – the "Exis", short for Existentialists – who had befriended the group. Kirchherr didn't suggest that they brush their Teddy boy quiffs forward – France was the birthplace of that style – but she was responsible for the collarless jackets and a number of stunning monochrome photographs of the Beatles. Some three years later, photographer Robert Freeman would also capture their moody, unsmiling faces in half light for the cover of their second album, *With The Beatles*.

Sutcliffe was briefly reunited with the band when they returned to Hamburg in March 1961, but by then Paul was angling to take over on bass. Sutcliffe was sanguine about leaving the Beatles. Never a committed musician, he decided to focus on his art studies and marry Astrid but died from a brain haemorrhage on April 10, 1962, two months before the planned nuptials. Several theories have been advanced as to what triggered the fatal condition. They include a severe blow to the head, which may have occurred during a fall down a flight of stairs, a gang brawl, or maybe during a fight.

Sutcliffe was briefly reunited with the band in Hamburg in March 1961, but by then Paul was angling to take over bass

The Beatles, meanwhile, were going from strength to strength. The Hamburg apprenticeship had turned them into electrifying, time-served performers and they were on their way to becoming Liverpool's top band. They did the rounds of the plethora of "jive hives" that Liverpool boasted, and on February 9, 1961 took their bow at the venue with which they would become most associated.

The Cavern had been a jazz club when it opened its doors in 1957, the management tolerating skiffle but frowning on beat music. Indeed, the Quarry Men had played there in August 1957, receiving an ear-bashing for slipping a few Elvis numbers into their set. Things changed when Ray McFall took over the Mathew Street establishment in 1959. Rock 'n' roll was now on the menu, in tandem with jazz initially, though the latter sessions were soon phased out, unable to survive the shock-waves of the Mersey Beat explosion.

The dank, fetid atmosphere of the underground vault was hardly salubrious, yet with the Beatles as the resident band no one was too bothered about the inadequate ventilation, walls running with condensation or the stench of disinfectant. They made almost 300 Cavern appearances over the next two and a half years, the last of them when "She Loves You" was about to hit the airwaves. Their fee increased from £5 to £300, though even a sixty-fold increase couldn't contain the Beatles by August 1963.

At the Cavern the group experienced Beatlemania in microcosm. There was fierce rivalry among the girls, who would queue from early morning to secure a good vantage point. Mad scrimmages ensued when the doors opened. The toilets were packed just before the Beatles arrived on stage as the girls dolled themselves up in the hope of being singled out for special attention.

In late June 1961, during their second Hamburg stint, the Beatles attended their first proper recording session. They signed with bandleader Bert Kaempfert after impressing on stage at the Top Ten. It was primarily as a backing group – singer Tony Sheridan was the main attraction – but a milestone nonetheless. They even got to record two songs alone, "Ain't She Sweet" and a Harrison-Lennon instrumental titled "Cry For A Shadow". Polydor released a single comprising two of the Sheridan numbers, "My Bonnie" and "The Saints", with the "Beat Brothers" credited as the backing group. "Beatles" was rejected as it was too close to the German word for male genitalia! The record made Germany's Top 40 but didn't get a UK release. The Beatles

weren't even able to bask in the limelight of their minor Continental success, for by then they were back on the Liverpool circuit, still seeking a breakthrough. It came at the end of the year, and from an unlikely source: a frustrated thespian turned record shop manager. It was furniture, not the entertainment business that ran in the Epstein family blood. Brian was expected to follow in the family footsteps, but from a young age he had other ideas. After briefly attending RADA, he reluctantly agreed to knuckle down, taking charge of a new division of the family concern, North End Music Stores. Epstein prided himself on the level of customer service NEMS offered. If a particular record wasn't in stock, he guaranteed that a copy would be sourced from somewhere. It was one such request that brought the Beatles to his attention in late October 1961.

The Beatles had brought a few copies of "My Bonnie" home with them, and, not wanting to miss a self-promotional trick, pressed one into the hand of Bob Wooler, the Cavern's resident DJ. Wooler enthusiastically plugged the record, so regular Cavernites would have been very familiar with it. One such fan, Raymond Jones, requested a copy of "My Bonnie" at NEMS, thereby taking his place in the history books as the first person to bring the Beatles to Brian Epstein's attention. Others soon followed, and Epstein made it his business to find out about the group that had prompted the enquiries. He discovered that not only were the Beatles a local band, but they were playing almost on a daily basis at a club a stone's throw away from his store.

On November 9 a besuited Epstein and his assistant Alistair Taylor descended into the Cavern to find out what all the fuss was about. Even had he swapped his pinstripes for more casual attire, the Beatles and regulars would have recognized 27-year-old Epstein as they all patronized his store. His presence certainly raised eyebrows and sparked comment. Epstein could have conducted the business in hand quickly by noting down the details of the record Raymond Jones and others had asked for. But he lingered, not just that day but on a number of occasions over the next three weeks. In that time, the idea formed that he might diversify into an altogether different branch of the music business.

Why did Epstein decide to take a leap into the unknown, from record retailing into band management? He certainly recognized the stardust, and maybe saw theatrical management as a proxy for his own failed stage ambitions. It also seems clear that the raw energy and animal appeal of the four leather-clad musicians was a further source of attraction to the homosexual businessman.

The Beatles were impressed with Epstein's pitch. He guaranteed to get them more gigs at better venues with increased fees. He also dangled the carrot of a recording contract, which sealed the deal. A management fee of 25 per cent off the top line was something that would grate further down the line, but in December 1961 it was waved away in the rosy afterglow of having acquired as their manager the head of a large record distribution outlet.

Epstein was an experienced retailer but green when it came to showbusiness management. He had to pick things up as he went along, which would lead to some woeful deals being done on the Beatles' behalf. But he believed in them, as they believed in themselves, and set about the task of gaining the Beatles an entrée into the big time. It looked as though he had struck gold immediately when he got an A & R man from Decca to pay a visit to the Cavern. In truth, Decca were paying lip service to an important client, NEMS's buying power giving Epstein considerable clout with the record labels. But Mike Smith, the executive dispatched to the far-flung north-western outpost, actually liked what he saw. The Beatles' performance earned them an audition on New Year's Day 1962.

The Beatles were impressed with Epstein. He guaranteed to get them more gigs at better venues with increased fees

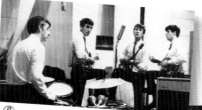

Below: The final line-up was created after Ringo Starr joined the band.

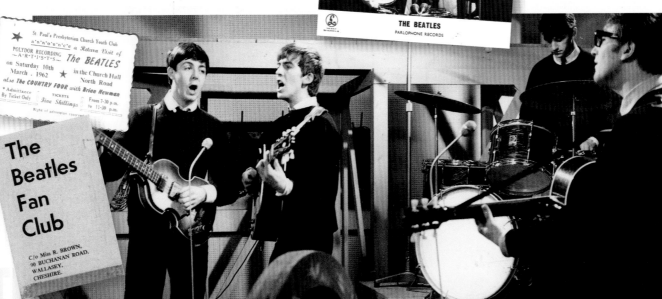

Smith decided to go with the Tremeloes, the deciding factor being that the Beatles sounded "too much like the Shadows"

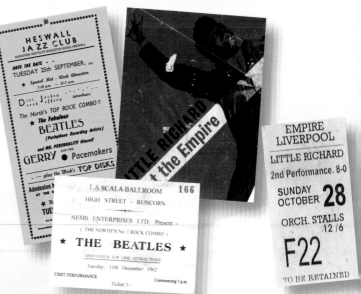

The first audition

Unfortunately, they chose the wrong time to have an off day. The group had had a fraught journey in icy conditions, arriving tired and hungry; they were forced to use unfamiliar studio equipment; and the occasion seemed to get to them. Though they failed to recreate the dynamism of their stage show, Smith was still prepared to take a chance. There was a contract opening with Decca, but the Beatles weren't the only band up for consideration. Smith had also auditioned Brian Poole and the Tremeloes, and would happily have signed both groups to the label. A & R boss Dick Rowe, who had seen neither group perform, told Smith they could add only one act to Decca's roster. Smith decided to go with the Tremeloes, the deciding factor being that the Beatles sounded "too much like the Shadows".

By the spring of 1962, Epstein had already made good on most of his promises. The Beatles' lot was immeasurably better in terms of the work they were getting, and they were now the undisputed top of the Liverpool pile. Polydor had also reissued "My Bonnie" in Britain, this time under their own name: "Tony Sheridan with the Beatles". If Hamburg had tightened the band, it was Epstein who smartened them up and turned them into a slick, professional outfit. However, the jewel in the crown was a recording contract, and on that issue he was struggling to deliver. He was certain the Beatles were going to be huge; all he had to do now was convince the industry's movers and shakers ensconced in the capital 200 miles away.

Before then, however, there was the small matter of an existing contractual agreement with Bert Kaempfert. During the Beatles' third Hamburg trip in April '62, Kaempfert had one last shot at recording the Beatles. A cover of "Sweet Georgia Brown" failed to convince the bandleader; they were free agents, though that was a moot point if Brian Epstein couldn't find a label to back his boys.

Epstein did the rounds of all the majors, including Pye, Philips and EMI, and was given short shrift by them all. Then, during yet another door-knocking exercise, he passed an HMV shop in Oxford Street that offered the very service he had been looking for. Epstein had been advised that he might have more luck if he left a demo disk rather than an unwieldy tape, and here was just such an outlet.

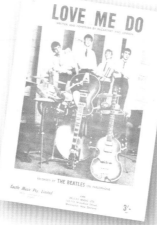

The engineer who made the copies liked what he heard, and was even more impressed to discover that some of the material was self-penned. This group was clearly a cut above the amateurish dross he often had to deal with. He put Epstein in touch with music publishers Ardmore and Beechwood, an EMI subsidiary located in the very same building. Sid Colman, who ran the operation, offered to put in a word with the Artists & Repertoire department of his parent company. Most of EMI's A & R men were tied up with top-line artists, but there was one who might give the Beatles a hearing.

Just as important, if he was going to smooth out the rough edges, Martin warmed to them on a personal level

Enter George Martin

George Martin headed up Parlophone, a minor EMI offshoot best known for putting out quirky comedy records, such as Peter Sellers' 1960 duet with Sophia Loren, "Goodness Gracious Me". It took some time to break down Martin's resistance, an exasperated Epstein once again using the buying power of NEMS as a bargaining chip. Martin relented, but was hardly knocked out by what he heard when the Beatles auditioned at Abbey Road on June 6 1962. The Beatles, fresh from their third Hamburg stint, recorded four songs that day: "Love Me Do", "PS I Love You", "Ask Me Why" and a cover that regularly featured in their set, "Besame Mucho". It was adequate. Martin thought "Love Me Do" had a certain something. The wailing harmonica — an instrument Lennon had almost certainly purloined on his European travels — made for an interesting hook. Overall he felt the material wasn't up to the mark, but he'd heard enough to rubber-stamp the pre-contract agreement already in place. Just as important if he was going to smooth out the rough edges, Martin warmed to them on a personal level. With one proviso: Pete Best's percussion work wasn't up to snuff.

THE EARLY YEARS THE EARLY YEARS

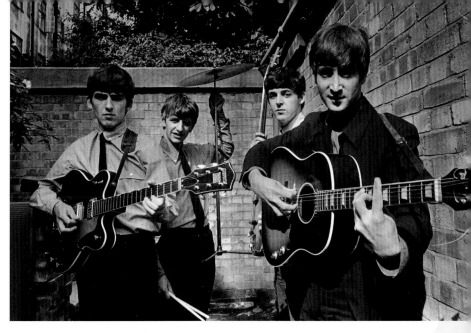

The Beatles were elated when "Love Me Do" started to get airplay and appeared on the charts

Right: The Beatles posing in a small backyard in London with their instruments in the year they ruled the charts as Beatlemania swept the country.

The group dug their heels in. From a position of relative weakness, it was remarkable that they overrode Martin's judgment

When they reconvened at Abbey Road three months later, September 4, the question of what to put out as a debut single was pressing. Martin strongly urged them to record a catchy Mitch Murray number that had just come his way. Under sufferance the Beatles ran through a lacklustre version of "How Do You Do It?" but were adamant that they wanted to record one of their own songs. "When you can write material as good as this, I'll record it," came the sharp rejoinder. Still the group dug their heels in. From a position of relative weakness, it was remarkable that they overrode Martin's judgment.

The debut single

So, Lennon-McCartney's "Love Me Do", a song that had been kicking around for some four years, was selected as the group's debut single. It might not have been Martin's first choice, but at least had that bluesy harmonica riff to recommend it. The producer had another concern, and this time he wouldn't give way. He was pleased to note that the Beatles had acted on his concerns over Pete Best, who had been axed since the June 6 session. Martin's reservations were undoubtedly a contributory factor in Best's sacking mid-August, though John, Paul and George had been pondering the issue for some time. Best may have been hugely popular with the fans — his dismissal provoked a severe backlash — but he was at best a limited drummer, somewhat taciturn, and had clung to his rock 'n' roller's quiff long after the others had adopted the Moptop look. In short, he didn't fit in.

His replacement was something of a coup: Liverpool's finest sticks man, Ringo Starr. Ringo had actually deputized for Best on a couple of occasions in Hamburg. Now the Beatles had recruited him as a permanent fixture on the drummer's stool. It was perfect timing for Ringo, who thought his career might have stalled as he faced yet another summer season on the holiday camp circuit. His mother and stepfather —

or "stepladder", as Ringo playfully called him — would have been happy to see the 22-year-old return to the joinery apprenticeship he had left behind.

Ringo might have reassessed his career options following the September 4 session, for George Martin was no more satisfied with his efforts than he'd been with Best's. The bass drum work wasn't tight enough with Paul's bass guitar. "Love Me Do" Take Three was thus arranged for the following week, this time with top session man Andy White on drums. Ringo was mortified, feeling that his time as a Beatle was over almost before it had started. He was reduced to rattling maracas and shaking a tambourine at that session, in which the Beatles also recorded "PS I Love You" and a nascent version of "Please Please Me".

Things weren't as bad as they appeared, however. It wasn't unusual to replace a capable stage drummer with a session musician for the different demands of the recording studio. And in any event, it was the September 4 recording, featuring Ringo, that was chosen for the single release. Strangely, when the group's debut album was put together early the following year, it was the Andy White version that was included in the set, and subsequent pressings of the single also featured White on drums.

The Beatles were understandably elated when "Love Me Do" started to get airplay and appeared on the various charts. Perhaps they wouldn't have been so surprised had they been aware that Epstein had ordered 10,000 copies to fill the NEMS stock cupboards. Even so, "Love Me Do" hovered in the lower reaches of most listings, apart from Mersey Beat, where, predictably, it shot to No 1. It was a steady if unspectacular debut to their recording career. A strong follow-up was needed. Once again, George Martin proposed "How Do You Do It?" and once again, the Beatles held out. They looked to their own songbook, as they would for every 45 release of their career. And there was a prime candidate in front of their noses; it just needed a new arrangement and change of tempo.

13

There's A Place

1963

1963 1963 1963 1963 1963 1963

1963

was the game-changing year for the Beatles — and for popular music. They ruled the UK charts and found themselves in the eye of an extraordinary storm as Beatlemania swept the country.

The Beatles began the year with a single Top 20 hit to their name, which conferred mere support-act status beyond their Liverpudlian hinterland. But as "Please Please Me" and "From Me To You" climbed the UK chart — the latter bringing the Fabs their first Number One — putative headliners such as Chris Montez and Roy Orbison found themselves in the Beatles' shadow. Their massive summer hit "She Loves You" added to the delirium, while the group's debut album *Please Please Me* dropped anchor at the top of the long-player chart for six months. Liverpool couldn't contain the Fabs any longer. Two months after making their final Cavern appearance in August '63, the Beatles took to the stage at the London Palladium for a spot on TV's top-rated variety show. A month later they performed by royal appointment at the capital's Prince of Wales Theatre. As the era-defining year drew to a close, "I Want to Hold Your Hand" hit the airwaves, and *Please Please Me* was finally deposed — by the group's sophomore album. Britain was in thrall to the Beatles. The world would soon fall under their spell.

Main picture and inset: A rehearsal for the *Royal Variety Performance* on November 4 at the Prince of Wales Theatre, London.

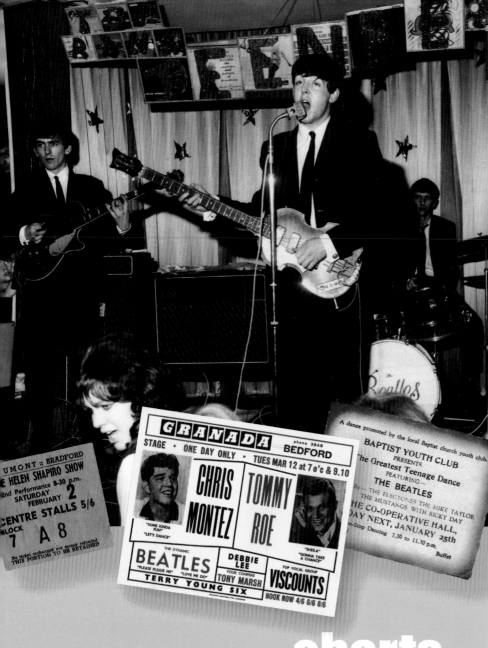

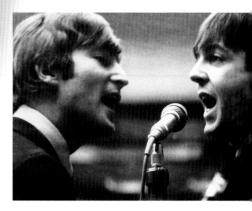

Left: The band's last performance at the Majestic Ballroom in Birkenhead. During their rapid rise to success the boys played at an incongruous mix of venues. A recording session at the BBC is soon followed by a local gig at the Baptist Youth Club in Darwen, where they top the bill. In contrast they then perform at the Granada in Bedford, albeit taking a back seat to American imports Chris Montez and Tommy Roe on this occasion.

Below: John and Paul provide the vocals.

Bottom: Paul McCartney in the early days.

Opposite top: George Martin poses with the band as they display their first silver disc for "Please Please Me". Afterwards they provide a private concert for the EMI executives to thank them.

Opposite middle Left: Dressed ready for their stage performance the lads lark around for the cameras backstage.

Opposite far right: As the boys continue to tour they soon have to find innovative ways to evade the waiting fans. At the Birmingham Hippodrome, police helmets come into play.

Opposite below: The corduroy industry soon benefits when fans begin to copy the Beatles' style.

Breaking into the charts

This was something different; raw and vibrant, a pulsating two-minute adrenalin rush

As the saying goes, you can lead a horse to water but that doesn't mean imbibing will occur. In presenting them with "How Do You Do It?" George Martin believed he had led the Beatles to a bountiful oasis. The group looked upon it as unpalatably brackish, unfit for consumption — theirs, at least. Martin found a willing consumer in Gerry and the Pacemakers, who vindicated the producer's judgment by taking the song to No 1; which left him with the same thorny question: what should the Beatles put out as the follow-up to "Love Me Do?" The debut release had stalled at No 17 in the *Record Retailer* chart — the official UK listing. It was imperative that their next single should build on that success.

1963 1963 1963 1963

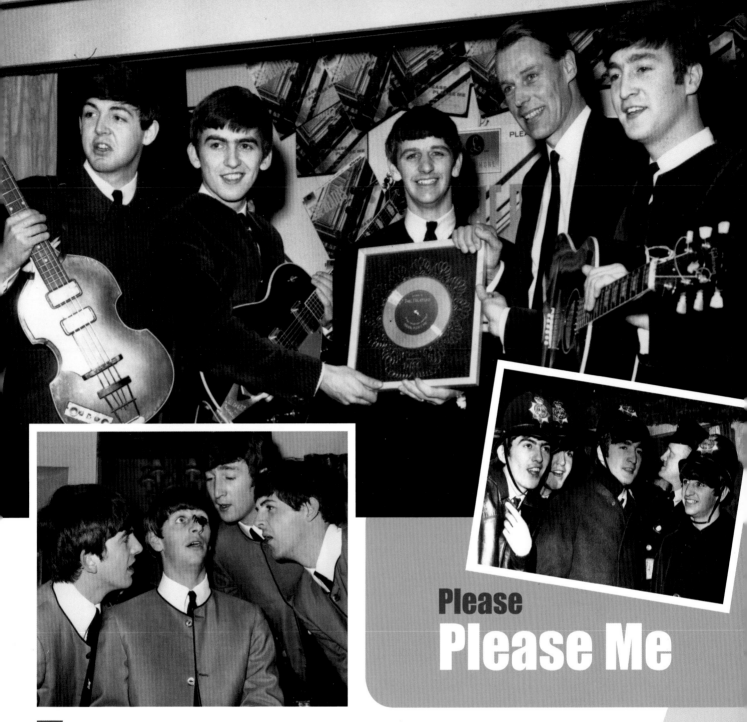

Please
Please Me

The recording sessions of September 4 and 11, 1962 had produced only one other candidate, the Lennon-penned "Please Please Me", which he described as "a combination of Bing Crosby and Roy Orbison". Trying to write a Big O-type song was understandable; the connection with the popular crooner was less apparent. It was a particular line in an old Crosby number — "Please lend a little ear to my pleas" — that appealed to the wordsmith in John, and he played with the same idea in his ballad. But in a typical twist of Lennon, gone was the saccharin sentimentalism, in came provocative lyrics with a sexual undertone, taking the boy-girl pop song a step further into the new permissive era.

Martin had no issue with the lyrics. It was the "dreary" pacing that was wrong. This time the Beatles deferred, and as soon as the up-tempo version was in the can, the producer congratulated them on their first chart-topper. "Please Please Me" was released on January 11 1963 and did indeed shoot to the top of many

charts, including the prestigious *Melody Maker* and *New Musical Express*. It just missed the No 1 spot in *Record Retailer*.

"Love Me Do" had received precious little promotion from either EMI or publisher Ardmore and Beechwood, leaving a disgruntled Epstein the unenviable task of trying to drive sales and get airplay for what George Martin regarded as essentially B-side material. "Please Please Me" was a different matter altogether. The country now saw what had held the Cavern-goers spellbound. This was something different; raw and vibrant, a pulsating two-minute adrenalin rush of cascading harmonica riffs, ascending guitar chords, and fabulous harmonies.

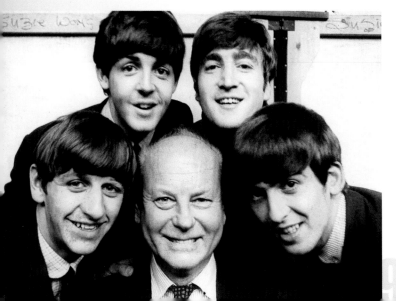

Debut album at
Abbey Road

The reception the Beatles were given in towns and cities around the country grew from cool restraint to wild abandon

The next priority was to capitalise on the success of "Please Please Me". On February 11, 1963 the Beatles convened at Abbey Road for a marathon recording session that would yield material for their debut album. They had a gig in the north of England the following day — just two windows in the entire month — so were up against the clock. The gruelling 13-hour session did mean there was some fraying at the edges, not least in John's rasping vocal on "Twist And Shout", the last of the eleven songs recorded that remarkable day. It was one of six covers, songs that featured regularly in their live repertoire. They laid down four self-penned numbers — "I Saw Her Standing There", "Misery", "Do You Want To Know A Secret" and "There's A Place" — with the A and B sides of the two singles fleshing out the 14-track set.

Please Please Me was a phenomenal success, providing EMI with a very healthy return on the £400 it had cost to produce. Released on March 22, 1963, it hit the top of the UK album chart, where it remained for 30 weeks. The Beatles would have ten more number one albums but none would match that feat.

The debut album provided another watershed moment in the group's development. The eight self-penned songs were credited to McCartney-Lennon, the duo having agreed that all their output, whether written individually or collaboratively, should carry a joint credit. The order was soon reversed, a decision that didn't go down well with Paul initially.

Exploding
onto the scene

Beatlemania may not have officially entered the English language until the autumn of 1963, but the group's three UK tours in the first half of that year provided ample indication that the Fab Four were about to explode onto the pop scene. Like the crescendo in the middle of "Twist And Shout", the reception the Beatles were given in towns and cities around the country grew from cool restraint to wild abandon. The ripple effect of the recently-released "Please Please Me" single soon swelled to tsunami proportions, engulfing the teenage fans — and leaving the other acts floundering in their wake. The Beatles were promoted up the bill but that made little difference. The performers who came on before them had to contend with a palpable air of anticipation; those who appeared afterwards were left to struggle with an audience sated by the aural feast they had greedily devoured.

THE
BEATLES
VIEW OF THE
MERSEYSIDE
JEAN-SCENE

Opposite above and Inset: Official photographs and autograph signing sessions become part of everyday life as the Beatles' popularity rapidly grows. Their third single "From Me To You" is released on April 11 and soon tops the British charts for seven weeks.

Opposite below left: The boys with the journalist Godfrey Wynn.

Top: The band perform in their iconic grey collarless suits — many of which are made by London tailor Douglas Millings.

Above: A session with a toy racing track gives the lads yet more opportunities to clown around.

Right: In April a promotional contract is signed with Lybro, a local jeans manufacturer.

From Me To You

The boys pleaded with Orbison to allow them to close the show, though in truth that decision was virtually inevitable, such was the hysteria being generated

The schedule was punishing. The Beatles did make their feelings known about the relentless criss-crossing of the country, but lassitude never impinged on their single-minded determination to make it to what John termed "the toppermost of the poppermost". Indeed, when they were on the road or in hotel rooms, John and Paul busied themselves dashing off more hits. "From Me To You" and "Thank You Girl", the A- and B-sides of their third single, were written during a month-long tour supporting Helen Shapiro. These songs kept up the early — and quite deliberate — trick of including personal pronouns in the title to give them a direct, intimate appeal. "Thank You Girl" was written first and slated as the new single. But when "From Me To You" came pouring out during the coach journey from York to Shrewsbury, they instantly revised their plan. The inspiration for the song was the From You To Us column in *New Musical Express*. It wouldn't be the last time that a line from a newspaper or magazine would be the springboard for a Lennon-McCartney classic.

Above: The boys in good spirits during the autumn tour.

Below: George has his hair trimmed. All four sported a similar hairstyle widely known as the "moptop". It was soon copied by fans and led to toy manufacturers making Beatles' wigs from plastic and even real hair.

Opposite above: The Beatles' manager Brian Epstein.

Opposite below: Parlophone/Decca's female ensemble, the Vernon Girls, who later charted with a Beatles tribute album, make the most of a photo opportunity with the Fab Four.

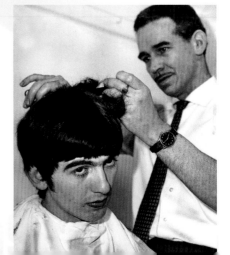

20

With "From Me To You" on its way to becoming the first of 11 straight UK number ones, the Beatles hit the road again in May. Epstein was keen to keep the bandwagon rolling, and this time his boys were promoted to second on the bill to top American star Roy Orbison. In contrast to the undemonstrative "Big O", the raw energy of the Moptops' performances charged the atmosphere in a way not seen since Elvis's lip-curling, gyratory antics of the previous decade. For the teenage girls there were clearly sexual forces at work. For the guys it was all about aspiration: they could dress like a Beatle, adopt the same mannerisms and "in" words. And far from antagonizing the older age group and the Establishment — as Elvis had done with his pelvic thrusting — the Beatles had the mums and dads cheerfully tapping their feet too. Their carefully crafted, clean-cut image — cheeky but not rude or subversive — offended no one. The combination of memorable music and universal appeal was a marketing man's dream.

By May 1963 it was clear that here was a bubble that was growing exponentially. The boys pleaded with Orbison to allow them to close the show, though in truth that decision was virtually inevitable, such was the hysteria being generated by the group.

ODEON - ROMFORD
ON THE STAGE
Sunday 16th June at 6.00 and 8.30 p.m. only
John Smith presents
THE BEATLES
"Please, Please Me" "From Me To You"
Billy Kramer and the Dakotas The Vikings with Michael London
GERRY AND THE PACEMAKERS
"How Do You Do It"
Your compere for th
Seats: 86 · 7 · 56

CITY HALL,
Northumberland Road, Newcastle upon Tyne, 1.
SATURDAY, 8th JUNE, 1963
at 6.30 p.m.
KENNEDY STREET ENTERPRISES LTD.
presents
The Beatles—Roy Orbison Show
and
FULL SUPPORTING COMPANY
BALCONY 5/- SEAT F 22
Booking Agents: A. E. Cook, Limited, 5-6, Saville Place,
Newcastle upon Tyne, 1. (Tel. 2-2901).
This Portion to be retained

Topping the bill

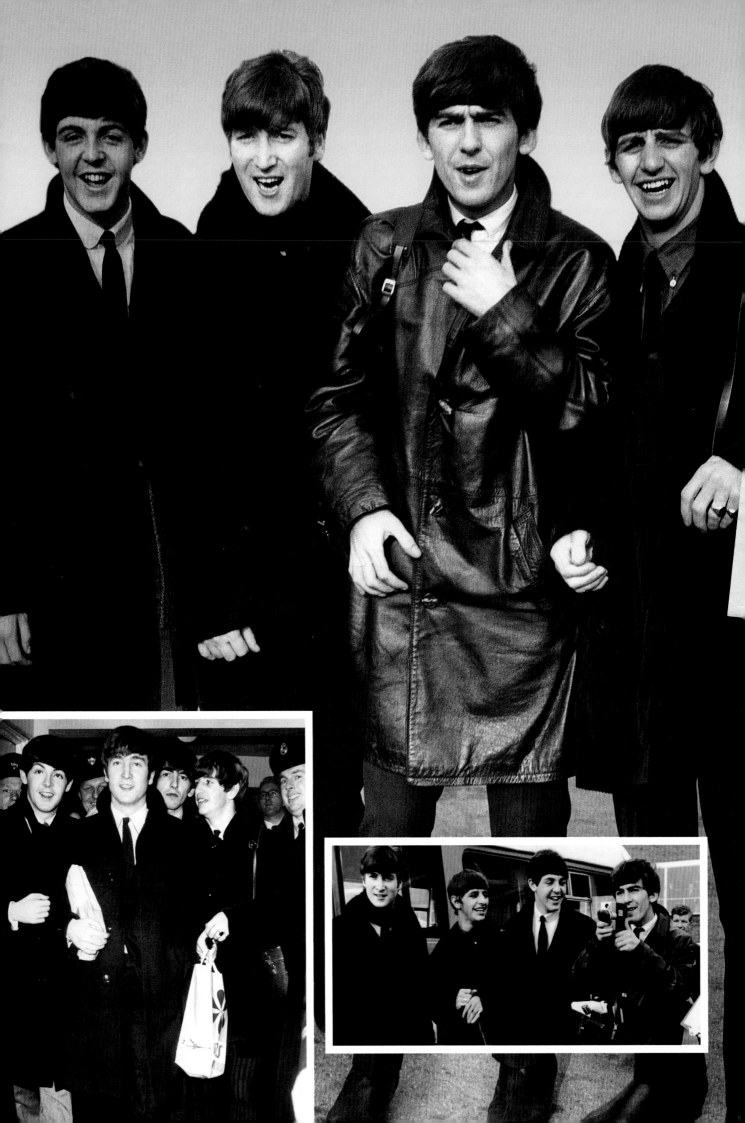

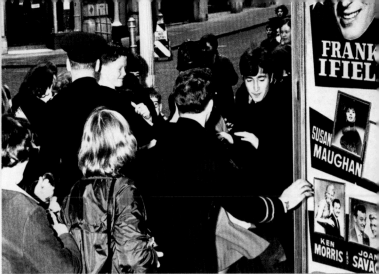

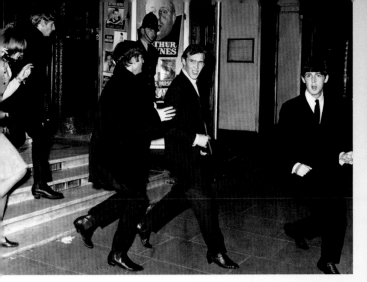

Opposite page: The band tour Sweden in October 1963 and when they fly back to London Airport are greeted by thousands of fans giving George the opportunity to capture the scenes on his cine-camera. Although Prime Minister Alec Douglas-Home is also passing through the airport, the boys cause the security staff a much greater headache.

This page: Along with road manager Neil Aspinall they try to decoy the waiting crowds by leaving the London Palladium via the front door, after their highly-successful television appearance on *Sunday Night at the London Palladium*. After their escape the boys race for their car waiting in Argyll Street.

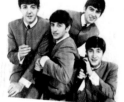

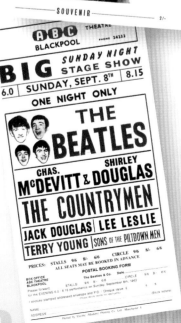

October 1963:
Beatlemania!

Hordes of fans laid siege to the Palladium ... "Beatlemania" had arrived with a vengeance!

On October 14, 1963 the *Daily Mirror* led with a one-word headline: "Beatlemania!". Like every other national newspaper, the UK's biggest-selling daily gave a detailed account of the frenzied scenes that had attended the Beatles' appearance on *Sunday Night At The London Palladium* the previous day. It was among the most prestigious variety shows in British entertainment, and the group seized upon the opportunity with a slick four-number set comprising "From Me To You", "I'll Get You", "She Loves You" and "Twist and Shout". But for once the performance was incidental; it was the pandemonium outside the Argyll Street theatre that was the real story. Hordes of fans laid siege to the Palladium, and there were hairy moments as the group's exit strategy went awry. "Beatlemania" had arrived with a vengeance, the latest manifestation of the new mood of liberation sweeping the land.

23

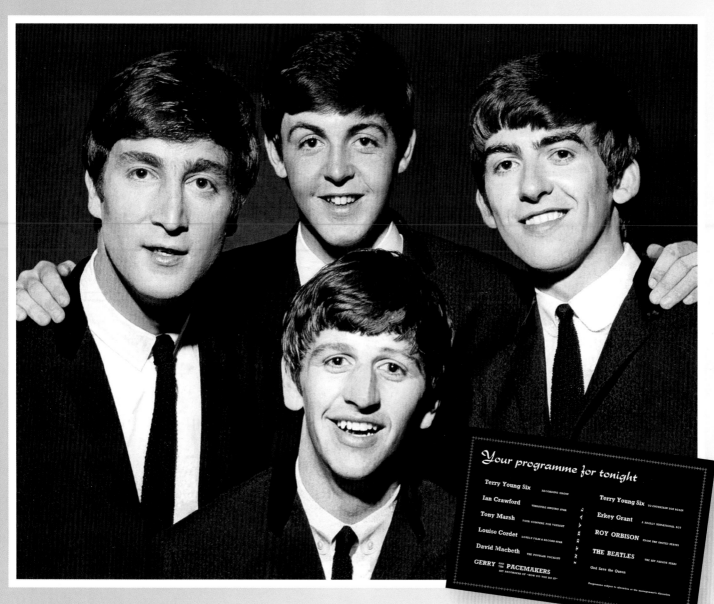

Your programme for tonight

Terry Young Six	RECORDING GROUP		
Ian Crawford	VERSATILE SINGING STAR	Terry Young Six	TO ENTERTAIN YOU AGAIN
Tony Marsh	YOUR COMPERE FOR TONIGHT	Erkey Grant	A REALLY SENSATIONAL ACT
Louise Cordet	LOVELY FILM & RECORD STAR	ROY ORBISON	FROM THE UNITED STATES
David Macbeth	THE POPULAR VOCALIST	THE BEATLES	THE HIT PARADE STARS
GERRY AND THE PACEMAKERS	HIT RECORDERS OF "HOW DO YOU DO IT"	God Save the Queen	

Below left and right: In South London police are called to contain the queue for concert tickets. Although the Beatles appealed to both men and women it was the screaming girls who attracted the attention of the media and often drowned out the band's instruments when they were playing.

Above: The band in their classic Chesterfield suits with the distinctive velvet collars.

Opposite: Millicent Martin, star of *TW-3*, with the Beatles at the Savoy Hotel, London.

Above: Gerry and the Pacemakers were also on tour with Roy Orbison.

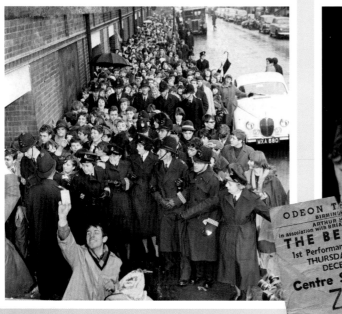

ODEON THEATRE
BIRMINGHAM
ARTHUR HOWES
in association with BRIAN EPSTEIN presents
THE BEATLES
1st Performance 6-45 p.m.
THURSDAY
DECEMBER 9
Centre Stalls 12/6
Z 44
No ticket exchanged nor money refunded
THIS PORTION TO BE RETAINED

963 1963 1963 1963 1963 1963 1

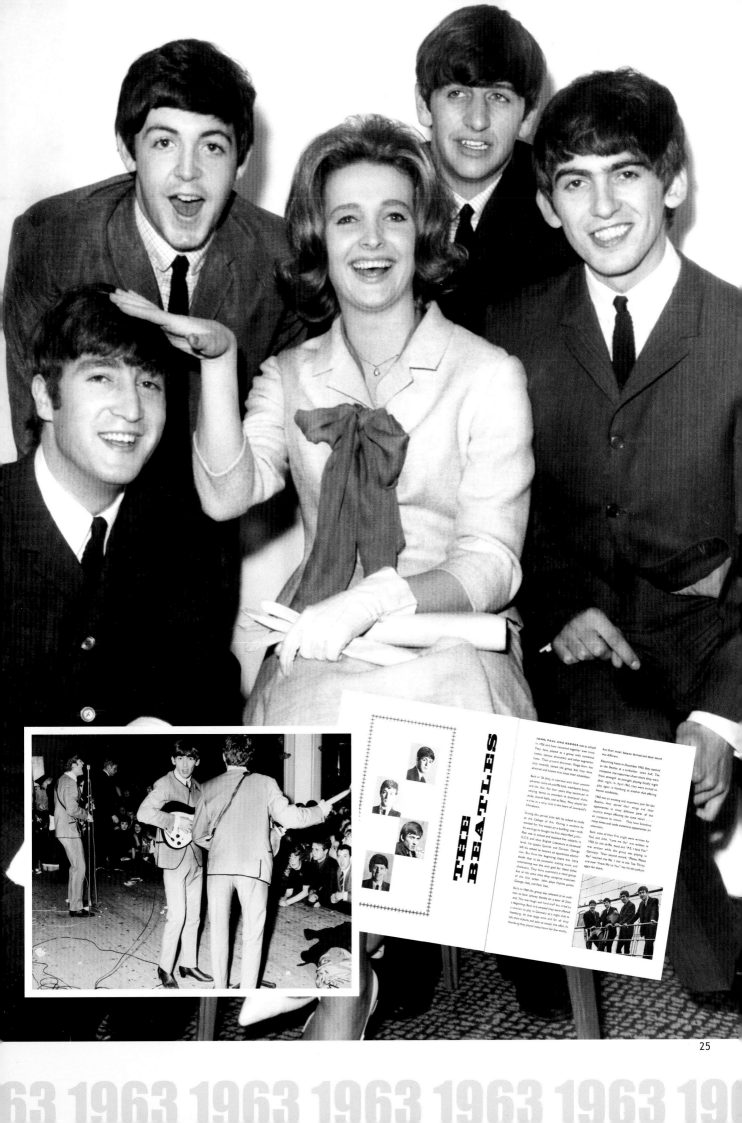

THE BEATLES

JOHN, PAUL AND GEORGE met at school in 1956 and have remained together ever since. They have played in a group with numerous names, various drummers and other segmentations. Their present drummer, Ringo Starr, has only recently joined the group but they have attained and known him since their schooldays.

Back in his day, in common with their contemporaries, were in a skiffle kick, washboard, banjo, and the like. For four years they continued in varying forms to entertain in Liverpool clubs, pubs, church halls, and at fêtes. They played for a time in a strip club in the heart of Liverpool's Chinatown.

During this period John left his school to study at the College of Art. During a vacation he worked for five weeks on a building site—which earnings he bought his first electrified guitar. Paul was at school and attained five subjects in G.C.E. and then English Literature at advanced level. He speaks Spanish and German. George left his school to become an apprentice electrician. But from the beginning things were fairly doubtful that it would be successful making music and entertaining was the only goal for these three characters. They form essentially a vocal group but at the same time they comprise musicians of the first order. John plays rhythm guitar, George, lead, and Paul, bass.

Early in 1962 the group was selected at an audition to back Johnny Gentle on a tour of Scotland. This was rough and hard stuff but it led to a beginning. Back in Liverpool they were offered a contract to play in Germany at a night club in Hamburg. At that time and for all they left their schools and jobs to accept the offer. In Hamburg they played many hours for few weeks.

But their music became formed and their sound was different.

Returning home in December 1960, they opened at the Beatles at a suburban town hall. The reception was rapturous—how they were from strength to strength playing locally right after night. In April 1961, they were invited to play again in Hamburg at another club offering better conditions.

1962 was an exciting and important year for the Beatles, they spread their wings and their appearances in every different parts of the country always affecting the same result ... an invitation to return. They have broadcast many times and made numerous appearances on television.

Both sides of their first single were written by Paul and John. "Love me Do" was written in 1958 (in the skiffle days) and "P.S. I love You," was written while the group was playing in Germany. Their second record, "Please, Please Me" reached the No. 1 slot in the Top Thirty, and now "From Me to You" has hit the jackpot again for them.

Fever pitch

Sullivan had a hunch that the Beatles might succeed where the likes of Cliff Richard had failed

It was impossible to hype Beatlemania. The press needed only factual reportage to convey the chaotic scenes when the Fabs were in town. Prime Minister Sir Alec Douglas-Home witnessed the bedlam first hand when he happened to be passing through London Airport at the same time.

So did Ed Sullivan, presenter of one of the USA's top-rated TV shows, who made it his business to discover what all the fuss was about. He was on the lookout for the next big thing, a fresh act that might have the same impact Elvis had had in 1956. Sullivan had a hunch that the Beatles might succeed where the likes of Cliff Richard had failed, and immediately entered into negotiations with Epstein to book the group. If their appeal crossed the Atlantic, he knew he had a scored a major coup; if they bombed, he could put it down as a novelty item from the old mother country.

1963 1963 196

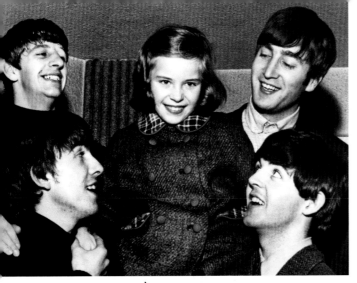

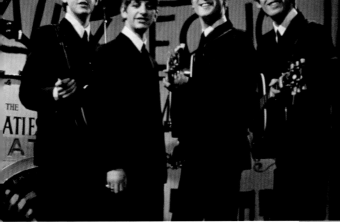

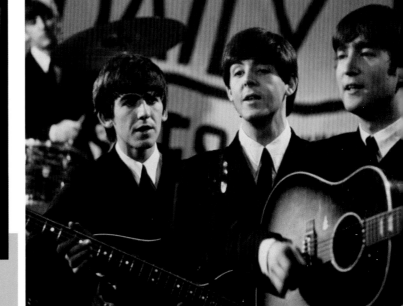

Opposite top left: Another backstage opportunity to play the fool as the fun-loving four make a game out of eating cheese on cocktail sticks.

Opposite above right: As police keep control of the line of fans waiting to buy tickets for the Beatles' concert in Lewisham, South London, three successful and jubilant girls hold theirs aloft.

Opposite middle: Exhaustion shows on the faces of the four as they sign autographs during their hectic autumn tour although John looks more animated as he gives yet more after a show (opposite bottom).

Left: A delighted young fan is photographed with the band.

Below left and right: Throughout the autumn tour the boys usually play six nights a week but still have yet more commitments during the daytimes including an appearance on *The Ken Dodd Show*.

The Beatles might have been the biggest fish on the UK scene, but in the US they remained minnows

The next phase

The Beatles had proved themselves in both the singles and album charts, and had shown that they could steal any show, no matter what slot they were given on the bill. There were two missing pieces of the jigsaw. One was the print media. The Beatles were getting plenty of coverage in provincial newspapers and music publications, but for most of 1963 there had been only sporadic references in the national press. Tony Barrow, who wrote a music column in the *Liverpool Echo* under the "Disker" by-line, was appointed full-time press secretary to NEMS in May 1963. At first Barrow's efforts to get his press releases into print were met with stony resistance in the capital. The time would come soon enough when London's Fleet Street newspapers would be vying for any snippets Barrow could toss them, pieces that could be worked up into a front-page splash.

The second issue was the lack of impact their records were having on the American charts. The Beatles might have been the biggest fish on the UK pop scene, but across the pond they remained minnows. The group's first two releases, "Please Please Me" and "From Me To You", sank without trace, largely through the woeful promotional efforts by the distributor. Vee-Jay had picked up the distribution deal after Capitol, which was owned by EMI and had first refusal, had shown itself unwilling to release any Beatles' records — or those of any other British artist, for that matter. The timing was unfortunate, for Vee-Jay's president blew a sizeable chunk of the company's operating capital in a gambling spree, which left a gaping hole in any plans to promote a record by an unknown British band. In short, cracking America would take a little while longer.

She Loves You

Middle: Ringo hits the dance floor with the wife of music publisher Lou Levy at a Mayfair party held by the millionaire John Bloom, while George dances with another party guest (left). The band were initially mistaken for gatecrashers when they arrived.

Below: Paul and Ringo during a television recording. Requests for both television and radio appearances were rapidly escalating during the autumn.

Bottom right: "She Loves You" had two separate runs at the top of the British charts.

It was more than simply a musical phenomenon; the Beatles transcended the status of hottest pop act in the land

John and Paul dashed off the group's fourth single in a hotel room in late June 1963, during the Beatles' summer tour. Within a week they had recorded "She Loves You", another irresistible winner, though with advance sales of almost a quarter of a million the fans were by now taking that for granted. With its drum-roll straight into chorus; its falsetto "oooohs", accompanied by the neatly choreographed quivering moptops — already rolled out successfully in "From Me To You"; and its "yeah, yeah, yeahs", which became media shorthand — this was the sound and enduring image, not only of summer 1963 but the entire era. It was more than simply a musical phenomenon; the Beatles transcended the status of hottest pop act in the land. An extraordinary sea change was taking place, a zeitgeist moment. The Beatles really did capture the spirit of the age: liberated Baby Boomers reaching majority, optimistic, aspirational, questioning entrenched attitudes and values.

"She Loves You" became the Beatles' best-selling single, breaking the million barrier in an eight-month chart run that included two separate spells at No 1. It set a UK record that would not be broken for 14 years. Ironically, McCartney would be responsible for ending that run as Wings' "Mull of Kintyre" set a new benchmark in 1977.

SHE LOVES YOU
By JOHN LENNON and PAUL McCARTNEY
Recorded by **THE BEATLES** on PARLOPHONE

Introducing **NEMPIX**
A BRAND-NEW RANGE OF BRILLIANTLY PRODUCED POP STAR PHOTOGRAPHS — THE ULTIMATE IN PICTORIAL PERFECTION

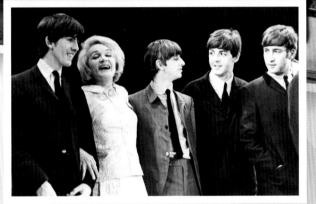

Left: The band rehearse for the *Royal Variety Performance* in November. The line-up that night included Tommy Steele, Harry Secombe, Pinky & Perky and Marlene Dietrich, the German-American actress and singer who joined the boys on stage during the show (below and below left).

Singer songwriters

Within a week of its release, With The Beatles *had replaced* Please Please Me *at the top of the UK chart*

By mid-July the group were being pressed to deliver a second album, despite the fact that *Please Please Me* had been in the shops just four months. The sophomore offering, *With The Beatles*, was another 14-song collection, with the same 8-6 split as their debut LP regarding self-penned songs and covers. "Hold Me Tight", a leftover from the earlier session, was dusted off, and there were six new Lennon-McCartney numbers. The other Beatles song on the album, "Don't Bother Me", marked George's first solo credit, though a collaboration with John had produced the instrumental "Cry For A Shadow" back in 1961. Faced with the hothouse of Lennon-McCartney creativity, George would find it hard to get his songs aired, something that began to pall over time.

Ringo had no such frustrations. He was sanguine about his role within the band, content with his percussion work and occasional lead vocal. On *Please Please Me* Ringo had sung one of the covers, the Shirelles number, " Boys". This time

John and Paul decided to write something specifically for him. They came up with two possibles that suited Ringo's limited vocal range, "Little Child" and "I Wanna Be Your Man", though at the last minute it was decided that the two frontmen themselves would share the vocals on the former.

As well as being an album filler for Ringo to let rip, "I Wanna Be Your Man" was also tossed to the Rolling Stones, who were looking for a new single. John and Paul jealously guarded their best efforts, but were quite happy to give away what they regarded as their second-string material. If others made a hit record out of one of their compositions, it meant more kudos and a few extra pennies in the royalty coffers.

What of the album? Within a week of its November 1963 release, *With The Beatles* had replaced *Please Please Me* at the top of the UK chart. Together these two long-players would give the Beatles almost a year-long monopoly at No 1.

29

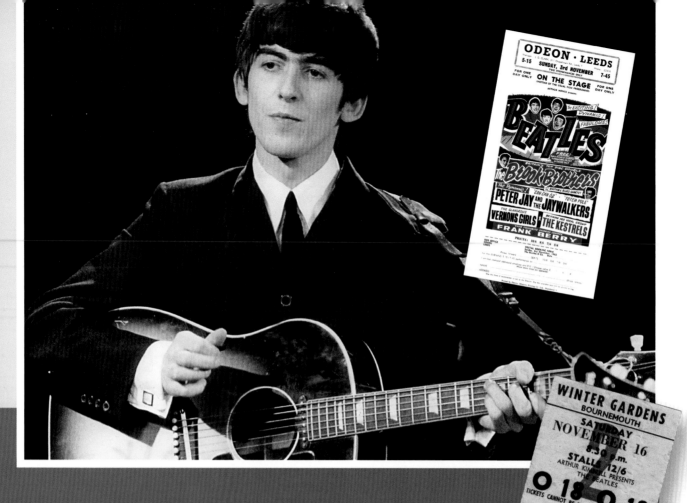

Another number one:
I Want To Hold Your Hand

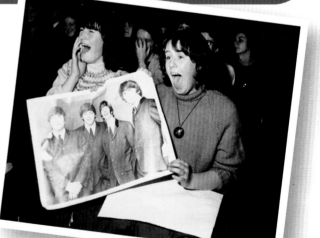

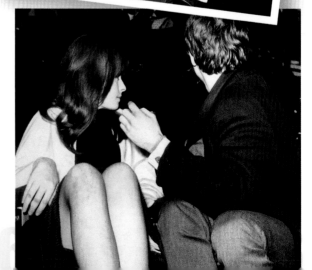

In autumn 1963 Brian Epstein entered into negotiations with United Artists, who were keen to put the Beatles up on the big screen. Or, more precisely, to cash in on a soundtrack album by the hottest band on the block, since such product was not covered in their EMI contract. As was typical at this stage in their career, the Beatles were more concerned with their art, leaving Epstein to take care of business. Paul and John had written their next single at the Wimpole Street home of Paul's new girlfriend, Jane Asher, whom he had met at a Royal Albert Hall concert in April. "I Want To Hold Your Hand" was released on November 29, knocking "She Loves You" off the top of the UK singles chart two weeks later.

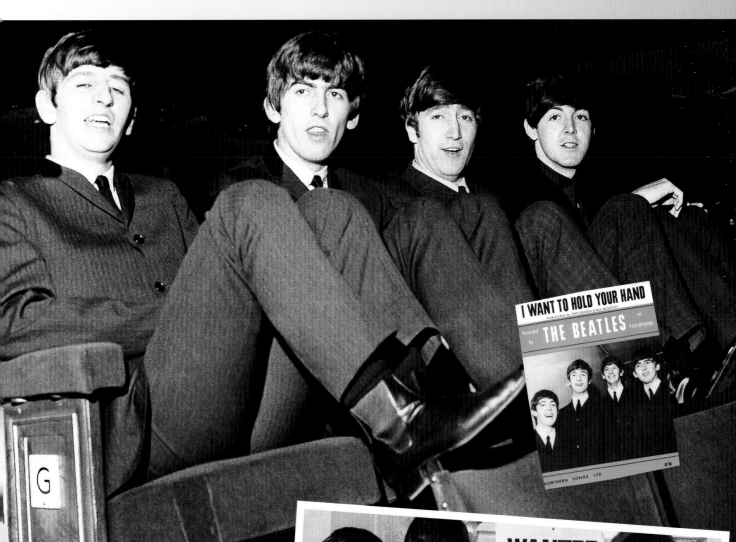

Opposite above: George in a pensive mood on stage at the Guildhall in Portsmouth. The gig had been postponed as Paul was ill on the original date planned.

Opposite left: A break for lunch at the Birmingham TV studios where they were recording *Thank Your Lucky Stars*.

Opposite right: Screaming fans in the audience at the Winter Garden Theatre in Bournemouth are filmed by US journalists who immediately screen footage on news channels back in America.

Opposite below: Paul tries to avoid the camera when he takes new girlfriend Jane Asher to the theatre.

Top: The boys relax just before a show. Due to their popularity Brian Epstein soon stipulated venues with fixed seating rather than ballrooms.

Above inset: Their fifth single "I Want To Hold Your Hand" was the first to top the American *Billboard* charts.

Above right: The band respond to aspiring MP Jeffrey Archer's request to support the Oxfam appeal. In December a plan is announced to cut up the Cavern Club stage and auction sections for the charity.

Right: A rest for the tired band. In November they only had four free nights and, even when the tour ended in the middle of December, it was straight on to record their *Christmas Show*.

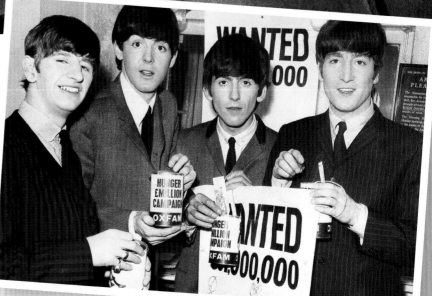

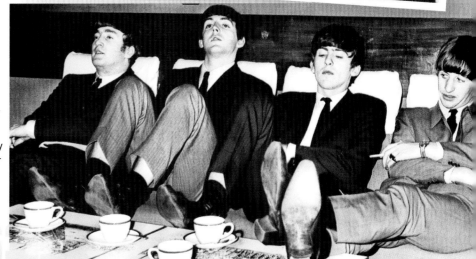

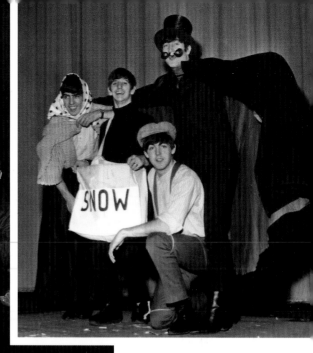

Left: Local and national press photographers continue to hound all their concert venues.

Above and below: Scenes from comic sketches during the *Beatles' Christmas Show* at the Finsbury Park Astoria.

American
advance

When US radio station WWDC began playing an import copy America braced itself for the onslaught of Beatlemania

Epstein didn't wait for the new single to reach number one, something that was already assured given advance orders of 1,000,000. He went to the States in mid-November, in part to finalize arrangements for the appearance on the Sullivan show, but primarily to mount a frontal offensive on Capitol Records. The EMI subsidiary had been obdurately ignoring the Beatles, happily standing aside as Vee-Jay, and the much smaller Swan label, issued the Fabs' first Stateside singles, to little effect. Thus, as 1963 drew to a close America remained largely unaware of the pop phenomenon that was sweeping Britain. CBS had carried a news item on Beatlemania, but a teenage craze 4,000 miles away cut little ice. There were Capitol Records executives

who hadn't heard of the Beatles, so it was hardly surprising that the rest of the country was oblivious. Now, having been leant on by their UK parent company, Capitol planned to release "I Want To Hold Your Hand" in late January 1964. The company hastily revised its plans when Washington DC radio station WWDC began playing an import copy and getting rave feedback, rushing the single out on December 26. Belatedly, America braced itself for the onslaught of Beatlemania.

1963 1963 1963 1963 1963 1963

Above and inset above: The Beatles are invited to appear on the prestigious *Morecambe and Wise Christmas Show*. At the end of the programme they join the comedy duo for a rendition of "Moonlight Bay", suitably attired in blazers and boaters.

Left: The band play in front of 2,000 screaming fans at the London Palladium.

Below: Ringo and fellow Liverpudlian singer Cilla Black on board a flight specially chartered by Brian Epstein to take all the Merseyside acts back to Liverpool after their appearance on the *Beatles' Christmas Show*. During the flight Ringo grasps the opportunity to visit the cockpit and take the controls.

Do You Want To Know A Secret

1964

F ollowing the giddy successes of 1963 in the Beatles' home market would be difficult enough. An even bigger task, and potentially greater prize, was to crack America, the graveyard of so many British artists.

Anyone who thought the tepid reception accorded the Beatles during their Paris residency at the start of the year was a bubble-bursting indicator was way off beam. It was there that they learned "I Want To Hold Your Hand" had given them their first US chart-topper, just as the group were about to set foot on American soil. By early April they occupied the top five spots on the *Billboard* Hot 100. A week later the boys had a jaw-dropping 14 records in that chart, an all-time record. Hits continued to flow from the Lennon-McCartney conveyor belt, including "A Hard Day's Night", a Ringoism that provided the title of their first celluloid outing and yet another monster long-player. A world tour elevated Beatlemania to the realms of global phenomenon, and they ended 1964 as they began it, on top of the 45 and album pile with "I Feel Fine" and *Beatles For Sale*. It was another year when they really had "been workin' like a dog".

Left: Despite the relentless touring schedule the new album *Beatles for Sale* was completed on time. Released on December 4, it replaced *A Hard Day's Night* at the top of the charts only two weeks later.

THE Cavern CLUB

MEMBERSHIP CARD
1963 SEASON

Ending 3 ...ember, 1963

SPECIAL PREVIEW • ADMIT ONE
Wed. Aug. 12th at 2:00 p.m.
THE BEATLES
in their First Feature-Length Motion Picture
"A HARD DAY'S NIGHT"
Produced by Walter Shenson / Released Thru United Artists
ALL SEATS $1.00
This Ticket Is Good Only For This Performance
at the
EMBASSY
THEATRE

No 1473
DO NOT DETACH. Present Entire Ticket To Doorman
THIS TICKET IS GOOD ONLY AT
EMBASSY
THEATRE
All Seats $1.00

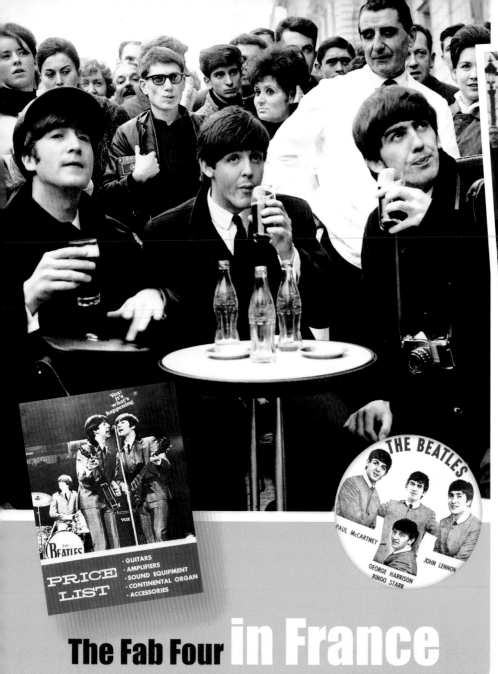

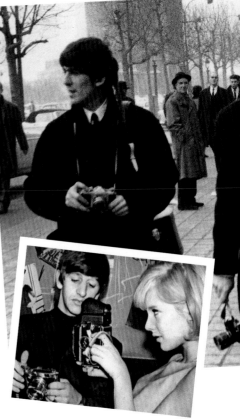

Left and top: During their residency in Paris the band have only a couple of rest days but take the opportunity to wander along the Champs Elysées and stop for a drink. Although Parisians showed an interest, Beatlemania had not reached the French capital and the lads were able to enjoy this relative freedom.

Above: Ringo shows Sylvia Martan some of his cameras. The French singer was also on the bill at the Olympia and had recently become engaged to Johnny Hallyday.

Below: "I Want To Hold Your Hand" shot to the top of the US *Cash Box* charts.

The Fab Four in France

News filtered through to the boys that "I Want To Hold Your Hand" had reached No 1 in America

If it was difficult for British artists to break America, France was also a notoriously tough nut to crack, as the Beatles found during their residency at the capital's Olympia Theatre in January 1964. The country that revered Johnny Hallyday as the last word in swoon-inducing pop stardom greeted the Fabs with a nonchalant air. The dress-suited, male-dominated audience found both the music and the boys' winsome charm quite resistible. Equipment problems didn't help. Reviews were less than complimentary, one journal saying "their ye-ye is the worst we have heard". For once the Beatles weren't drowned out by hysterical fans, but the muted response was concerning. If they couldn't crack France, what chance the States? Those fears were soon allayed as news filtered through to the boys at their George V Hotel suite that "I Want To Hold Your Hand" had reached No 1 in America's *Cash Box* chart. It took just three weeks to top the *Billboard* Hot 100, a feat no other British act had managed. Having let four Beatles singles slip through its fingers, Capitol had finally got the message. But by the time the label's marketing machine swung into action, the touch-paper was already alight.

Above: The band used the luxurious surroundings of their suite at the George V Hotel, complete with a specially commissioned grand piano, to pen further compositions including Paul's "Can't Buy Me Love". Their forthcoming third album would contain thirteen new songs; all written by members of the band.

Left inset and below: Time for some rest and relaxation in the French capital.

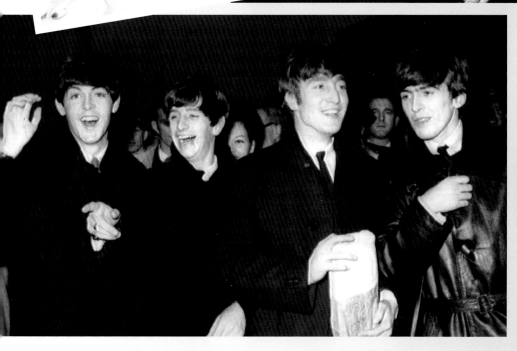

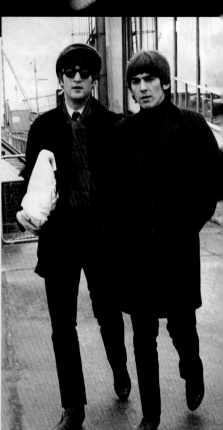

Five million
American sales

Meet The Beatles flew off the shelves, sales eventually topping the five million mark

Having vacillated over the Beatles for so long, Capitol wasted no time in putting out a long-player to capitalise on the phenomenal success of "I Want To Hold Your Hand". *Meet The Beatles!*, rush-released on January 20, 1964, carried the strap line: "The first album by England's phenomenal pop combo". It contained nine of the 14 songs from *With The Beatles*, along with "This Boy" and both sides of the smash-hit single. "I Saw Her Standing There" had been chosen as the flip to "I Want To Hold Your Hand" – Capitol opted for a pair of driving rockers for its debut 45 – and the single was deliberately included on the LP to drive sales. The same Robert Freeman sleeve photograph was also used, with a blue tint. *Meet The Beatles!* flew off the shelves, sales eventually topping the five million mark, at a time when shifting 500,000 copies was considered hugely successful, a million-seller a rarity. It took just three weeks to scale the *Billboard* summit, where it remained for 11 weeks, holding off Vee-Jay's rival *Introducing The Beatles*. The latter spent nine weeks at No 2 and also comfortably exceeded the million-sales mark.

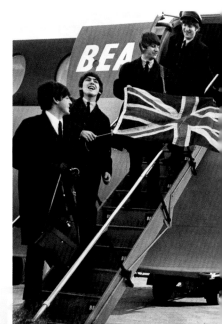

Opposite page: The boys return to London on February 5 and are once again greeted by their devoted fans. While in Paris they had collected their US visas and were due to fly to the States after a single day's rest.

Opposite inset: Vee-Jay release their first US album *Introducing the Beatles* on January 10.

Right: At the airport they are immediately interviewed by a journalist keen to find out about their forthcoming American tour.

Insets below: George then rushes up to Liverpool to visit his delighted parents as his father has been unwell. He is still holding his specially commissioned gift holdall from BEA to advertise the airline.

American
record companies

Capitol's decision to throw its considerable weight behind the Beatles was a beacon to Vee-Jay and Swan, who had gained precious little from their earlier efforts with the group and were keen to get a piece of the action. On January 30, Vee-Jay issued "Please Please Me"/"From Me To You", the A-sides of their two single releases of the previous year. The latter had sold the better of the two first time round, though not well enough to break into the Hot 100. In fact, Del Shannon scored better with his version of "From Me To You", giving Lennon-McCartney their first American chart success when he took the song into the lower reaches of the Hot 100 in summer '63. The new single reached No 3, but in trying to guarantee a sure-fire hit Vee-Jay missed a trick. Had the songs been released separately, Vee-Jay would undoubtedly have had two top-five hits instead of one.

Vee-Jay also issued the Beatles album it had been forced to shelve the previous summer because of the parlous state of the company finances. Label bosses mistakenly thought that *Introducing The Beatles* contained essentially the same material as Capitol's album, and wanted to make a quick buck

before the inevitable litigation began. In fact, *Introducing The Beatles* mirrored the UK album *Please Please Me*, minus the title track and "Ask Me Why", which Vee-Jay had already put out as a single. Thus, the only song common to both US albums was "I Saw Her Standing There". It was still a minefield, however. Vee-Jay was unsure of the precise legal position, and took a "calculated risk" to fill the coffers, even though the cash-strapped company might face a hefty penalty down the line. One thing was crystal clear: Vee-Jay didn't hold the rights to "Love Me Do" or "P.S. I Love You". These were hastily replaced with "Please Please Me" and "Ask Me Why", though not before a number of pressings had been made. *Introducing The Beatles* thus exists in two forms.

Capitol still filed suit, on the grounds that Vee-Jay had defaulted on the royalty payments due for the two singles issued in 1963, resulting in the termination of their contract with EMI in August of that year. Vee-Jay had indeed failed to pay its royalty dues, the gambling predilection of then-company president Ewart Abner having created a financial black hole in the company accounts.

The Beatles
are coming!

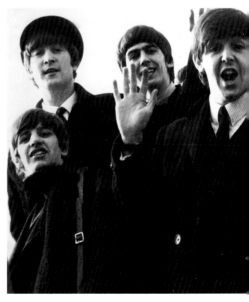

With Capitol, Vee-Jay and Swan falling over themselves to release — or re-release — Beatles products, and with injunctions flying around in pursuit of legal clarity, the Fab Four set foot on American soil for the first time on February 7, 1964. The group had been wary of committing to a US trip until they were big-name players, and any apprehensions as to whether they could recreate their homeland success in the land of their musical heroes would have been swept aside by the tumultuous reception at JFK Airport. The kids turned out in force, the chaotic scenes matching any the Beatles had witnessed on their home turf. A phalanx of reporters captured the first wave of Beatlemania, American-style. Inevitably, hype played a part. Capitol ran a slick marketing campaign, liaising with United Artists — the studio backing the first Beatles movie — and CBS — the network behind *The Ed Sullivan Show*, to ensure every publicity angle was covered. Bumper stickers informed the populace "The Beatles are coming". Some kids received a free T-shirt, some may have been bussed in to swell the screaming ranks. But no one could have orchestrated the crowds that packed the terminal, lined the route to the city and laid siege to New York's Plaza Hotel. And the city's radio stations wouldn't have supplied blanket coverage had there been no substance to back the buzz.

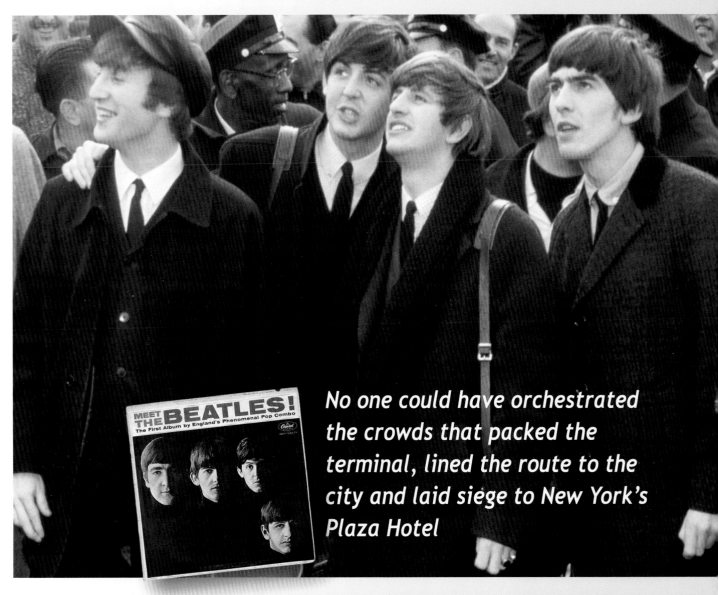

No one could have orchestrated the crowds that packed the terminal, lined the route to the city and laid siege to New York's Plaza Hotel

Opposite above left: The Beatles are immediately interviewed at the Plaza Hotel for the next day's edition of *Saturday Club*.

Opposite above right and middle: John's wife Cynthia accompanies him to the States. She had given birth to their son Julian the previous year and although Epstein asked John to keep their marriage a secret, the press soon found out, although Cynthia was always happier out of the limelight.

This page and opposite below right: Scenes at JFK airport after the boys land. Police are on hand to contain the fans who crowd into the airport although they have to fight to control the surging crowds.

Inset above: *Meet The Beatles!* reaches the top of the *Billboard* album charts holding the top spot for 11 weeks, only to be immediately replaced by their next LP.

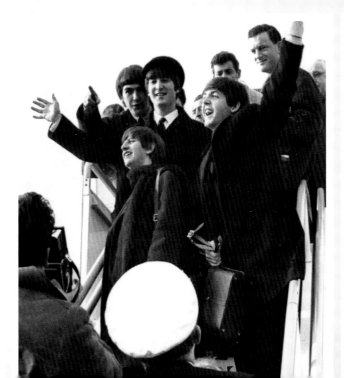

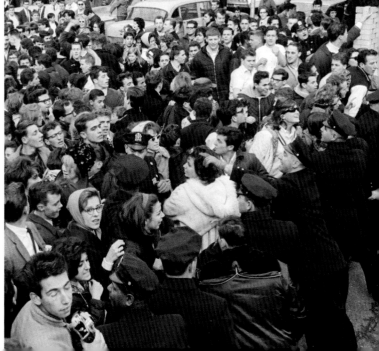

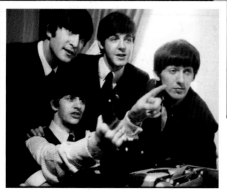

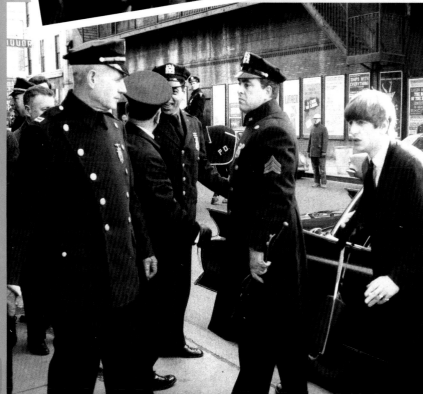

Opposite above: Veteran host Ed Sullivan welcomes the band onto his prime time television show.

Above: Backstage they are introduced to fellow guest American speed skater Terry McDermott who had just won gold at the Winter Olympics. Sharing the lads madcap sense of humour he proceeds to pretend to cut Paul's hair as the others look on in mock horror.

Above and right: In New York the Fab Four are virtually imprisoned in the Plaza Hotel as the fans besiege the building. They can only look out of the window and communicate by phone and need police protection to travel anywhere.

Left: Bad weather cancels their next flight from New York to Washington but local police escort the boys to the station in safety.

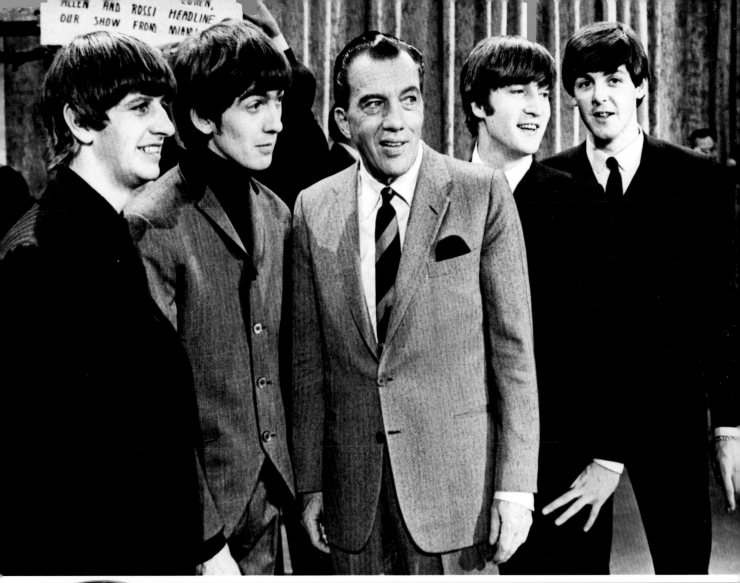

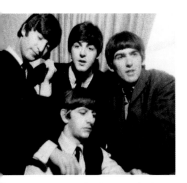

Then there was music:
The Ed Sullivan Show

*It was viewers in American homes coast to coast
— a record 73-million tuned in that evening —
who were the real target audience*

In November 1963 Brian Epstein negotiated the deal that gave his boys the best possible exposure in America: back-to-back star spots on the prestigious *Ed Sullivan Show*, plus a taped performance to be broadcast the week after they'd returned home. It was arranged long before "I Want To Hold Your Hand" broke the band. The timing was perfect. On Sunday, February 9 the "tremendous ambassadors", as Sullivan introduced them, performed live on American soil for the first time. A few hundred saw them in the flesh as they opened the show with "All My Loving", "Till There Was You", and "She Loves You", then returned in the second half to perform both sides of their number-one single. It was viewers in American homes coast to coast — a record 73-million tuned in that evening — who were the real target audience.

43

Washington goes wild

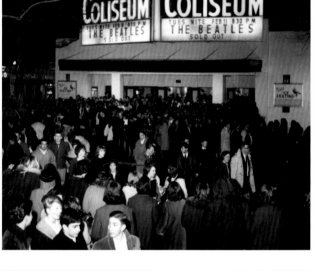

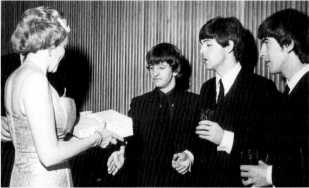

8,000 delirious fans paid up to $4 for the privilege of saying they were there for the Beatles' concert debut in America. It took place at Washington Coliseum on February 11, the boys tearing the place up with a 12-song set including all the hits and rounding off with one of Paul's favourite rockers, "Long Tall Sally". As the stage was in the centre of the auditorium, the group turned 90 degrees after each three-song segment so that the entire audience had a front-on view for at least part of the show. The group's biggest gig to date was electrifying, but it was also a staging post on the road to disillusionment, for they could scarcely be heard above the din. An interesting footnote to the Washington show: among the support acts were the Chiffons, whose 1963 hit "He's So Fine" George would be accused of subconsciously plagiarising a decade later.

Top: Even on this brief horse-drawn buggy ride in Central Park police are needed to monitor their movements and keep the fans under control.

Above middle: 7,000 fans gather outside the Washington Coliseum where the band hold their first US concert.

Inset above left and above: A welcome reception is held for them at the British Embassy in Washington but they even have to escape from these formalities when a guest tries to cut off a piece of Ringo's hair.

Opposite below: Fortunately the crowds aren't so frenzied in Washington and the band has some much-needed space allowing them to wander freely around the capital. Only a few photographers follow them and the fans keep their distance.

Left and circle insets: At the Coliseum they play in the middle of the arena which means turning the whole set round every 15 minutes. Unfortunately they are also bombarded with a shower of jelly babies after fans find out about George's favourite sweets.

Beatles cause chaos at
Carnegie Hall

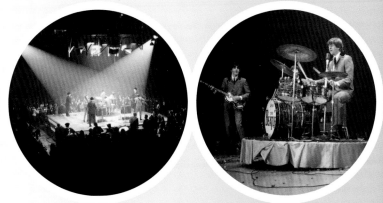

A day after their Washington triumph, the Beatles were back in the Big Apple, where they played two concerts at Carnegie Hall. Promoter Sid Bernstein dangled the carrot of one of the world's pre-eminent concert venues before Brian Epstein in autumn 1963, having felt the shockwave of Beatlemania via media reportage. He knew nothing of their music, but was acutely aware of the Beatles' impact on British audiences and was prepared to gamble on a similar seismic shift his side of the Pond. Epstein considered it a major coup, but wouldn't risk having the boys play to half-empty houses. The Carnegie Hall deal wasn't sealed until January '64, when America was bitten by the Beatle bug and sell-out shows were assured. Tickets changed hands for 30 times the face value. Many high-profile celebrities missed out as the Beatles took to the stage at 7.00pm, and again at 9.30 — both shows running well behind schedule in one of the venue's more chaotic nights. Thousands gathered in the streets, hoping for a miracle or at least a glimpse of the Fabs. Epstein and Bernstein were fast realizing quite what a sensation the Beatles had become in America.

ON THE SCENE
EXCLUSIVE
Photographed by United Press
International Candid Camera Team.
THE
BEATLES
AT CARNEGIE HALL

THE TITLE PRODUCTION
BEATLES
CARNEGIE HALL
WED. FEB. 22

Written by RALPH COSHAM in New York **2/6**
Over 60 Illustrations A Panther Pictorial

Thousands gathered in the streets. Epstein and Bernstein were fast realizing quite what a sensation the Beatles had become in America

Fab Four make a
splash in Florida

One in three of the US population watched them perform for the second time in a week

With three triumphant stage shows behind them, the Beatles were able to indulge themselves for much of the second week of their American sojourn. Swapping snowbound New York for Florida sunshine, they took up residence at Miami's Deauville Hotel, from where the second *Ed Sullivan Show* was broadcast live on Sunday, February 16. The boys performed four of the five numbers they had sung the previous week, adding the sumptuous three-part harmonies of "This Boy" and "From Me To You" at the expense of Paul's showpiece ballad, "Till There Was You". Actress Mitzi Gaynor was the home-grown star, but it was the Beatles who were responsible for another 70-million countrywide audience. It meant one in three of the population had watched them perform for the second time in a week.

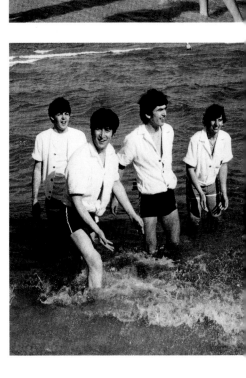

1964 1964 1964 1964 1964 1964

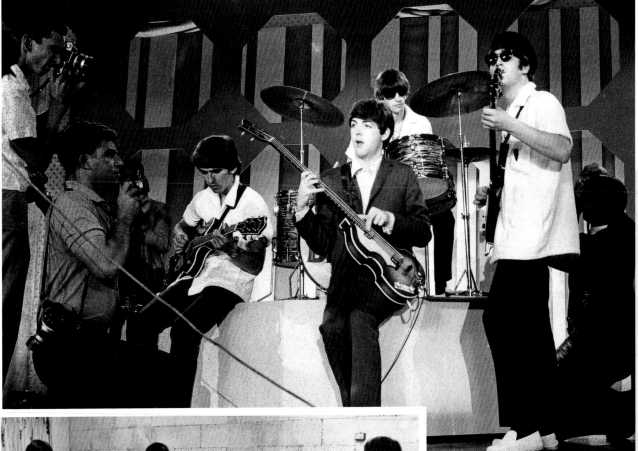

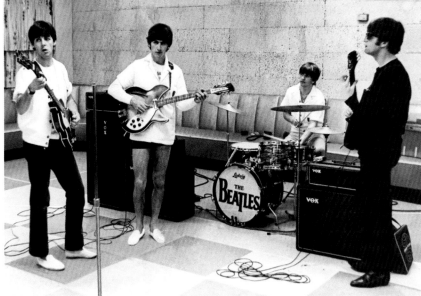

Above and opposite above: A final run-through on set before *The Ed Sullivan Show*. It is screened from the Deauville Hotel in Miami Beach before an audience of 3,500. Mitzi Gaynor tops the bill with a reported 70 million people watching the programme.

Left: The Beatles rehearse at the hotel in prepraration for their second appearance on *The Ed Sullivan Show*. The classic drum head cover was designed by Ivor Arbiter, the owner of the music shop in Shaftesbury Avenue where Ringo purchased the Ludwig set. The capital B and dropped T were intended to emphasise the word "Beat" within the band's name.

Opposite below right and below: At the end of the tour they have the luxury of a few days in Miami to relax and enjoy the sunshine. Inevitably the lads are followed by the press but this does not deter them as they mess around in the warm waters with a few selected young ladies who are allowed to join them.

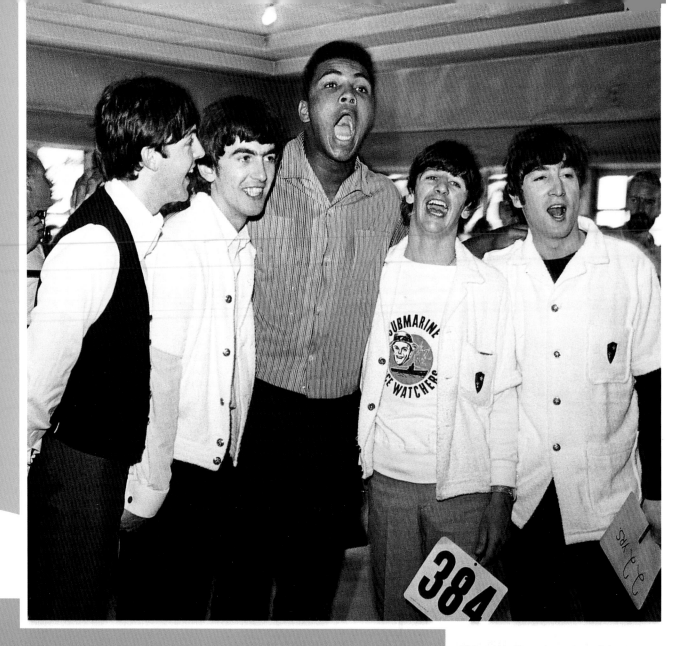

The Beatles
are the greatest

This page: Clay towers over all four members of the band.

Opposite page: The band take the opportunity to have a leisurely cruise along the Florida coast on the *Southern Trail* and are subsequently invited to the home of their security officer Sergeant Buddy Dresner, whose wife gives them a sample of American home cooking and a chance to relax with their three children.

While in Miami, the Beatles took the opportunity to visit heavyweight title contender Cassius Clay, who was training locally for his forthcoming bout with champion Sonny Liston. It is said that the group, keen to ally themselves to winners, would have preferred a photo-call with red-hot favourite Liston, who had been in the audience for the second Sullivan show. In fact, the pretty and witty challenger was a perfect match for the Fabs. And publicity-wise, they backed the right horse, for a week later Clay defied the odds and claimed his place at the top of his profession, which he dominated for the rest of the decade. The parallel is clear. The future Muhammad Ali was prescient as well as playful when he said the Beatles were "the greatest" in their field, as he was in his.

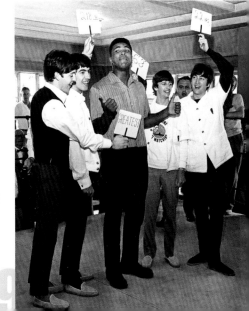

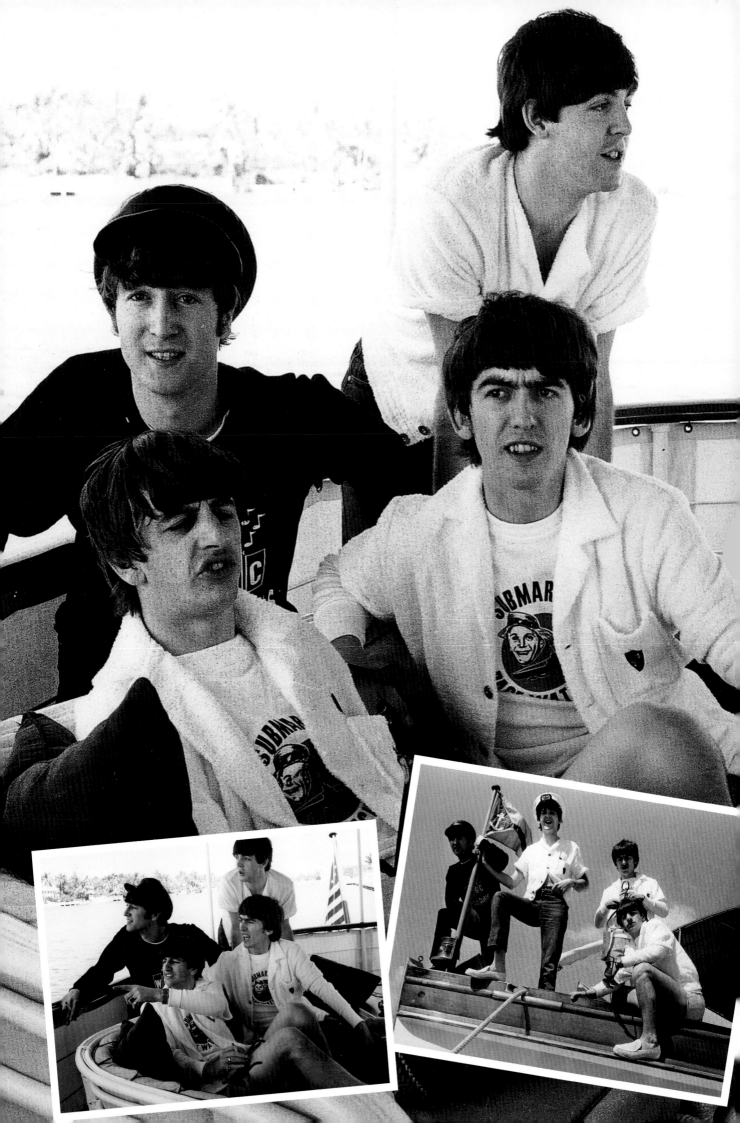

Beatles top Hot 100
for thirteen weeks

Capitol considered issuing "Roll Over Beethoven" as the follow-up to "I Want To Hold Your Hand". The Chuck Berry number had been released in Canada and was doing a storming trade as an import. In the end the label deferred to George Martin, and the exuberant "Can't Buy Me Love" — a McCartney song first aired during their stay in Paris — became the group's next US chart-topper. Following hard on the heels of "I Want To Hold Your Hand" and "She Loves You", it gave the Beatles an aggregate 13 consecutive weeks at No 1.

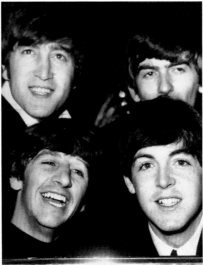

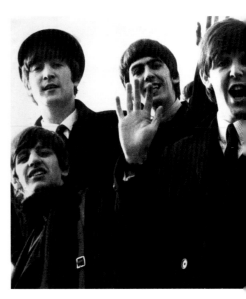

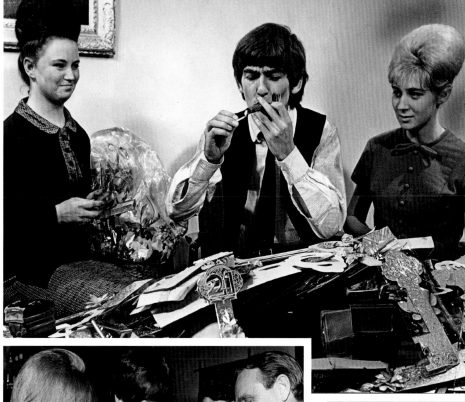

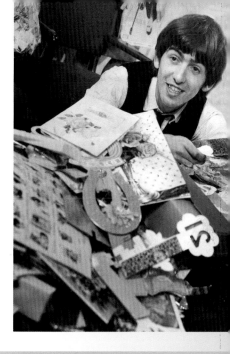

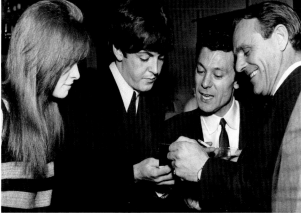

Birthday boy
George at 21

No sooner had the Beatles arrived home from their triumphant first visit to the USA than Brian Epstein was inundated with offers for them to return, virtually naming their price. The boys had a lot of commitments before they could return to the States for a concert tour proper. Even celebrations for George's 21st birthday had to be restrained as that very day, February 25, they had pressing studio business to attend to. With a week to go before they were required on set for their big-screen debut, the priority was to lay down the tracks that would feature in the movie.

Top: Three days after their return, George, the youngest member of the band turns twenty-one. Fifty-two sacks of mail are delivered along with countless presents including the ubiquitous jelly babies. Lucky members of the Beatles' Fan Club are on hand to help him.

Middle left: Paul and Jane Asher talk to Lionel Blair and Dickie Henderson at a party held for Sammy Davis Junior at the Pickwick Club in London. Afterwards George joins them for dinner (below left).

Above and left: The boys are invited to dinner at Brasenose College, Oxford where they dine with the college principal Sir Noel Hall, tutor David Stockton and Jeffrey Archer and Michael Hall, two college students.

Fab Four film
A Hard Day's Night

George was smitten by model Pattie Boyd, cast in the film as one of the schoolgirls who meet the Beatles on their hectic London-bound train journey

On Monday, March 2, 1964 the cast and crew of the new Beatles film convened at Paddington Station to begin shooting the as-yet untitled feature. Writer Alun Owen flirted with the idea of scripting a fantasy before realizing the stars' own lives had more unreality than any storyline he could dream up. The result was a madcap romp through a typically frenetic 48 hours in the lives of the band, shot in cinéma vérité style. The mock-documentary approach gave an insight into the goldfish-bowl existence, though film and fact parted company as adoring female fans were kept at arm's length from the band. The decision to avoid a love interest was deliberate, but romance did spark away from the cameras. George was smitten by model Pattie Boyd, whom director Richard Lester had worked with on a Smith's crisps advert and cast as one of the schoolgirls who meet the Beatles on their hectic London-bound train journey.

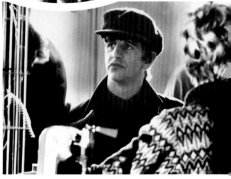

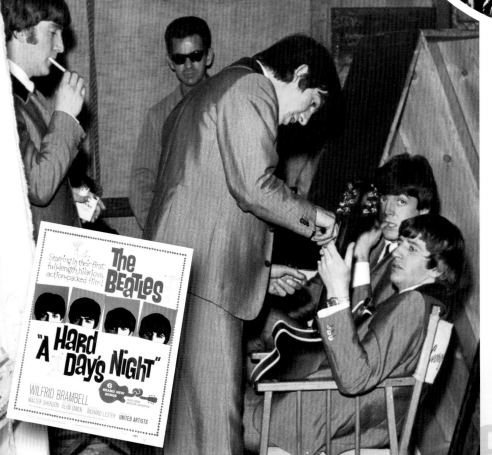

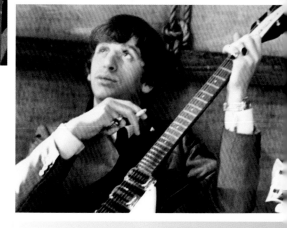

Opposite page: *A Hard Day's Night* features a day in the life of the Fab Four and centres on Ringo's decision to go wandering around London and the attempts of the others to find him. It is during filming that George falls for model Pattie Boyd (circle inset), successfully wooing her away from her current boyfriend and marrying her eighteen months later.

Above: Film co-stars (l to r) Pattie Boyd, Tina Williams, Pru Bury and Susan Whiteman attend to the locks of the Four.

Right and below: The boys often use the breaks in filming to play their instruments and work on new compositions.

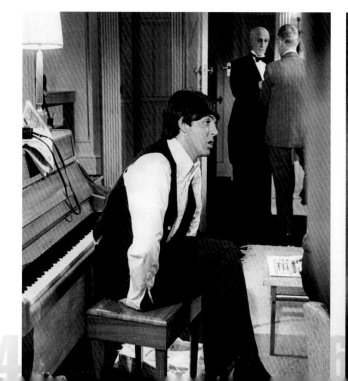

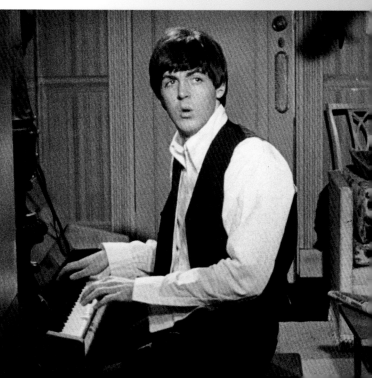

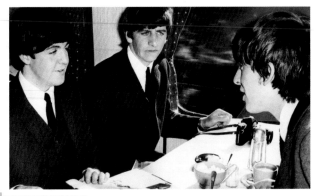

A creative battle

"A Hard Day's Night" was recorded barely 24 hours after it was written and became another instant classic

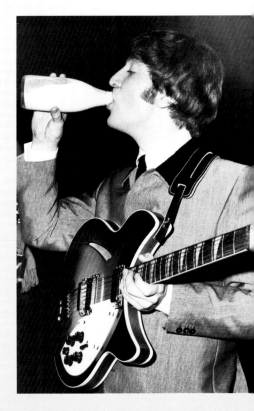

O nce Richard Lester seized upon a Ringo throwaway line for the movie's title, the race was on to write a top-notch title track. It was the first time Lennon and McCartney had been confined by a titular straitjacket, but it proved no encumbrance. John arrived with the completed song the next morning – the days when the duo wrote "eyeball to eyeball" were largely over – thereby winning the latest round of the creative battle with Paul over A-side quotas. "A Hard Day's Night" was recorded barely 24 hours after it was written, John taking the verse and handing over to Paul for the middle eight as it was beyond his range.

George contributed the ecstatically clangorous, instantly recognizable opening chord, which took its place in music lore as guitarists tried to fathom what he was playing on his 12-string Rickenbacker. Most fans neither knew nor cared; all they were interested in was the result. "A Hard Day's Night" was another instant classic and added to the list of transatlantic chart-toppers.

United Artists initially may have regarded *A Hard Day's Night* simply as a means to a soundtrack-album end, but the studio found itself with a minor cinematic gem on its hands, an unexpected and highly lucrative bonus. Marx Brothers comparisons abounded in the reviews, one critic calling it "the *Citizen Kane* of jukebox movies". *A Hard Day's Night* received two Academy Award nominations, for Best Score and Best Screenplay, and did brisk business at the box office, taking well over 50 times what it cost to make on its initial release.

1964 1964 1964 1964 1964 1964 19

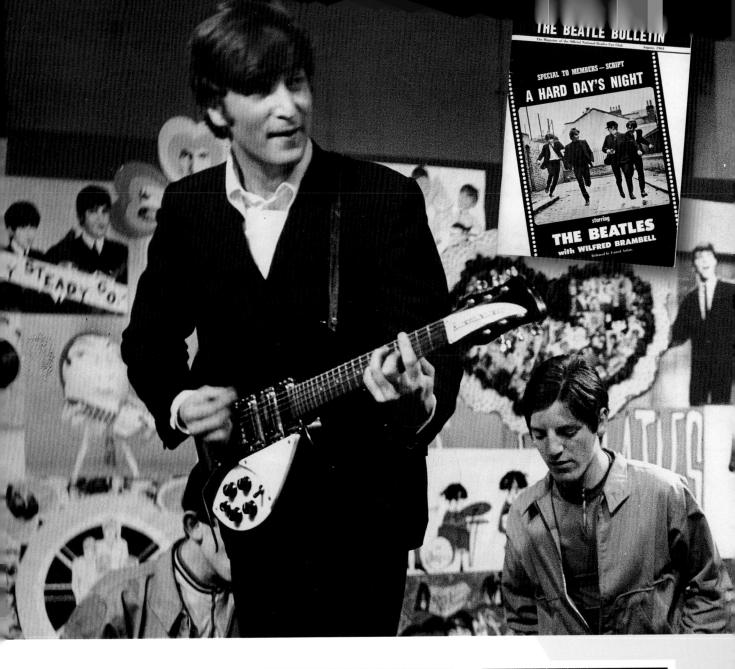

THE BEATLE BULLETIN
The Magazine of the Official National Beatles Fan Club
August, 1964

SPECIAL TO MEMBERS—SCRIPT

A HARD DAY'S NIGHT

starring

THE BEATLES

with WILFRED BRAMBELL

Released by United Artists

Opposite above left: Paul on set with Rosemarie Frankland. Although uncredited in the film she had been crowned Miss World in 1961.

Opposite above right: The train sequences actually took six days to film and for this a train constantly travelled between London and Minehead in Somerset.

Above: John performing on *Ready, Steady, Go!* During the show the lads are presented with an award from *Billboard* magazine to acknowledge the band's success in holding the first three positions on the American charts in the same week.

Right: George hides his mophead under a trilby.

Far right: Using his recently purchased Rickenbacker George plays the classic opening chord of "A Hard Day's Night".

Below right: Images of John captured at the Scala Theatre while *A Hard Day's Night* is being filmed.

Opposite below right: His preferred drink during filming at the theatre is a pint of milk.

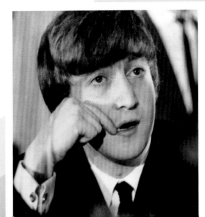

55

Joining the Beatles
bandwagon

Harold Wilson recommended the group for their MBEs. He also received a name-check on George's song "Taxman", along with Conservative leader Edward Heath

It wasn't just the likes of EMI, United Artists and the merchandising men who knew that the Beatles "sold". Those who frequented the corridors of power were also cognizant of the fact. There were votes to be had in being "with it", and the leaders of the main political parties in the UK were keen to hitch a ride on the Beatles' bandwagon. In the spring of 1964, with an election looming, it was said that Conservative candidates were urged to include Beatle references in their speeches. Opposition leader Harold Wilson, a northerner with a Liverpool constituency, was quick to align himself and his party with the Fabs. Wilson stole a march on his political rivals when he angled for the job of presenting the Beatles with their Royal Variety Club Awards for Showbusiness Personalities of 1963. The Dorchester Hotel ceremony provided just the photo-opportunity Wilson wanted, and he went on to win the general election. John recorded the event in his book, *A Spaniard in the Works*: "Azue orl gnome, Harrassed Wilsod won the General Election, with a very small marjorie over the Torchies". It was Wilson who recommended the group for their MBEs, and he also received a name-check on George's "Taxman", along with Conservative leader Edward Heath. Wilson's premiership lasted until 1970; he was ousted from power at the same time that the Beatles were breaking up.

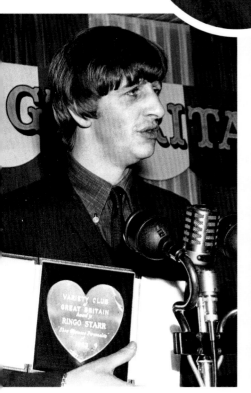

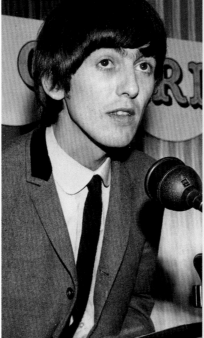

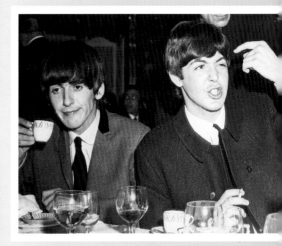

This page and opposite: Opposition leader Harold Wilson grasps a publicity opportunity to present the Beatles with the Showbusiness Personality of the Year Award at the Royal Variety Luncheon Club at the Dorchester Hotel in London.

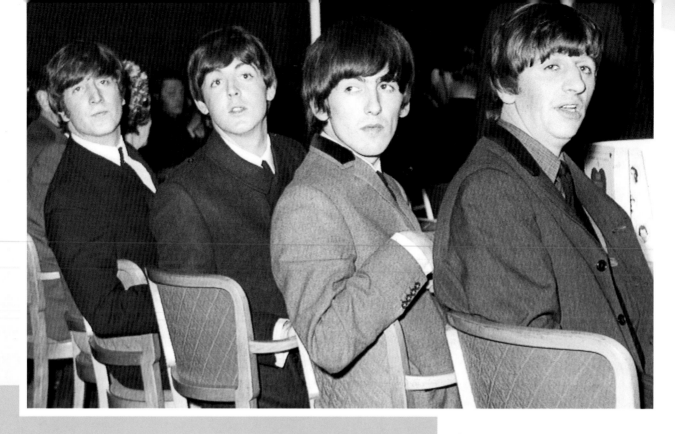

Most Outstanding Contribution
to British Music

Advance sales of a million were now the norm in the UK, but even that figure was dwarfed in the USA, where Beatlemania was in full swing

Above and opposite page: The boys were always able to relax during their visits to the Variety Club as they were mingling amongst many long-standing celebrities and away from the public eye.

Below left and opposite middle: A chance to meet the Duke of Edinburgh at the Carl-Alan Awards at the Empire Ballroom in Leicester Square, followed by congratulatory cigars for George and Ringo (opposite below right).

Below right: Mrs Bessie Braddock, the sixty-five year old fiery MP for Liverpool takes to the dance floor with George during the Awards Ceremony.

Opposite insets: "Can't Buy Me Love" is released on both sides of the Atlantic in March 1964, selling over a million copies in each country.

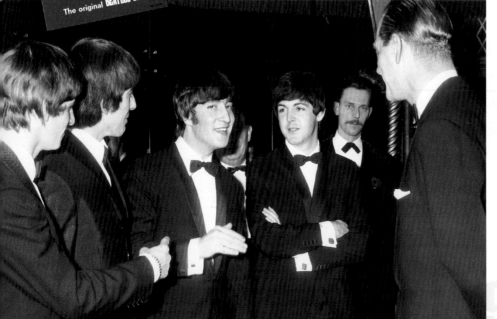

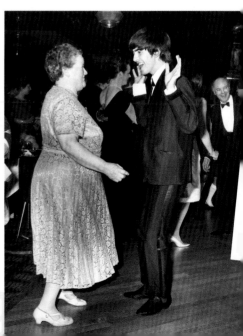

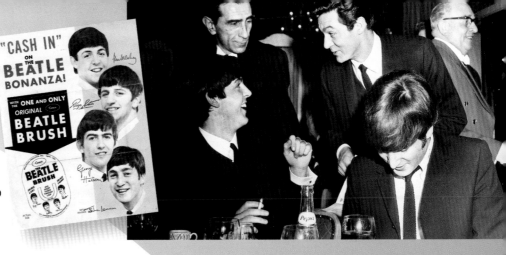

On March 23, 1964, just four days after picking up their Variety Club Awards, the Beatles were suited and booted for another gala occasion where more honours were heaped upon them. The prestigious Carl-Alan Awards were organized by Mecca, a vast leisure group whose famous chain of ballrooms had witnessed a number of Beatles gigs. At the ceremony, staged at London's Empire Ballroom, the Duke of Edinburgh presented the Beatles with two awards: Best Group of 1963, and Best Vocal Record of that year, for "She Loves You". Later in the year they would scoop five Ivor Novello Awards, including one for The Most Outstanding Contribution To British Music in 1963.

There was inevitably a lengthy time lag between the achievement and the bestowing of honours at glitzy award ceremonies. Not so with the fans, who could vote with their feet and their money as soon as a new Beatles record was released, the results of which could be seen within days. In the week before the Carl-Alan Awards ceremony, "Can't Buy Me Love" hit the record stores on both sides of the Atlantic. Advance sales of a million were now the norm in the UK, but even that figure was dwarfed in the USA, where "Beatlemania" was in full swing. When "Can't Buy Me Love" went to No 1 in the States on April 4, the Beatles occupied the top five spots on the *Billboard* chart. The boys had seven other numbers in the listing, and when "Love Me Do" and "There's A Place" broke through the following week, it gave them a record 14 songs in the Hot 100. Several of those, such as "All My Loving", "Do You Want To Know A Secret" and "Thank You Girl", were deemed album or B-side material in the UK, but in the States it seemed Capitol and Vee-Jay could raid the Beatles' catalogue indiscriminately and watch the sales figures soar. The year-end statistics showed nine Beatles songs in the Top 40 best sellers, reflecting the group's dominance of the American charts in 1964.

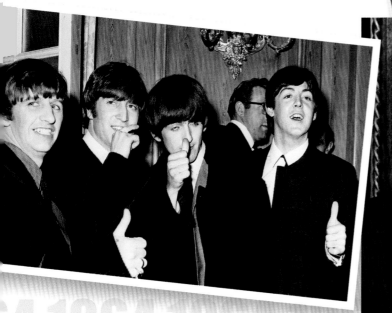

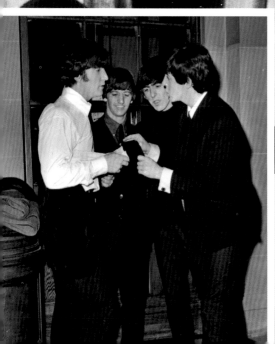

The year-end statistics showed nine Beatles songs in the Top 40 best sellers, reflecting the group's dominance of the American charts in 1964

Top left and middle left: Scenes backstage during filming. Amongst the 350 extras used for the audience scenes was 13 year-old Phil Collins, soon destined to explode onto the pop music scene.

Main picture and bottom left: The filming schedule lasted nearly two months with the end of shoot party held in a hall behind the Turks Head on April 24.

64 1964 1964 1964 19

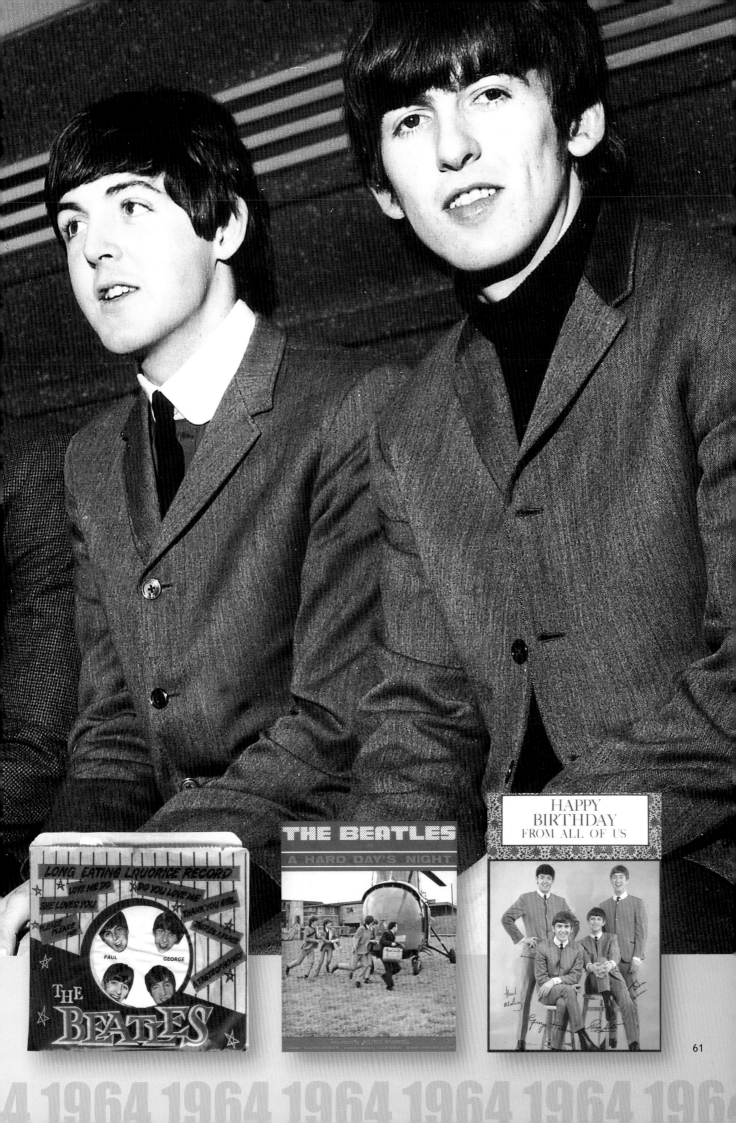

LONG EATING LIQUORICE RECORD
☆ LOVE ME DO ☆ DO YOU LOVE ME
SHE LOVES YOU ☆ THANK YOU GIRL
☆ PLEASE PLEASE ME ☆ ☆ A TASTE OF HONEY
PAUL GEORGE

THE BEATLES

THE BEATLES IN
A HARD DAY'S NIGHT

HAPPY BIRTHDAY
FROM ALL OF US

1964 1964 1964 1964 1964 196

EXCLUSIVE! 2968

THE BEATLES
STARRING IN
A HARD DAY'S NIGHT

With a special foreword by The BEATLES themselves

THE OFFICIAL UNITED ARTISTS' PICTORIAL SOUVENIR BOOK
★ Candid cameras behind the scenes
★ Stories you won't see on the screen
THE WHOLE CRAZY MAKING-OF-THE-FILM STORY — FROM START TO F

John Lennon
In His Own Write

The first edition of In His Own Write *sold out immediately, the public eager to see where the "witty" Beatle's flights of fancy had taken him*

Since his schooldays John had been an inveterate scribbler with a passion for wordplay, quirky turns of phrase, nonsense verse, and anarchic humour. He would jot down his musings on scraps of paper, and, unsurprisingly, "Ringoisms" were assiduously recorded. Indeed, "hard day's night" turned up in a Lennon story called *Sad Michael*, as well as providing the title of a hit song and movie. The tale of a downcast evangelist was part of a 57-piece collection, including 26 drawings, that was published on March 23, 1964. The first edition of *In His Own Write* sold out immediately, the public eager to see where the "witty" Beatle's flights of fancy had taken him. The critics were equally impressed with offbeat offerings such as *No Flies on Frank* and *Good Dog Nigel*. The *Times Literary Supplement* saw elements of Lewis Carroll and James Thurber in a "remarkable" book that was "worth the attention of anyone who fears for the impoverishment of the English language and British imagination". A somewhat bemused Lennon ("They took the book more seriously than I did") found himself the darling of the literary establishment, breaking off from filming *A Hard Day's Night* to attend a Foyle's luncheon. In his absence Richard Lester completed the sequence accompanying "Can't Buy Me Love", the end of which thus features only Paul, George and Ringo.

This page and opposite bottom right: The exclusive Les Ambassadeurs nightclub in London was used to film the night club scenes. Actress Merrill Colebrook snuggles up to Paul McCartney while Ringo and George launch themselves onto the dance floor.

Opposite above: The Fab Four with the American producer of *A Hard Day's Night*, Walter Shenson.

Opposite below left and opposite middle right: John and his wife Cynthia are invited to the Foyle's literary lunch at the Dorchester Hotel to celebrate the launch of his first book *In His Own Write* (inset).

1964 1964 1964 1964 19

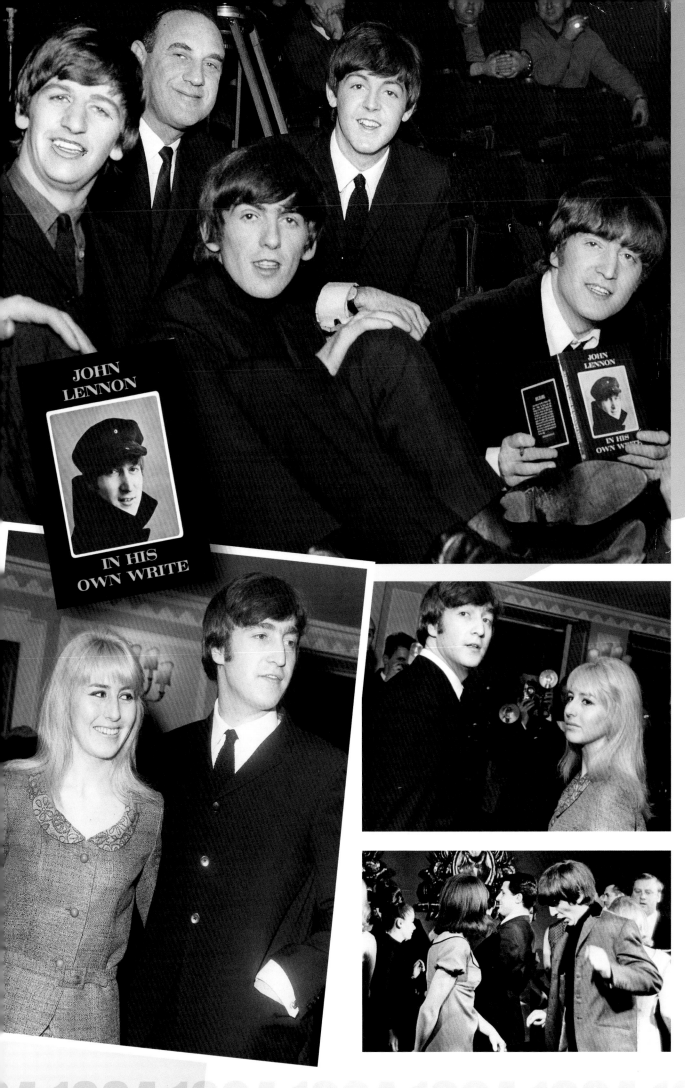

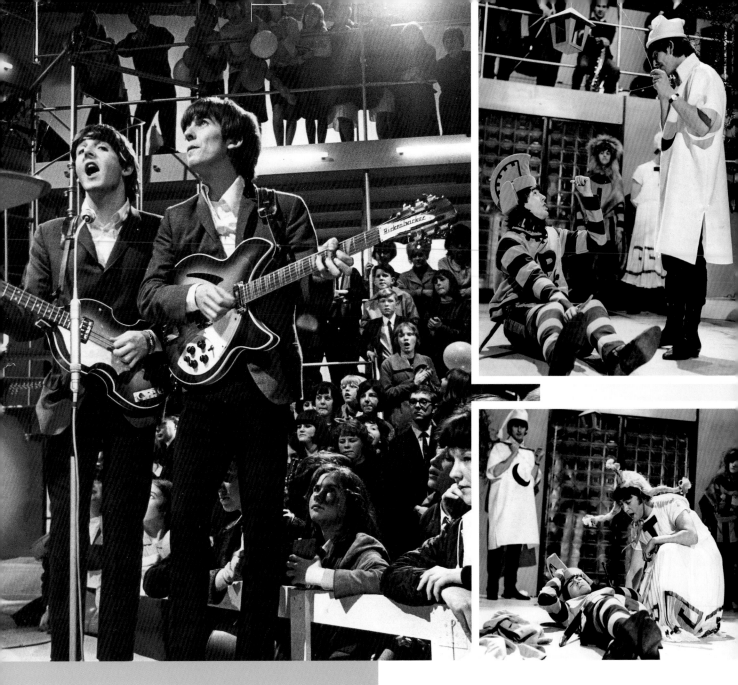

TV special
for adoring fans

Between the Fabs' departure from America and their return for their first concert tour, Beatlemania continued unabated

The Beatles' 1964 schedule was truly punishing. Even before *A Hard Day's Night* wrapped, rehearsals were underway for their next project. *Around The Beatles* was an hour-long television special boasting a strong pop line-up, including Cilla Black and Sounds Incorporated, who were also part of Epstein's NEMS stable. The stars engaged in some Shakespearean high jinks with a spoof of *A Midsummer Night's Dream*, and for the performance part of the show mimed to a specially recorded set that included their most recent number one, "Can't Buy Me Love", and a medley of hits. *Around The Beatles* aired in the United Kingdom in early May and America later that year.

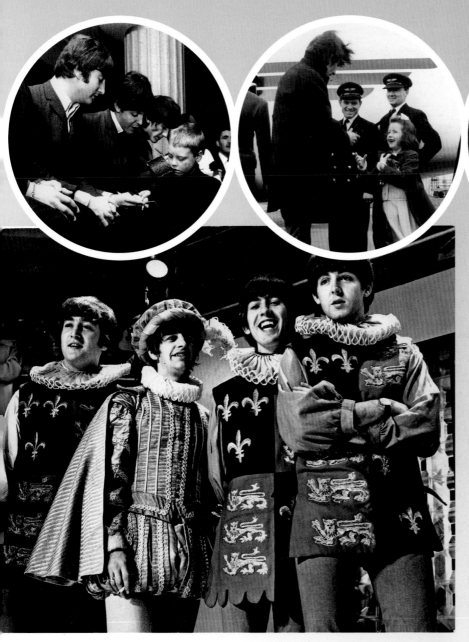

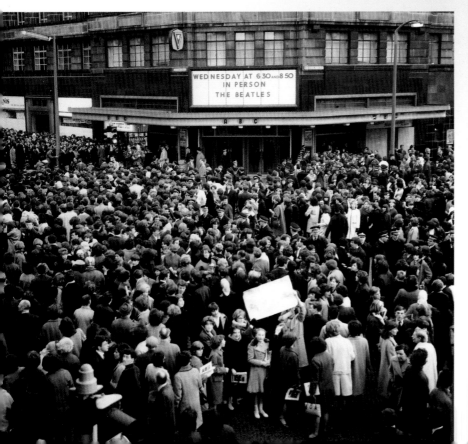

Opposite page and above left: The TV special *Around the Beatles* includes a performance of "Can't Buy Me Love" along with many early hits. Other guests include PJ Proby and Long John Baldry. In a sketch from *A Midsummer Night's Dream* John plays Thisbe to Paul's Pyramus, complete with full costumes.

Below right: After filming the special it is then on to Scotland for a brief visit after landing at Turnhouse Airport. They play two houses in Edinburgh and two in Glasgow and record several interviews while there.

Below left: Crowds of excited fans gather outside the ABC in Edinburgh.

Above right: An official welcome to Scotland's capital.

Top Row: They afford plenty of time for their young fans and freely sign autographs during the trip.

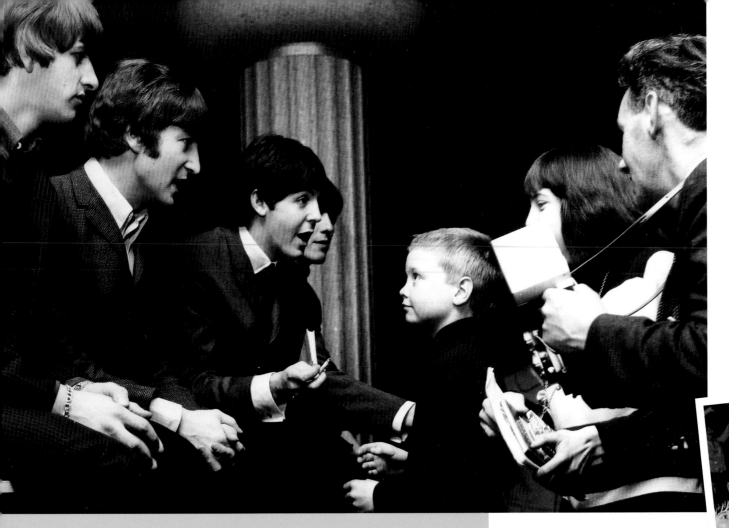

Record breaking
second American album

Above and opposite middle right: A further opportunity to meet young fans and a chance to chat to the Lord Provost in Edinburgh (opposite top right).

Opposite above left: The band arrive backstage in preparation for their Edinburgh show.

Opposite centre and below: As the band play the first of two shows, hysterical Scottish fans clearly show their excitement and appreciation.

No other artist had ever unseated one of his or her previous releases in reaching top spot in the album chart

Between the Fabs' departure from America in late February and return that summer for their first concert tour, Beatlemania continued unabated. In April Capitol released the group's second Stateside long-player, prosaically titled *The Beatles' Second Album*. It featured "Roll Over Beethoven" and "Please Mr Postman", left off the debut LP as Capitol altered the song list on *With The Beatles* to suit the American audience. The two songs had been paired as a single in Canada with huge success, and Capitol was quick to issue them on the sophomore set. The other three unreleased tracks from *With The Beatles* were also included — "You Really Got A Hold On Me", "Devil in Her Heart" and "Money" — along with four tracks that had already appeared in the US as 45s. To British ears it was old stock. But America did have one

coup: the album included "Long Tall Sally" and "I Call Your Name", which had yet to see the light of day in Britain. They were issued in the UK in June, part of a four-cut EP that included covers of Carl Perkins' "Matchbox" and "Slow Down", a Little Richard number.

The Beatles' Second Album replaced Capitol's own *Meet The Beatles* in the American album chart in the first week of May, with Vee-Jay's *Introducing The Beatles* still riding high in the top five. It was yet another first: no other artist had ever unseated one of his or her previous releases in reaching top spot in the album chart.

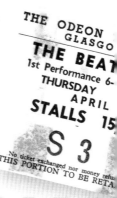

1964 1964 1964 1964 1964 1964 1964

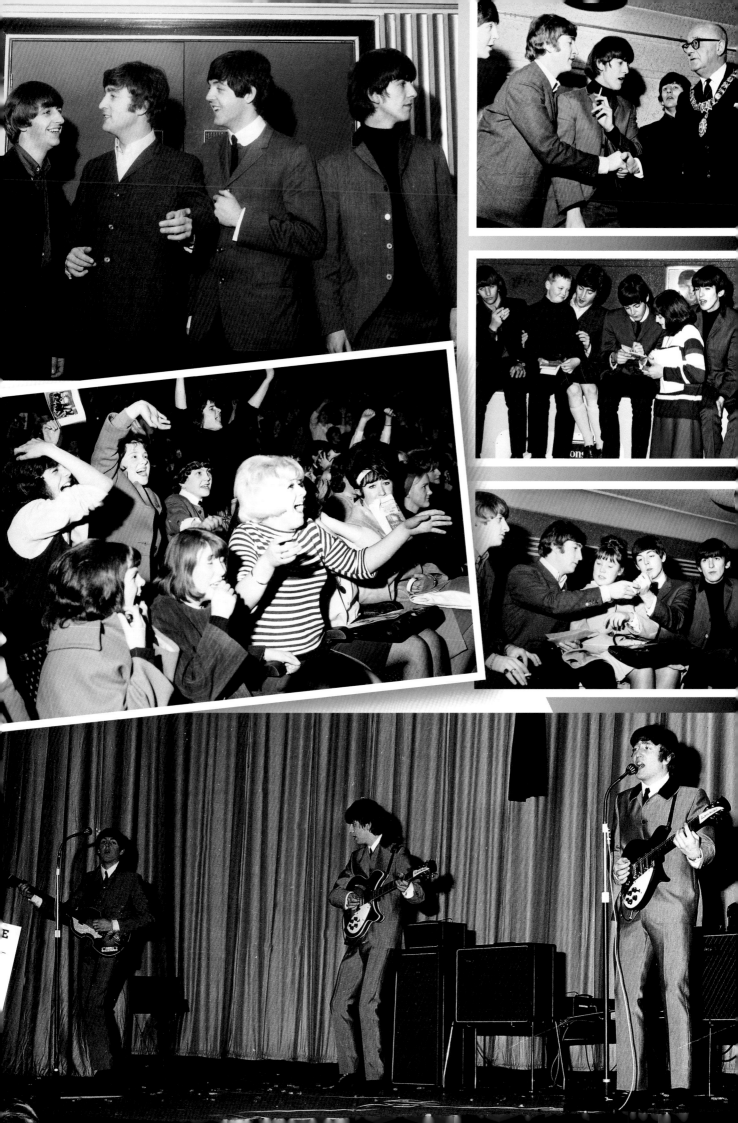

THE BEATLES'
SECOND ALBUM
featuring SHE LOVES YOU
and ROLL OVER BEETHOVEN
ELECTRIFYING BIG-BEAT PERFORMANCES BY ENGLAND'S
Paul McCartney, John Lennon, George Harrison and Ringo Starr

Above and inset right: Final photographs for the press before moving onto Glasgow.

Below: It is then a chance for the band to have a proper break; Pattie and George choose to holiday in the Pacific with John and Cynthia. The press trail them in Hawaii but they successfully elude the cameras on the island of Tahiti.

Right and below right: Both couples return to the UK. While away John wrote *A Spaniard in the Works* with George's help.

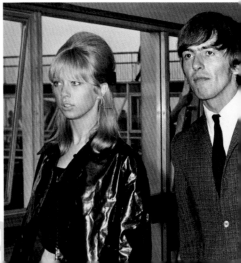

964 1964 1964 1964 19

Centre inset: Meanwhile Paul, Jane Asher, Ringo and his girlfriend Maureen Cox travel to the Virgin Islands but (right) Paul is soon signing autographs again on his return.

Below: The boys visit their new waxwork models at Madame Tussauds in London. Their mannequins are subsequently used on the album cover of *Sgt. Pepper's Lonely Hearts Club Band*. George uses the opportunity to mess around with a pair of fake eyeballs (below) while Ringo closely inspects his own image (circle inset).

Opposite left inset: *The Beatles' Second Album*, their third released in the US in April, reaches the top of the album charts three weeks later.

FOUR BY THE BEATLES

ROLL OVER BEETHOVEN ~ THIS BOY
ALL MY LOVING ~ PLEASE, MR. POSTMAN

EAP 1-2121

Capitol RECORDS

Produced by
GEORGE MARTIN

Above: A moment of rest prior to the start of a concert at the Prince of Wales Theatre in London at the end of May, just before embarking their first world tour.

Above inset: Capitol releases the EP *Four By The Beatles* in May.

Opposite page: While other members of the band concentrate on tuning their guitars Ringo enjoys a solitary drum practice accompanied by a cigarette (circle inset).

1964 1964 1964 1964 1964 1

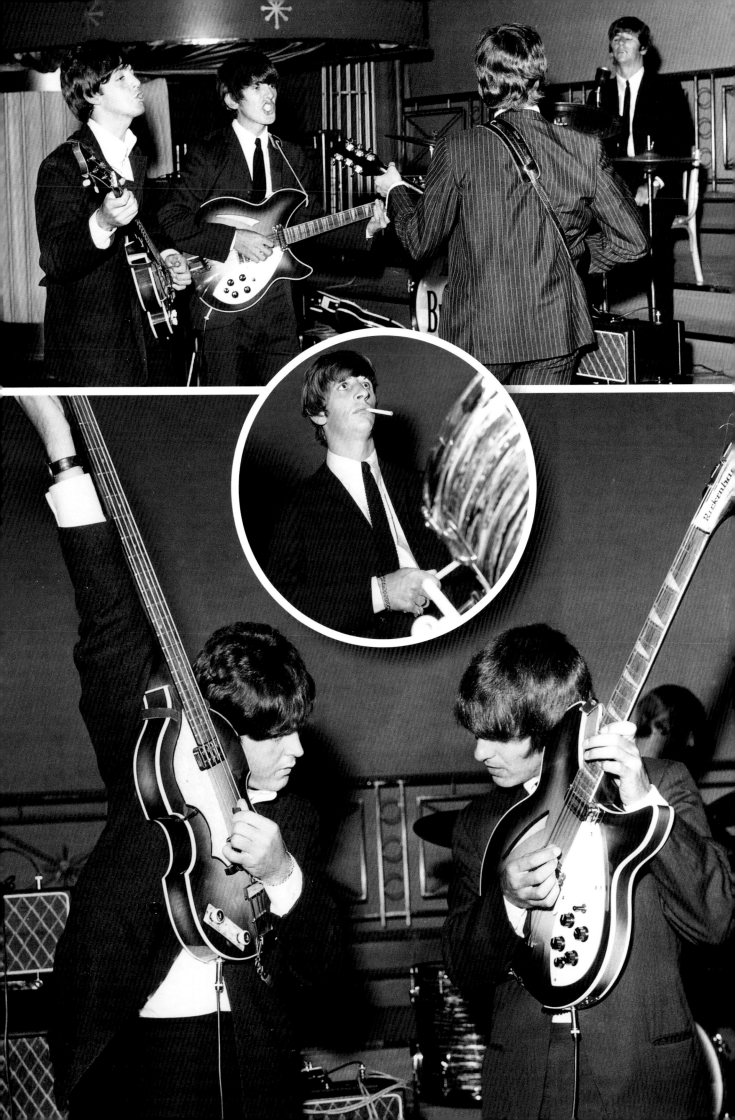

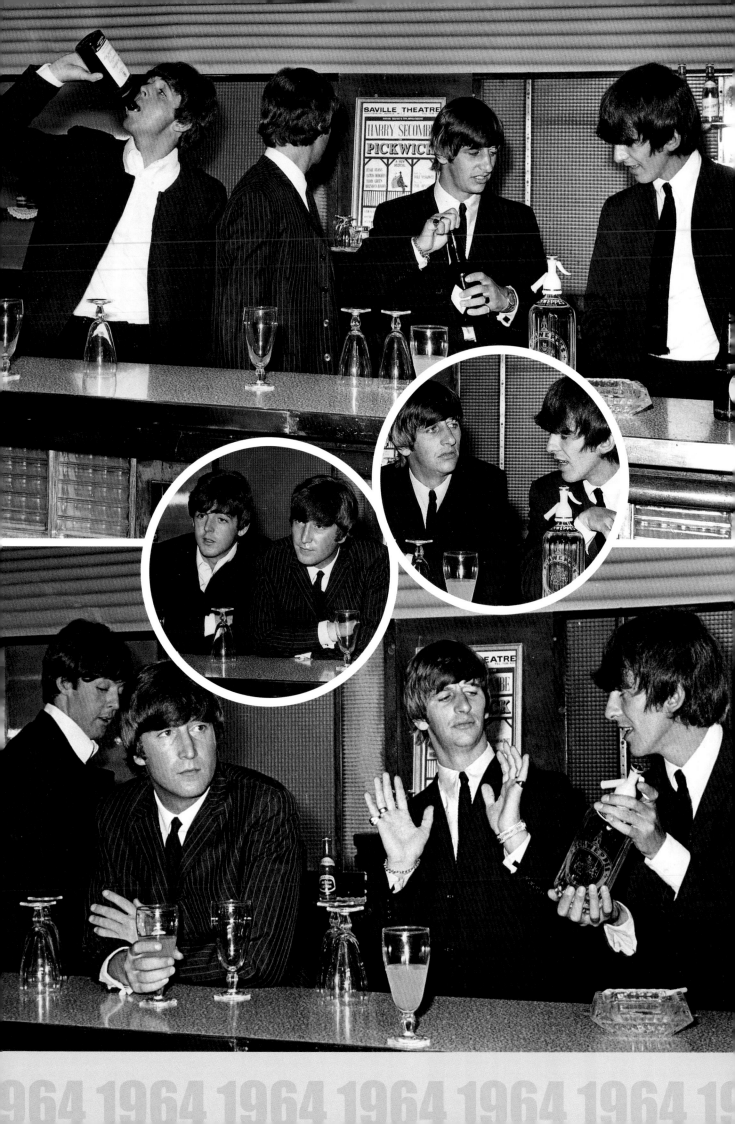

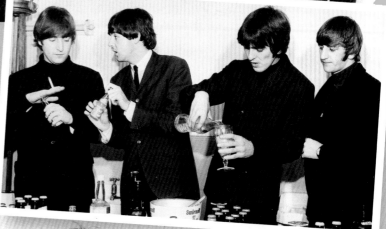

This page and opposite: Time for a rest and a chance to fix themselves some drinks after the concert and subsequent press conference at the Prince of Wales Theatre. Predictably it gave them a chance to lark around in front of the camera.

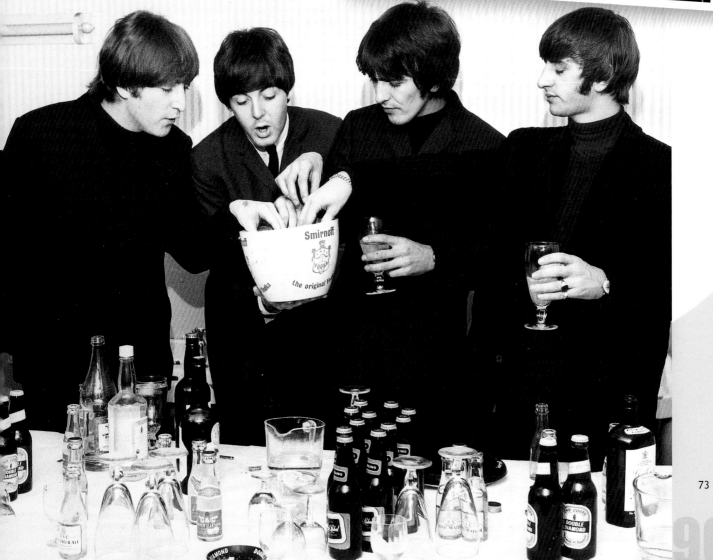

73

Martin called Nicol at his West London home. How would he like to become a member of the world's hottest band for a while?

Ringo forced to
stay at home

Above: Cathy McGowan, host of *Ready, Steady, Go!* interviews Paul.

Above left: Ringo, just prior to the start of the world tour.

Below: After a severe bout of tonsillitis photos of Ringo recovering in his hospital bed at University College Hospital are shown in the press, to reassure worried fans.

The Beatles spent most of May recharging their batteries. Almost as soon as they returned from vacation they were back in the studio to record the non-soundtrack side of *A Hard Day's Night*. The Abbey Road session on June 3 was to have been their last before heading off to Denmark, the first leg of their world tour. At a photo-shoot that morning Ringo collapsed and was rushed to hospital, where he was diagnosed as suffering from tonsillitis and pharyngitis. Cancelling the early tour dates was considered. The Beatles were a foursome, and George was particularly vociferous that there should be the full complement of Fabs or none at all. Brian Epstein was caught between a rock and a hard place: to risk antagonizing his boys or disappointing hordes of fans. He came down on the side of honouring the contract; three Beatles would have to do.

Discussions were held to consider a replacement sticks man, and Jimmy Nicol emerged as a strong candidate. 24-year-old Nicol was an accomplished session drummer who had played with Georgie Fame and also fronted his own band, the Shubdubs. He looked the part, was well known to George Martin and, in a neat twist, had even played on an ersatz Beatles album and so was familiar with the material. Martin called Nicol at his West London home. How would he like to become a member of the world's hottest band for a while?

1964 1964 1964 1964 1964 1964

Jimmy Nicol
to the rescue!

After a hasty rehearsal at Abbey Road, Nicol was on the plane to Denmark, taking to the stage at Copenhagen's K B Hallen just 24 hours after receiving Martin's call. He was decked in Ringo's gear — there was no time to kit him out — and the set list was amended to take out Starr's vocal showpiece, "I Wanna Be Your Man". In his 11-day stint as a Beatle Nicol wielded the sticks in Holland, Hong Kong and Australia, where a recovered Ringo took over. Nicol headed home and returned to relative obscurity, £500 and a gold watch to the good for his valiant efforts. The latest candidate for the "Fifth Beatle" tag spoke of being an outsider intruding into a special, tightly bonded unit. When normality returned, Nicol found the sparkling addition to his curriculum vitae didn't open any doors. Within a year he was declared bankrupt, eventually swapping his drumsticks for a paint-brush as he turned to decorating to earn his living.

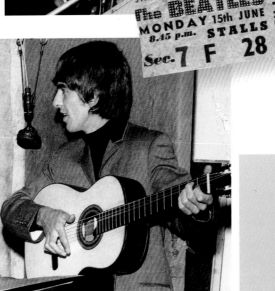

This Page: Jimmy Nicol plays drums with the band until mid-June when Ringo is well enough to fly out and join them again.

Inset: Paul shows off his new pair of clogs, purchased while the band were playing in Holland.

75

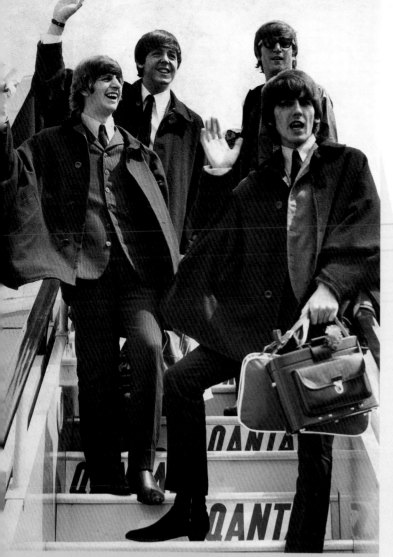

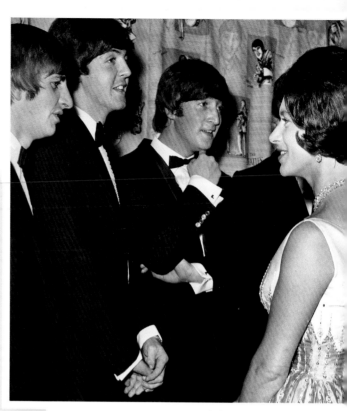

The band would never return to Australia, and the fans milked every last moment

Three weeks
'Down Under'

Before the Beatle whirlwind hit Australia in June 1964, no major recording artist had ever visited the country's shores. Three weeks of the group's 27-day globe-trotting tour were spent in Australia and New Zealand, where they cooked up a storm that made their American reception look like a tea dance. An estimated 300,000 thronged the route along Anzac Highway into the centre of Adelaide, around half of the city's population turning out to welcome the boys to the city which hosted their first concert on that continent. From there it was on to Melbourne and a ticker-tape greeting, Ringo joining the party for six sell-out shows over three nights. Over-excitement occasionally spilled over into something more ugly, and the army was brought in to help maintain order. The Beatles themselves were asked to appear on the balcony of their Melbourne hotel to defuse a volatile situation,

a snapper's delight as Jimmy Nicol had yet to depart and the Fab Five were pictured together for the only time. Overall, the trip was a resounding triumph. The band would never return to Oz, and the fans milked every last moment as if they knew they might never get another chance to see them in the flesh.

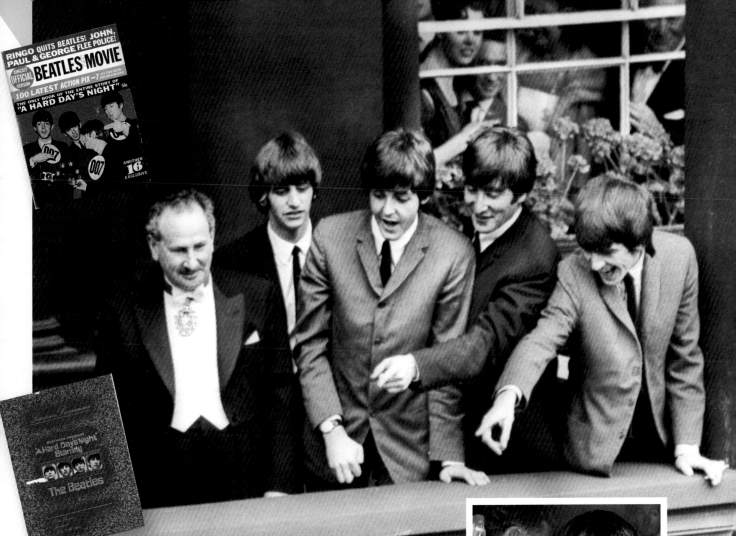

Opposite above left: The Beatles finally return to Britain on July 2 to be greeted by an even larger throng of fans at the airport.

Opposite below: John and Cynthia soon make their escape from the waiting press.

Opposite above right: The band are introduced to Princess Margaret at the world charity premiere of *A Hard Day's Night* at the London Pavilion cinema on July 6.

Centre inset: Thousands gather outside the cinema to catch a glimpse of the Four as they arrive for the performance.

Above: Four days later the band travel to Liverpool for the film's northern premiere. 6,000 fans gather around the Town Hall where the boys wave from the balcony.

Below and middle right: The boys were invited to an official reception at the Town Hall, to celebrate the film's success.

Below right: Paul with dancer and presenter Lionel Blair.

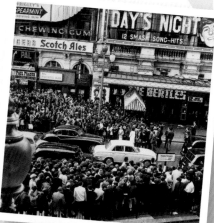

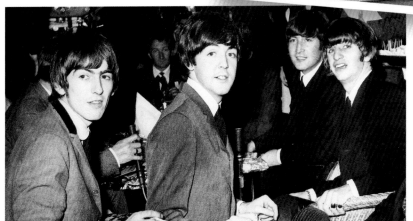

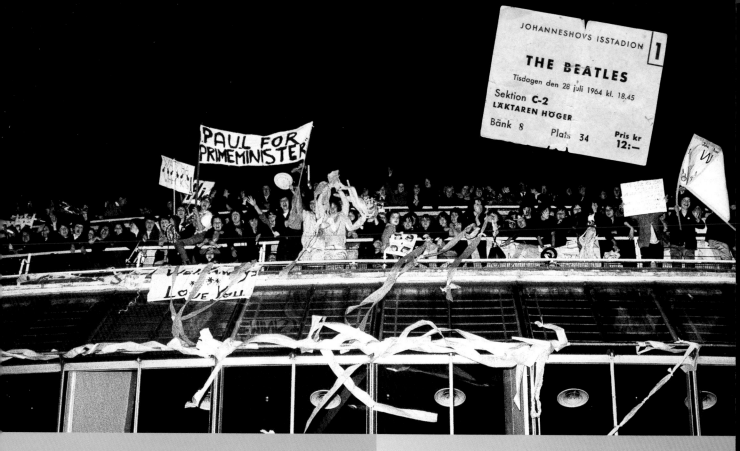

24-city, 32-date tour of America

The month-long, 32-date tour saw the Beatles criss-cross the country, clocking up enough air miles to circumnavigate the globe twice

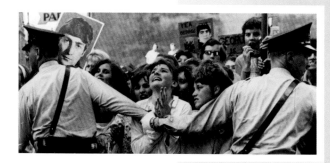

The Beatles departed London Airport on August 18 for a mammoth 24-city tour of America — increased by one when they accepted a lucrative offer to play Kansas on a scheduled rest day. There was no need for a publicity budget, much less any of the apprehension that had beset the boys in the run-up to their first Stateside trip six months earlier. All the shows sold out as soon as tickets went on sale, and there were reports of disorder outside box offices as demand comfortably outstripped supply.

The month-long, 32-date tour saw the Beatles criss-cross the country, clocking up enough air miles to circumnavigate the globe twice. It was a ceaseless round of concert halls, hotels and airport lounges, anything but a cultural experience. Inordinately wealthy in the land of consumer capitalism, they were virtual prisoners, falling back on their own resources for diversion. Often they would leave the stage and head straight for their next plane connection simply to avoid the worst excesses of the fans' behaviour. There was a fine line between adulation and intimidation, one that was crossed on numerous occasions. Over-exuberance led to some hairy moments, notably in Cleveland, where a crash barrier broke, fans rushed the stage and police halted proceedings on safety grounds. The show resumed 10 minutes later, the police chief threatening to pull the plug if there was any recurrence.

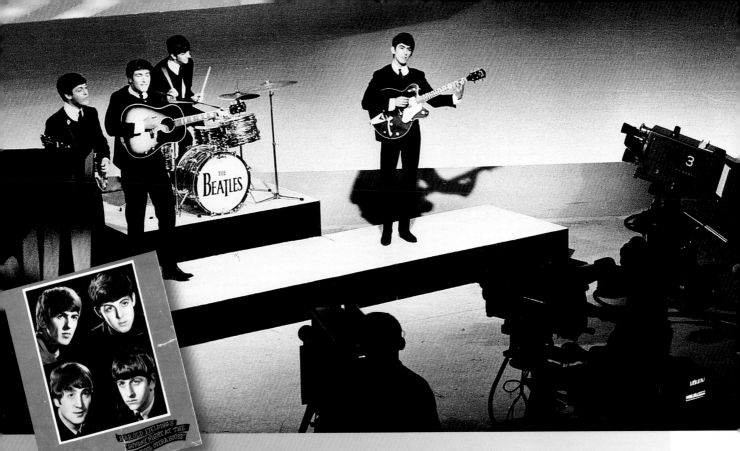

Opposite page: As the band sets off for their twenty-five date American tour fans flood to London Airport to wave them goodbye. Wherever they go in the US, fans flock to see them causing a security headache for local police meaning the boys are usually trapped in an aeroplane or a hotel room for their own safety.

This page: In mid-July the boys appear in *Blackpool Night Out*, with show hosts Mike and Bernie Winters. They join fellow guests Lionel Blair and Jimmy Edwards to perform some of their hits and join in with the comedy sketches. At the close of the show the performers assemble onstage for the final line-up and finale (below).

Below left: An album and a subsequent single are released to accompany *A Hard Day's Night*.

Below right: Capitol release "I'll Cry Instead" and "I'm Happy Just To Dance With You" on August 20 and follow up with another single four days later featuring "Matchbox" and "Slow Down".

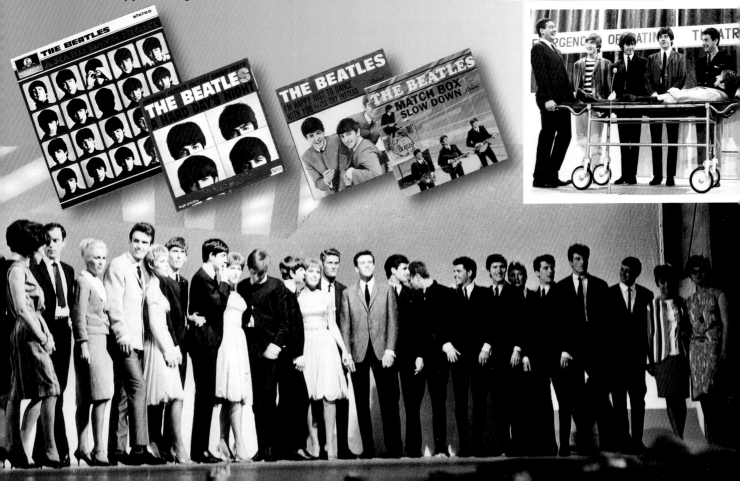

The Beatles at the
Hollywood Bowl

Plans to record the Beatles' Carnegie Hall show in February foundered in a musicians' union wrangle. It was ironed out by the time the Beatles played the Hollywood Bowl, Los Angeles, on August 23, and Capitol was finally able to green-light its long-cherished idea for a live album. The 29-minute set was duly recorded, but deemed unsuitable for release. The tapes gathered dust for 13 years, when George Martin and EMI sound engineer Geoff Emerick skilfully stitched together half of that 1964 LA concert with its counterpart on the following year's summer tour. The resulting album, *The Beatles At The Hollywood Bowl*, gave the group yet another number one seven years after they disbanded.

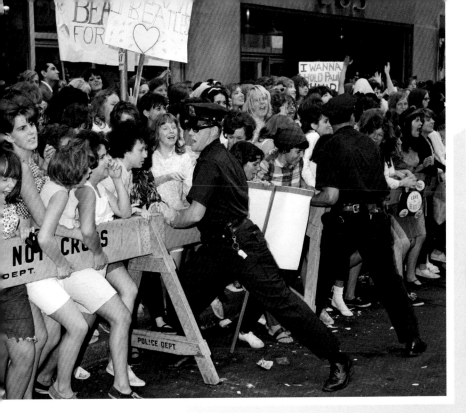

Influenced by
Dylan

"Instead of projecting myself into a situation, I would try to express what I felt myself"

The Beatles visited New York twice during the tour, playing a couple of shows at Forest Hills early on, then returning to end the run at a glitzy $100-a-ticket charity affair held at the city's Paramount Theater. The Plaza Hotel politely declined to accommodate the group, obviously feeling the headaches outweighed the benefits, and the entourage put up instead at the Hotel Delmonico. It was here that they first met Bob Dylan. Elvis might have made them rock 'n' rollers, but they developed a special reverence for Dylan. His *Freewheelin'* album had a profound impact, especially on John. Dylan's songs stood up as poetry, in a different league from the lyrics of early Lennon-McCartney fare. Dylan's exhortation for them to "Listen to the words, man"

played a major part in turning John and Paul from writers of great tunes to writers of great songs. The effect was immediate. Songs such as "I'm a Loser" and "You've Got to Hide Your Love Away" showed John looking inward for lyrical inspiration. "Instead of projecting myself into a situation, I would try to express what I felt myself... It was Dylan who helped me realize that." John even adopted the Dylan look as he took to wearing a Huck Finn cap. The folk singer also introduced the four of them to marijuana during that historic New York meeting in August 1964. It was an unexpected introduction. Surely they had already partaken, said Dylan. Hadn't he heard "I get high" in their lyrics? As it transpired, he had misheard a line from "I Want to Hold Your Hand": "I can't hide".

Opposite: A performance in front of a crowd of 8,000 at the Las Vegas Convention Center.

Above left: With the band inside the Delmonico Hotel in New York, police officers try to force back frenetic fans desperate to catch one tiny glimpse of the Fab Four. 3,000 people had stayed up through the night to greet them at the airport at 3 o'clock in the morning.

Above right: The crowd surges forward as American fans try and touch their idols.

Below left: Accompanying the concert schedule is a constant round of interviews and press conferences at each city the Beatles visit.

Above: The band wave farewell on leaving the United States.

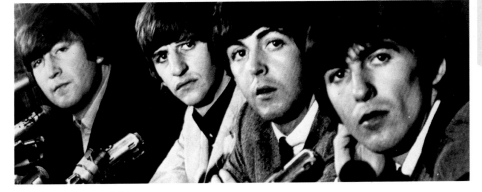

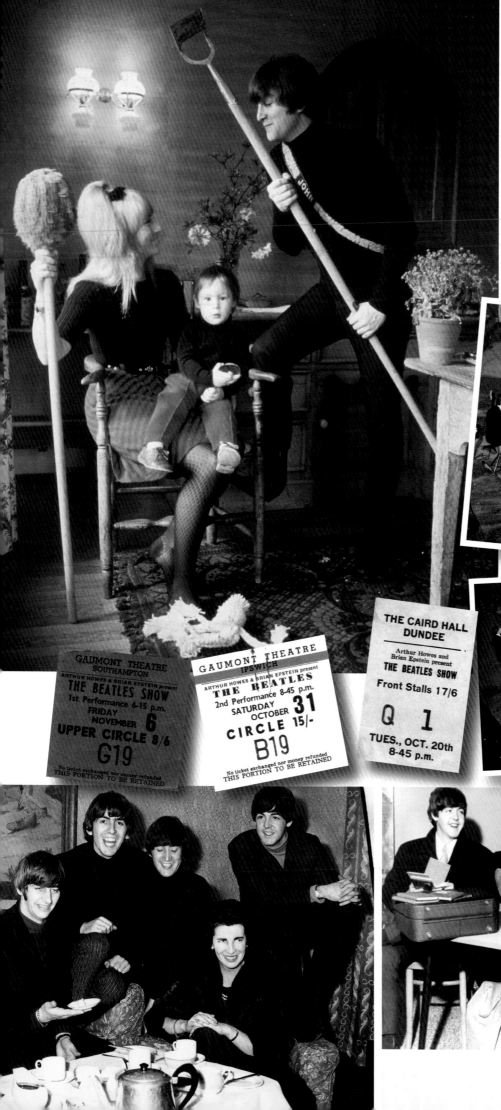

Left: In Robert Whitaker's photograph John, Cynthia and a young Julian send up the suburban stereotype that they had bought into by purchasing a new mansion in the heart of the stockbroker belt in Surrey, England.

Insets below: Their next British tour begins on October 9 and includes a performance at the Caird Hall in Dundee, Scotland.

Bottom left: The band take tea with the Countess of Strathmore.

Bottom right: The Beatles take a breather. The UK tour lasted a month and visited twenty-seven venues but even on the occasional rest day they were back at Abbey Road, working on further songs.

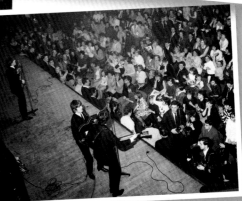

GAUMONT THEATRE
SOUTHAMPTON
ARTHUR HOWES & BRIAN EPSTEIN present
THE BEATLES SHOW
1st Performance 6-15 p.m.
FRIDAY
NOVEMBER 6
UPPER CIRCLE 8/6
G19
No ticket exchanged nor money refunded
THIS PORTION TO BE RETAINED

GAUMONT THEATRE
IPSWICH
ARTHUR HOWES & BRIAN EPSTEIN present
THE BEATLES
2nd Performance 8-45 p.m.
SATURDAY
OCTOBER 31
CIRCLE 15/-
B19
No ticket exchanged nor money refunded
THIS PORTION TO BE RETAINED

THE CAIRD HALL
DUNDEE
Arthur Howes and
Brian Epstein present
THE BEATLES SHOW
Front Stalls 17/6
Q 1
TUES., OCT. 20th
8-45 p.m.

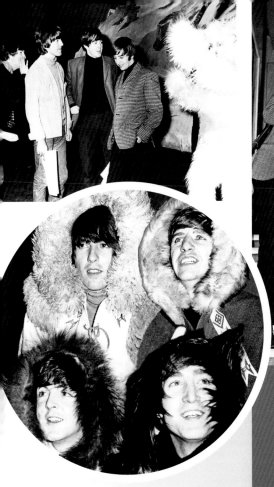

Above left: In November the boys begin rehearsals for *Another Beatles' Christmas Show*.

Above middle: This year's *Christmas Show* gives them plenty of scope to introduce comedy into their act once again as well as performing hit records.

Circle inset: Cosy hoods for the show.

Above right: In November John is on Wimbledon Common filming a cameo performance for Peter Cook and Dudley Moore's *Not Only ... But Also*. The sequence is due to be played while he reads a section from his first book.

Below: Pattie and George fight their way through waiting photographers.

Seven songs in one day: Beatles For Sale

The song bank wasn't overflowing, yet John and Paul still came up with eight new tracks in the 14-cut set

Less than three weeks after returning from America, the Beatles were on the road again, this time another hop around the British provinces. Thoughts had already turned to the obligatory second album of the year, and a new single, to be delivered in time to catch the festive-season shopping spree. The song bank wasn't overflowing, yet John and Paul still came up with eight new tracks in the 14-cut set. If they hadn't been working "Eight Days a Week" — an early candidate for their next 45 — then maybe they could have dispensed with one or two of the covers. These harked back to some old 50s favourites — Buddy Holly, Carl Perkins, Chuck Berry — but soon the Beatles would have only forward gear. The cover quota was cut to two on the next long-player, then it was self-penned material all the way.

Meanwhile, the fittingly titled *Beatles For Sale* reinforced the fact that they weren't just a group, they were an industry. The scale of industrial production told in the unsmiling faces on the album cover. In one day alone, October 18, the group hopped off the tour bus at Abbey Road to record seven songs. Six were for the album, the other was the new single "I Feel Fine", which elevated feedback to lead instrument.

83

Above: The band performed two shows at the White Sox Park in Chicago playing to a combined audience of over 60,000.

Another crop of classic vinyl releases, a second movie and a record-shattering performance at New York's Shea Stadium. The Beatles' Midas touch was evident at every turn in 1965, but glittering success came at a price and fame was beginning to lose its sparkle.

The Fabs kicked off their year in seemingly enviable style, location-hopping to exotic climes during the making of their second feature. But compared to their witty, shoestring-budget debut — "the *Citizen Kane* of jukebox movies" — this Technicolor comic-strip romp left the group cold. The title, *Help!*, was indicative of their growing dissatisfaction, and there was little succour to be found performing in vast arenas where they lost an unequal battle with screaming hordes. The Beatles wanted to wrest back control, to hop off the gruelling tread-mill and explore new creative avenues. With Beatlemania appearing to be cooling — a blessed relief — they rounded off the year with the tour de force that was *Rubber Soul*. It signalled the end of the cheeky Moptop era, the boy-girl, sad-glad, poptastic crowd-pleasers giving way to songs of greater sophistication and depth.

Words Of Love

1965

Bottom: In January John and Cynthia take a break and travel to Switzerland with George Martin and his wife. John is a talented skier but deliberately takes a tumble for the cameras (below) in the hope they will get the shots they need and then leave him in peace.

The first signs of change

Beatlemania was by no means dead, but it was ebbing... The band were actually relieved. They could move on

Top: A chance to try out a tobogganing run while in St. Moritz.

Above left: John and Cynthia return to London.

Below left: In February Capitol release another EP *4 By The Beatles*.

There was a world-weariness about the Beatles as they convened early in 1965 for the next round of recording, performing, media events and movie commitments. Three years earlier, they had been a hungry band desperate for a deal. Now they knew the downside of "making it". The money men, meanwhile, were determined to mine the rich seam before it was played out. If contracts were in place, the Beatles' work ethic and professionalism meant they would be honoured, even if their heart wasn't in it. Their Christmas show, which ran through to mid-January, was a case in point, and lurking on the horizon was a feature film that would almost pass its stars by, such was their level of interest in the project.

The saviour was the music. Had they stood still, the future could have looked bleak. But the Beatles were keen to develop their art, to experiment musically and endow their lyrics with a Dylanesque poetic quality. And ever since getting stoned with Dylan during their '64 American tour, pot-smoking played no small part in the process. They invested in its mind-expanding possibilities and the perception doors it opened. McCartney would ask one of the roadies to write down everything he said when he was high.

Beatlemania was by no means dead, but it was ebbing. Far from being worried that the decibel level was down or that there were fewer fans to wave them off at the airports, they were actually relieved. They could move on, and the fans were ready and waiting to hitch a ride.

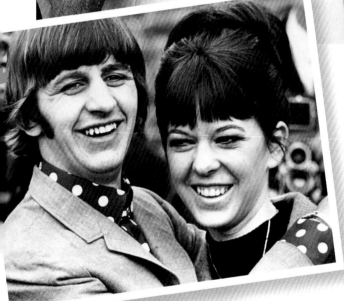

Ringo ties the knot

Left, below left and right:
After the ceremony Ringo
and Maureen spent their
honeymoon in Sussex at the
home of the Beatles' lawyer
David Jacobs. Maureen had
known Ringo from his Rory &
the Hurricane days.

Above: A thumbs up from John
after he passes his driving test
in Weybridge.

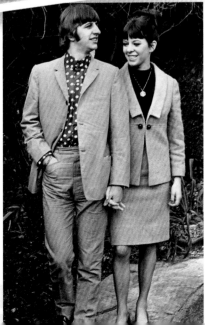

February 11, 1965 was a dark day for the adoring female faithful as a second
Beatle tied the knot. Ringo married 18-year-old Maureen Cox — already pregnant
with son Zak — at London's Caxton Hall Register Office. Ringo's sweetheart from
the Cavern era, Maureen had suffered the same kind of jealousy-inflamed abuse
that had befallen Cynthia Lennon, the Cavernites taking none too kindly to anyone
catching a Beatle's eye — unless, of course, it was them. Maureen left Liverpool —
and hairdressing — behind as she and Ringo set up home in a mock-Tudor mansion
in Surrey, a stone's throw from the Lennons' pile. Zak arrived on September 13, a
second son, Jason was born two years later and a daughter, Lee, in 1970.

Right: After waving farewell to the waiting fans at London Airport they fly to the Bahamas where they stay at the Balmoral Club in Cable Beach and begin filming sessions for their next movie.

Below: Thumbs up for the cameras as they discuss the forthcoming film.

Bottom right: Their co-star Eleanor Bron, recruited to play the role of the high priestess Ahme, joins them at the airport.

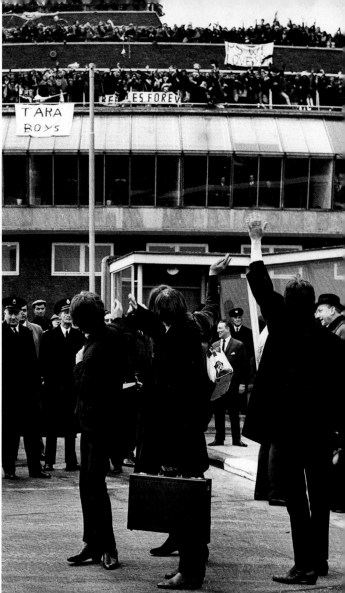

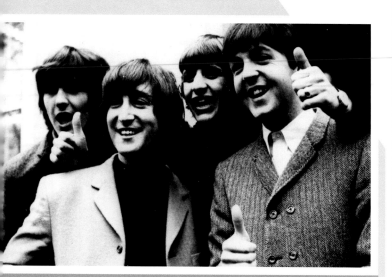

Shea:
first stadium concert

No sooner had sanity been restored to Carnegie Hall, following the delirium of the Beatles' February '64 concert, than promoter Sid Bernstein's thoughts turned to repeating the trick — this time on an even grander scale. He considered Madison Square Garden, whose capacity was six times greater than the 2,800-seat Carnegie Hall. But by the time the deal was done, early in 1965, Bernstein had come up with a much more ambitious scheme. He wanted the Beatles to play Shea Stadium, home to the Mets baseball team and capable of housing 55,600. No pop act had performed before so many. Even for a draw such as the Beatles it was a leap of faith to think such a massive venue could be sold out. And there was the rub. Epstein wasn't about to allow the PR disaster of a sparse crowd, his anxieties assuaged when Bernstein guaranteed ten dollars for every unsold seat. Epstein demanded $100,000 against 60 per cent of the gross, half of the guaranteed minimum up front.

Coming up with the $50,000 advance wouldn't have been a problem if Bernstein had been able to advertise the show. But Epstein demanded that the money be paid and the concert inked into the schedule before he would sanction the use of the Beatles' name in the sales drive. It couldn't have come

at a worse time for Bernstein. He had cash flow problems, having lost a fortune putting on a stage version of the US TV show *Shindig*. His credit rating was so low that the prospects of raising the up-front fee in the three-month window granted him by Epstein looked bleak.

In the event, the rumour mill saved the day. There may have been no Twitter or internet, but as soon as Bernstein let slip to a few kids what his next big promotion was, he sparked an ad campaign that didn't cost him a cent. He set up a P.O. box number for ticket applications, hoping to receive enough cheques to buy him some leverage with the banks. Applications poured in, some from beyond America's shores, and when Epstein came to New York for the appointed meeting in April '65, Bernstein was able to hand over a cheque for the full $100,000 instead of the required minimum.

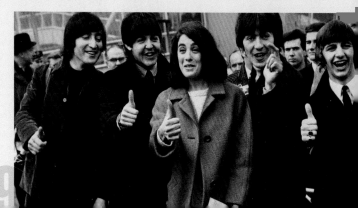

Once on the island they are forced to stay in the shade as their faces are not allowed to be exposed to the sun for fear of sunburn.

Circle inset: Paul on location on New Providence Island.

Below left: Filming immediately begins at the Nassau Beach Hotel where they are required to climb out of the pool fully clothed as part of the scene where they escape from an Eastern temple.

Below right: In sharp contrast, the filming moves to Austria in mid-March to shoot the skiing sequences in Obertauern. Body doubles are used to make the boys' skiing skills look more impressive although Paul takes the opportunity to have some lessons from Harriet Davidson, the niece of the Duke of Norfolk.

Back to filming

The Help! *soundtrack was an important transitional record between the Fab era and the band's mature works*

The second instalment of the movie trilogy to which the Beatles were contracted was a glossier affair, a Technicolor romp involving Eastern cults and sacrificial rings — the very kind of comic-book adventure yarn Alun Owen had rejected when scripting *A Hard Day's Night*. Instead of West Country train rides, there was the glamour of the Bahamas and Austrian Alps, exotic locations that helped swell the budget to £400,000, three times that of the debut feature.

The mood was buoyant when shooting began in late February. The boys were more than happy to trade an English winter for Caribbean sun and sand. But with zero input and too much time on their hands, ennui soon set in. A year earlier, they got away with playing cartoon versions of themselves and firing off one-liners. But they weren't trained thespians, and a quality supporting cast including Leo McKern and Eleanor Bron

highlighted their shortcomings. Their answer was to wallow in a marijuana-induced fug and let it all happen around them. No wonder they felt like "guest stars in our own movie". As ever, salvation came in the music. When not required on set or out of it on dope, John and Paul wrote the songs that provided the backbone of the next album. Film critics may have been divided over *Help!*, but it matched its predecessor at the box office. And more importantly, the soundtrack was an important transitional record between the Fab era and the band's mature works.

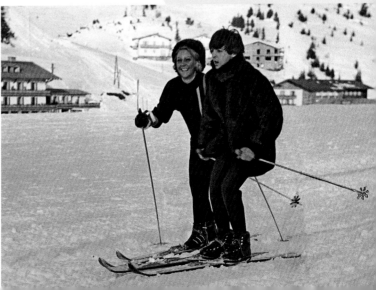

I'm feeling down

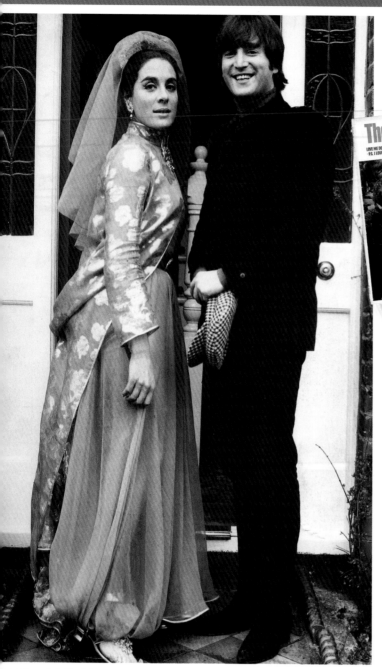

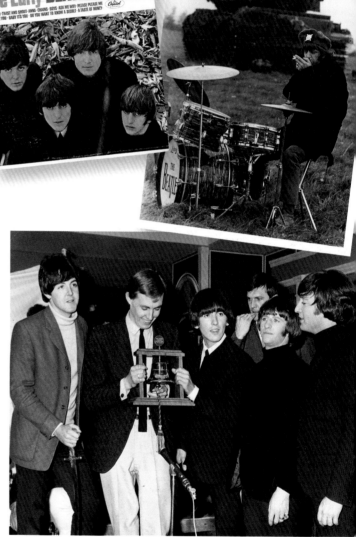

The group's second feature was called "Beatles Two" while various title suggestions came and went. The unwieldy "Eight Arms to Hold You" stuck around for a while, before director Dick Lester came up with *Help!*, which was much less restrictive. John and Paul withdrew separately to write to that title, and as had been the case with *A Hard Day's Night*, it was Lennon who came up with the goods.

If there was little scope for emotional truth and introspection in the lightweight movie, John laid it bare in the title track. It was a genuine cry for help. "I meant it," said John. "You can see in the movie. He – I – is very fat, very insecure, and he's completely lost himself." A favourite among his compositions, the song represented a key moment in Lennon's development as a lyricist. Years later he would single out "Help!" and "Strawberry Fields" as the only songs he wrote "from experience and not projecting myself into a situation and writing a nice story about it, which I always found phony".

Naturally, the film's title track was slated for single release. Unlike America, where Capitol was happy to issue ballads on 45rpm, home-market singles were unwaveringly upbeat. John had reservations over the arrangement and, after the Beatles went their separate ways, toyed with the idea of remaking the song. The shackles of poppy commercialism were off by then, but it was an idea that never materialised.

Opposite left: John and Eleanor Bron on location in Ailsa Avenue in Twickenham.

Opposite below right: In early April Simon Dee presents Radio Caroline's first ever Birthday Bell Award to the Beatles while they are filming at Twickenham Studios. He then interviews them for his radio show.

Top right and opposite middle right: Ringo huddles over his drum kit against the cold at Knighton Down on Salisbury Hill, in the scene where they search out the British Army to give them protection. Real soldiers are used as extras (opposite above right) while the army carries on with their manouevres in the background.

Middle: Disguising themselves as a marching band, Ringo is the only one who gets to play his own instrument.

Below: Seeking protection from a bunch of amused policemen as they try and hide from the murderers.

Opposite inset: In the Summer Capitol release the album *The Early Beatles* featuring a compilation of their older tracks. It was very similar to *Introducing the Beatles*, issued by Vee-Jay.

Later he would single out "Help!" and "Strawberry Fields" as the only songs he wrote "from experience"

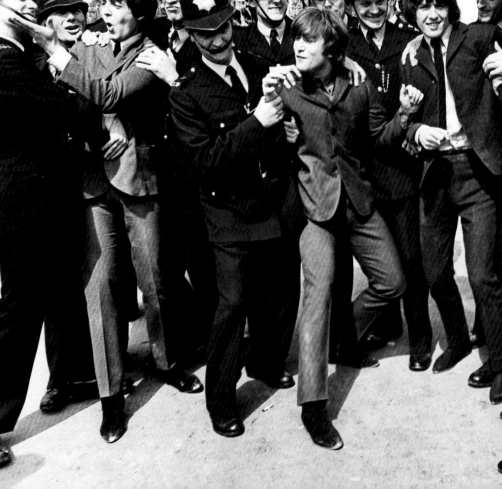

Below: Two days are spent filming in the luxurious surroundings of Cliveden House in Berkshire, country estate of the Astor family.

Right: After the filming schedule is finished John and Cynthia fly to Cannes for the Film Festival while Paul and Jane Asher take a break in Albufeira in Portugal. There was much speculation at the time that they were about to marry (opposite above right).

All they have to do is
act naturally

The Beatles' fifth studio album was written and recorded at a rate to make Miss Lizzy well and truly dizzy.

It has been described as their least inspired set, a harsh judgment on a collection that includes "Yesterday" and "Ticket To Ride", as well as the title track. Tight deadlines undoubtedly meant an unevenness of quality and a need for fillers. John, the album's chief architect, was particularly disparaging about "It's Only Love". Yet even when Lennon and McCartney were coasting, it was a cut above most songwriters' best efforts.

In addition to the seven new songs used in the film, there were five more originals, the cover count cut to two. One of those, "Act Naturally", was a neat choice for Ringo's vocal vehicle, for he'd taken most of the plaudits in their big-screen excursions. George for the first time had two of his songs included. On one, "I Need You", he brought the wah-wah pedal into play. More significant in the longer term was the sitar he encountered while shooting a restaurant scene in the new movie — but that was for future recordings.

As well as "Yesterday", Paul weighed in with "I've Just Seen A Face", with its tumbling lyrics and deft rhyming pattern.

On "Help!", though, Lennon gained an ascendancy he would never repeat. He wrote both of the album's hit singles, "Ticket to Ride" and the title track. The former had a clever bit of titular wordplay to go with the saturated sound, whether it referred to the Isle of Wight town of Ryde, or the kitemark for Hamburg hookers. John described it as "one of the earliest heavy metal records". He also penned the Dylanesque "You've Got To Hide Your Love Away", the first all-acoustic song recorded by the Beatles. This track was notable for the introduction of a fifth musician, flautist John Scott becoming the first non-Beatle to feature on a recording since Andy White took over the sticks from Ringo at the "Love Me Do" session in September '62.

For all its weaknesses — and they were magnified in America, where Capitol padded out the non-soundtrack side with George Martin-directed instrumentals — *Help!* had more than enough polished jewels to recommend it. The album headed the UK chart for nine weeks, and with record advance orders running into six figures in America, its destination there was guaranteed.

Bottom: On June 12 it was announced that the boys were to be awarded an MBE in the Queen's Birthday Honours list, after a recommendation by Harold Wilson. Paul and Jane read the article in the *Daily Mail* on their return from Portugal (below left and inset).

Right: There was much speculation in the press that the couple were about to marry or had already done so in secret.

Below: In the States, the album *Beatles VI* is at No 1 in the album charts. Meanwhile "Ticket To Ride"/"Yes It Is" tops the singles' charts in both Britain and the US.

Paul accepted that he was the beneficiary of a "mystical" experience: "the only song I ever dreamed"

Yesterday:
a dream of a song

Lennon and McCartney were no longer bouncing ideas off each other in intensive writing sessions, crafting songs in each other's faces. That merely sharpened the competitive edge, and during the making of *Help!* there was only one winner. The title track gave Lennon his fourth single in a row. Both were used to turning embryonic ideas into fully-fledged songs speedily, a pattern that was broken with a new McCartney composition that had an inordinately long gestation period. Exactly when Paul woke with the melody of "Yesterday" swirling round in his head, fully formed, is unclear. George Martin maintained that Paul played him the tune during the Beatles' stay at Paris's George V Hotel in January 1964. Later, he drove Richard Lester to distraction, playing it repeatedly on the film set. Having finally convinced himself that it wasn't "a steal", Paul accepted that he was the beneficiary of a "mystical" experience: "the only song I ever dreamed".

93

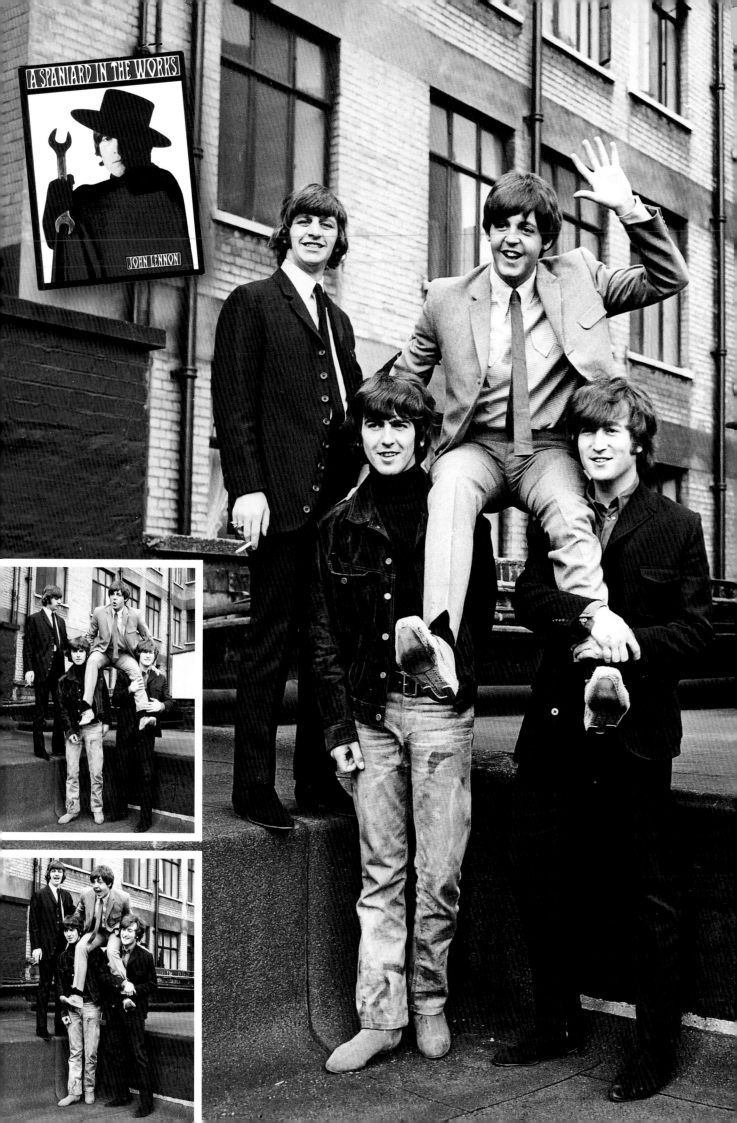

Paul's outstanding
song of the year

Almost 50 years on, "Yesterday" still justifies Paul's contention: "the most complete thing I've ever written"

The tune to "Yesterday" may have arrived fully formed, like a divine gift, but it took Paul 18 months to come up with the lyrics. The breakthrough came while holidaying in Portugal in May 1965, and a month later he took the finished song into the studio. When he played it through, the other Beatles felt they could add nothing. George Martin suggested a string embellishment, to which Paul acceded, though he insisted on a spare sound to suit the haunting melody — not too much vibrato. The result was magical. The balladeer supreme had surpassed himself.

The billing issue then arose. It was clearly good enough to break the unwritten rule of releasing only upbeat material on the UK singles market. But could it go out as a Beatles song? Epstein wouldn't countenance a solo release, which risked creating division in the ranks, or the illusion thereof. The most recorded song in history — some 3,000 cover versions to date — was thus tucked away on the non-soundtrack side of *Help!*. Capitol had no qualms about releasing it as a 45, under the Beatles name. It topped the *Billboard* chart for four weeks, gave the group yet another million-seller and won the Ivor Novello Award for Outstanding Song of the Year. Almost 50 years on, "Yesterday" still justifies Paul's contention: "the most complete thing I've ever written".

Opposite page: The band lark around to celebrate Paul's 23rd birthday. They spend the day at Abbey Road before travelling to the NEMS office for an interview to promote their forthcoming European tour.

Above left: John gives his best matador impression for the cameras after they return from Spain while Paul looks around (above right). The European tour had visited France, Spain and Italy and ended at the Plaza de Toros Monumental in Barcelona.

Insets above: Paul's "Yesterday" is released in the States in September and shoots straight to the top of the charts. It is to be another 10 years before it is released as a single in the UK although it is included on the album *Help!*.

Opposite top inset: John's second book *A Spaniard in the Works* was published in June.

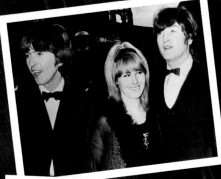

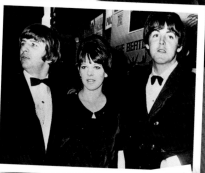

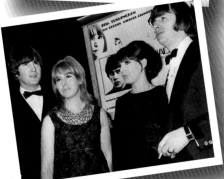

Top and left insets: Princess Margaret and the Earl of Snowdon meet the band after the Royal Charity premiere of *Help!* at the London Pavilion cinema. They boys were accompanied by Cynthia and Maureen who were great friends and often spent much time together.

Below: The band performing on ABC's *Blackpool Night Out.*

Opposite page: A fond farewell from fans when the boys fly out to the States on August 13, to begin their next US tour. After a rest day they perform to an audience of 55,600 at the Shea Stadium in New York after travelling to the venue by helicopter and armoured truck. A record $304,000 was taken at the box office from the largest crowd to ever watch a pop concert.

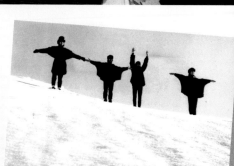

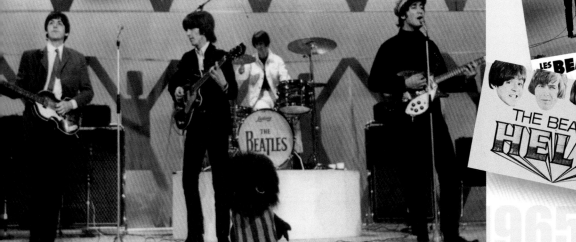

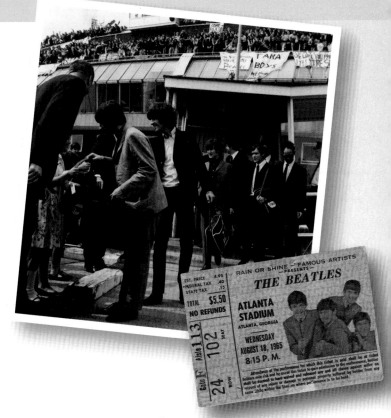

When the Beatles returned to America in summer 1965, they played bigger venues, packing more people into fewer shows. None was bigger than the *Shea Stadium* opener on August 15, where 55,000 people paid a world record $304,000 to watch the 11-song, sub-30-minute set. "Watch" was the appropriate verb, for it was effectively a phantom concert, one the wildly transported crowd probably thought they'd heard. If they caught the strain of an opening chord they were doing well. The group were whisked in and out by armoured truck, a heavy-duty symbol of suffocation and detachment.

During the 10-city, 16-show tour the Beatles were on stage for around eight hours in total — the kind of time they would have clocked up in a single night in Hamburg. Over the 17 days they sent more than 300,000 punters home happy, and reached a lot more by taping a segment for another *Ed Sullivan Show*. It was highly lucrative but wholly unrewarding. The group scarcely bothered to rehearse, knowing that these were visual happenings, not aural events. At least it was Beatlemania on their terms.

George was the first to become frustrated, bored and unnerved by touring. He had railed against their being touted around as "performing fleas" after the first tour of the States. Now the cracks widened significantly. If they played badly

— and they often did — no one knew or cared. If they stopped playing completely, nobody noticed. As soon as they were back home, the group reined in their concert commitments. They did accede to one final — and very short — domestic tour at the end of the year, and they would continue performing into 1966. But their days as a touring band were numbered.

55,000 people paid a world record $304,000 to watch the 11-song, sub-30-minute set

Becoming a
studio band

Much as the group wanted to take more control of their lives, excising the unsatisfying and unwanted from their helter-skelter schedule, autumn 1965 saw them facing yet another album deadline, and with little fresh material in the songbank. When they repaired to Abbey Road on October 12 to begin work on their sixth long-player, all they had in the can was "Wait", which had been held over from the *Help!* sessions. Remarkably, a mere month later they had completed *Rubber Soul*, a dazzling collection which showed precocious pop talent metamorphosing into mature craftsmanship before our very ears. From the beep-beep of "Drive My Car" to the closing strains of "Run For Your Life" – no covers here - *Rubber Soul* revealed itself as a game-changing masterwork that elevated album production to another plane. Equally remarkably, when they went on the road in December, the Beatles included a token couple of tracks from the just-released LP. Yes, much of the new material had more layered complexity, but it was also true that they knew where their musical horizons lay, and it wasn't attempting to reproduce the studio sound for a concert audience.

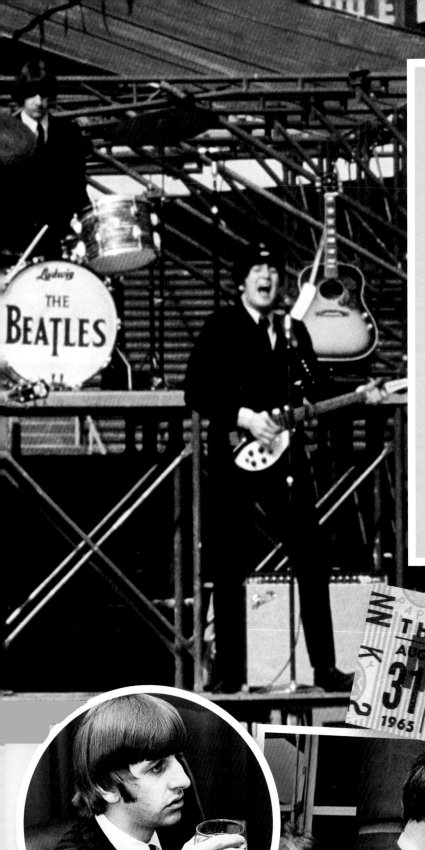

US tour dates:

August 15	**Shea Stadium**,	New York NY, USA
August 17	**Maple Leaf Gardens**,	Toronto ON, Canada
August 18	**Atlanta Stadium**,	Atlanta GA, USA
August 19	**Sam Houston Coliseum**,	Houston TX, USA
August 20	**White Sox Park**,	Chicago IL, USA
August 21	**Metropolitan Stadium**,	Minneapolis MN, USA
August 22	**Memorial Coliseum**,	Portland OR, USA
August 28	**Balboa Stadium**,	San Diego CA, USA
August 29	**Hollywood Bowl**,	Los Angeles CA, USA
August 30	**Hollywood Bowl**,	Los Angeles CA, USA
August 31	**Cow Palace**,	San Francisco CA, USA

Left: Two shows are performed at the White Sox Park in Chicago. A few days later they meet Elvis Presley at his home in Hollywood. They spend the evening jamming together but by all accounts have little in common. Elvis is invited to their concert at the Hollywood Bowl but he does not attend.

Radio Station KILT
Presents
The Sixth Annual Back-To-School Show
Sponsored By
THE VARIETY BOYS CLUB OF HOUSTON
STARRING THE BEATLES
(IN PERSON)
AND ALL-STAR SUPPORTING CAST
Master of Ceremonies: RUSS KNIGHT—The Weird Beard
GENERAL ADMISSION TICKET: $5.00
COLISEUM — 3:30 P.M.
19, 1965 • HOUSTON
KILT N⁰ 10888 KILT

Paul R. Catalana
Presents
THE BEAT
AUG
31
Tuesday After
COW PAL
SAN FRANCISCO
Elevated Main
1965 Admission Tax
$6.45 55c
No Refund
NN K 2

Left, above and right: Ringo talks to the media after the birth of his son Zak at Queen Charlotte's Hospital in Hammersmith and proudly describes the size of his 8lb son.

The Beatles
at the palace

In three years the Beatles had established themselves as a global brand and one of the country's most successful exports

Official recognition of the Beatles' achievements came on October 26 with a trip to Buckingham Palace, where they were awarded the MBE. They were the first pop artists to be thus honoured — wrongly so, according to some irate previous recipients. But in three years the Beatles had established themselves as a global brand and one of the country's most successful exports. "Super salesmen for Britain," as Paul put it.

ASTORIA - Finsbury Park
ARTHUR HOWES in association with
BRIAN EPSTEIN presents
THE BEATLES SHOW
1st Performance 6-40 p.m.
SATURDAY 11
DECEMBER
STALLS 8/
Y25

CAPITOL - CARDI
ARTHUR HOWES in association with
THE BEATLES
2nd PERFORMANCE 8-0
SUNDAY 12
STALLS

GAUMONT THEATRE
SHEFFIELD
ARTHUR HOWES in association with
THE BEATLES SHOW
2nd performance at 8-50 p.m.
WEDNESDAY 8
DECEMBER
FRONT CIRCLE 15/-
E45

ODEON THEATRE
BIRMINGHAM
ARTHUR HOWES
in association with BRIAN EPSTEIN presents
THE BEATLES
1st Performance 6-45 p.m.
THURSDAY 9
DECEMBER
BACK CIRCLE 8/6
V35

CITY HALL
Northumberland Road, Newcastle upon Tyne, 1.
SATURDAY, 4th DECEMBER, 1965
at 6.30 p.m.
THE BEATLES SHOW
ARTHUR HOWES in association with BRIAN EPSTEIN
presents
AREA 8/6
SEAT HH 32
Booking Agents: A. E. Cook, Limited, 54, Saville Place,
Newcastle upon Tyne. (Tel. 22031)
This Portion to be retained.

The Beatles' first
double-A side

Opposite page: On October 26 the band are at Buckingham Palace to receive their MBEs, afterwards holding a press conference at the Saville Theatre. Thousands of fans gather at the palace gates in the hope of spotting their idols.

Below: John and Paul are surrounded by the showgirls after taking part in a Granada television special. The show is a celebration of Lennon and McCartney songs with many special guests invited to sing cover versions.

Left: Just as the Rubber Soul album marked something of a musical departure for the Beatles, the sleeve design and photography reflected a group in transition; the familiar suits had been replaced by more fashionable suede attire and the album would also be the first not to bear the Beatles' name on the front.

The song showed John and Paul in microcosm: the upbeat optimism of Paul's verse and chorus, tempered by John's edgy middle eight

Even though they faced a daunting six-week deadline to produce a new album and single in time for Christmas, the Beatles stuck to their principle of keeping the two markets separate. Instead of easing their workload by issuing a *Rubber Soul* track on 45rpm, Lennon and McCartney contributed a song apiece on a crackerjack single.

John took the chief writing credit on "Day Tripper", a skewering of part-time hippies based around the same riff as "Ticket To Ride". Paul countered with "We Can Work It Out", in which he pontificates on a relationship under threat — a lyrical exploration, perhaps, of the issues he faced with Jane Asher. Unlike the other Beatle partners, who were content to take a back seat, Jane was a celebrity in her own right, with aspirations and professional commitments that caused Paul a degree of consternation. The song showed John and Paul in microcosm: the upbeat optimism of Paul's verse and chorus, tempered by John's edgy middle eight. The dividing line isn't perfect, though. The title suggests conciliation, but with a veiled threat that the lovers may have to go their separate ways.

"We Can Work It Out" took some 11 hours of studio time to complete, the longest session thus far to perfect one number. The group's entire debut album had been polished off in the same time two years earlier.

The only remaining issue was to decide which of these two gems should get the A-side tag. "Day Tripper" was recorded first and slated for top billing until "We Can Work It Out"

came along and gained EMI's vote. John wasn't having that, and the compromise of a double A-side was reached. In America "We Can Work It Out" proved more popular, topping both the *Billboard* and *Cash Box* chart, while "Day Tripper" reached only No 5 and No 10 respectively. It signalled a return to singles ascendancy for Paul, the first time since "Can't Buy Me Love" 18 months earlier that a McCartney song had prevailed in the 45rpm stakes. It was a dominant position he would maintain.

Act Naturally

1966

Left: The Beatles rehearsing for their first and only live performance on Top of the Pops.

Inset: Fans gathered to say goodbye to the boys when they flew to Boston on August 11.

Below: Paul and Ringo with two other British greats, Dusty Springfield and Tom Jones, at the *Melody Maker* awards held at the GPO Tower in London.

I f 1965 was the year of transition, '66 saw the Beatles chart a new creative course. Dogged by controversy and disillusioned with stadium screamfests, they retreated to the studio, pushing the sonic boundaries and exploring new lyrical ideas.

Gone were the days of packing four singles and two albums into the calendar, with a movie thrown in for good measure. The Beatles released just two 45s and one glorious long-player, *Revolver*, which would top numerous best-album polls over the decades. This acid-drenched jewel embraced randomness and distortion, effects that couldn't be replicated when they went back on the road one final, eventful time. After stirring up a hornets' nest in Japan and the Philippines, and raising hackles over an album cover showing them draped in cuts of meat and surrounded by dismembered dolls, the Beatles found themselves at the centre of an unholy row in America over John's "more popular-than-Jesus" comment. They were relieved to complete the schedule at San Francisco's Candlestick Park in August still in one piece. The Beatles' touring days were over.

PUT THE BEATLES ON YOUR BRACELET
OR IN YOUR POCKET

Be among the first to have this fabulous Beatles Medal. In sterling silver and weighing 30 grms, it is a memento you will treasure for ever, only £2.18s.6d.

SEE OVERLEAF FOR DETAILS OF OUR FABULOUS COMPETITION

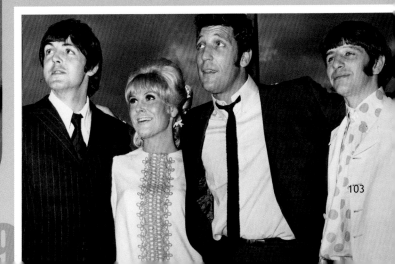

66 1966 1966 19

103

George and Pattie
tie the knot

This page: George marries Pattie in a quiet ceremony at Epsom Register Office. His present to his new wife is a red fur fox coat, designed by Mary Quant. She in return chooses George III wine goblets for him. The Lennons and the Starrs were away at the time so Brian and Paul put on a double act as his Best Men.

The newlyweds honeymooned in Barbados, but for spiritual growth they looked eastward

All four band members knew they had to scale back their commitments, a pruning exercise that kept them out of the performing arena until May '66. No longer were they prepared to dance to the tune of record companies, promoters, TV and radio producers — not even Brian Epstein.

George was particularly disenchanted with life inside the Beatle bubble, his apprehension about flying exacerbating the touring grind. It was a turning point for Harrison, both personally and professionally. He would make his most significant contribution thus far to a Beatles album, and also tie the knot with Pattie Boyd, in a low-key ceremony at Epsom Register Office on January 21. The newlyweds honeymooned in Barbados and set up home in Surrey's commuter belt, but for spiritual growth they looked eastward.

Left and below left: Ringo and Maureen return from Trinidad with Ringo sporting a new beard that he has been free to grow once away from the cameras and the media.

Above, circle inset and below right: Two weeks after their marriage George and Pattie set off for their honeymoon in Barbados. Once married, Pattie reduced her modelling work and began to focus much more on charity work and spiritualism.

Bottom Left: In the States "Nowhere Man" from the album *Rubber Soul*, was released as a single in February.

THE BEATLES
NOWHERE MAN
WHAT GOES ON
Capitol 5587

Revolver
"trying to create magic"

Paul, in the throes of seizing creative control, delivered "For No One" and the hauntingly beautiful "Eleanor Rigby"

BEATLE BULLETIN
April '66
SPECIAL INTERNATIONAL ALBUM
THE MAGAZINE OF THE OFFICIAL NATIONAL BEATLES FAN CLUB

The chief casualty of the curtailed schedule was a third movie project. With no acceptable script in the in-tray, the group ensconced themselves at Abbey Road, taking a leisurely 300 hours between April and June to produce their seventh album, plus their only two single releases of the year.

These sessions showed all four on top form. George took the prized opening slot on the 14-cut long-player with "Taxman", an acerbically witty take on the Beatles' substantial contribution to the Exchequer under the "one for you, 19 for me" regime. Two other Harrison songs were included in the set, his strongest showing to date. Ringo took lead vocal on a single — "Yellow Submarine" — instead of the usual afterthought filler. He also delivered some of his finest percussion work, notably on "Rain", relegated to a B-side but which he regarded as his best vinyl performance. John was ahead of the field in pursuing the consciousness-expanding possibilities of LSD, the sonic fruits of his tripping most evident on the album's grand finale, "Tomorrow Never Knows". He also supplied "I'm Only Sleeping", "And Your Bird Can Sing" and "She Said She Said", the latter born from a tale of near-death experience. Paul, in the throes of seizing

creative control, delivered "For No One", "Here, There and Everywhere", "Got To Get You Into My Life" and the hauntingly beautiful "Eleanor Rigby", which possessed "the minimalist perfection of a Beckett story", according to Booker Prize-winning novelist A S Byatt.

The whole was a powerhouse package widely hailed as the group's high watermark, an album that regularly tops polls as an unsurpassed example of that art form. Given its conjuring-trick virtuosity and liberal use of sleight-of-hand studio wizardry, the working title "Abracadabra" was eminently suitable. That was dropped when it was found that someone else had got there first, but *Revolver* fitted the bill just as well, for here was indeed a revolution in which the rulebook of musical form was torn up. Instruments were distorted to take them to new sonic places; backwards guitar became almost de rigueur; tape loops abounded and access to vari-speed equipment opened up new vistas in both recording and playback. As Paul put it: "The aim is to change it from what it is and to see what it could be. To see the potential in it. To take a note and wreck the note and see what else there is in it … It's all trying to create magic."

Beatles' final UK concert
performance

It should have been the highlight of the televised show but the Beatles' last home performance was not recorded for posterity

Opposite above right: Paul and Jane Asher arrive for the premiere performance of her latest film *Alfie* in which she plays the young hitchhiker Annie. Paul is the now the only Beatle yet to marry.

Opposite above left: The couple out with Paul's brother Peter. At the time Peter was a member of The Scaffold but took the stage name of Mike McGear to avoid riding on the back of his brother's fame.

Opposite below: Paul listens to composer Luciano Berio at the Italian Institute in Belgravia. He wanted to hear Berio describe his latest work *Un Omaggio a Dante* and to hear about his views of electronic music as the Beatles were also trying to introduce electronics into their compositions.

Top: "Paperbackwriter"/"Rain" topped the singles charts on both sides of the Atlantic.

Right: Paul and George perform at the *New Musical Express* Poll-Winners' Concert at the Empire Pool, Wembley, their last UK concert.

On Sunday, May, 1 the Beatles broke off from the *Revolver* recording sessions to take to the stage at the *New Musical Express* Poll-Winners' Concert, held at Wembley's Empire Pool. The group's first live show of the year, and their last concert performance on British soil, they delivered a 15-minute, five-song set of material dating from 1964-5. They wowed the 10,000-strong audience with "I Feel Fine", "Nowhere Man", "Day Tripper", "If I Needed Someone" and "I'm Down". It should have been the highlight of the televised show, but a contractual dispute meant the Beatles' last home performance was not recorded for posterity.

Musical mayhem

Below: The band prepare for their only live performance on *Top of the Pops*.

Inset: The album *Yesterday And Today* was released by Capitol in the States in June.

Opposite page: In June the boys set off for another world tour when they fly to Munich in West Germany.

While many bands stuck to the guitars-and-drums template that had been the staple of the rock era, the Beatles were keen to play with everything they could lay their hands on in the vast sonic toybox. George had already displayed his sitar skills on "Norwegian Wood", strings had featured on "Yesterday"; but Revolver represented a prodigious leap forward as the group broke from pop convention. A tabla player was brought in to augment the Indian flavour on George's "Love You To"; Paul wanted a brass section on "Got To Get You Into My Life", a French horn solo on "For No One" and a string octet on "Eleanor Rigby". Where classical instrumentation was used they deferred to their classically trained producer — for now. A year later, on *Sgt. Pepper*, they would even tear up the orchestral rulebook.

Revolver was the "acid" bookend to its pot-infused predecessor. In seeking to transfer the kaleidoscopic vision onto vinyl, sounds were often daubed on with a randomness that rendered the recordings unique. A prime example was "Yellow Submarine", a charming McCartney children's song that chimed perfectly with the age of psychedelia. It provided the Beatles, their entourage, studio staff, and the odd passer-by with the chance to let their hair down in one of the most chaotic, fun-filled sessions ever seen at Abbey Road. On top of the rhythm track and Ringo's vocal, the group plus an ad hoc supporting cast raided the EMI props cupboard and proceeded to rattle, clang and whoop, using an assortment of effects equipment that had been gathering dust for many moons. This nautical novelty was paired with the spare, hauntingly poetic "Eleanor Rigby" for the singles market, further testament to the fact that the Beatles really were a group for all seasons.

Revolver presented a prodigious leap forward as the group broke from pop convention

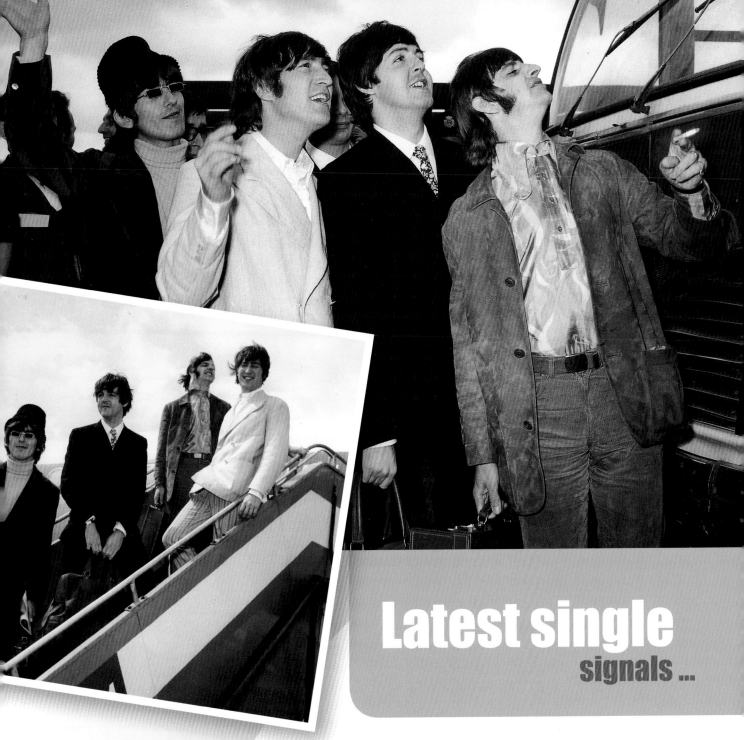

Latest single
signals ...

After four months away from the studio the group spent 10 weeks intensively perfecting 16 top-notch songs

By 1966 Abbey Road was jumping to the Beatles' tune. They curtailed their output, devoting more time to achieving the desired effect. Thus, after four months away from the studio, the group spent 10 weeks intensively perfecting the 16 top-notch songs that would flesh out their new album and singles quota for the year. Following this remarkable burst of creativity, they would not return to recording mode until the festive season was clicking into gear.

McCartney's "Paperback Writer" took A-side precedence over Lennon's "Rain" in the latest 45rpm stakes. The bass-driven tale of a would-be author reached only No 2 in the week of its release, the first time since "She Loves You" that a

Beatles single hadn't gone straight to number one in the home market. Sinatra's "Strangers In The Night" barred the way, an obstacle Epstein determined to remove by agreeing to a Beatles appearance on *Top of the Pops*. For two years the show's producers had had to make do with the group's self-made promos; now, at last, they had the coup of a live appearance. The Beatles mimed to both sides of the new single, and a week later duly secured their 10th successive UK chart-topper. Number 11 came two months later in the shape of "Yellow Submarine"/"Eleanor Rigby", but the group had made their one and only live appearance on the BBC's flagship pop show.

Beatles
on the road again

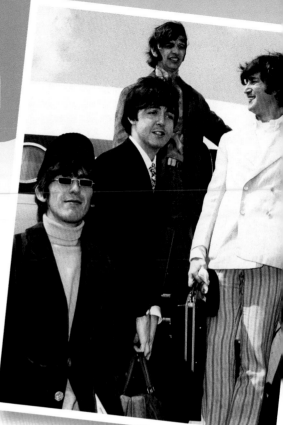

On June 23, 1966 the Beatles flew to Germany, the first leg of a two-week tour that merely hardened their resolve to withdraw from the touring circus. Hotfoot from the *Revolver* sessions, they were under-rehearsed and it showed, but slipshod performances were as nothing compared with the trials that lay ahead. The next port of call was Japan, where "Beatle-mania" was still in full flow. Tickets were allocated by ballot, and the lucky winners who saw one of the five shows celebrated their good fortune. Unfortunately, the choice of venue — the recently built Nippon Budokan Hall — sparked a sizeable protest by those who thought a pop group performing at a sacred martial arts centre was an act of cultural vandalism. A heavy police presence kept a lid on things, and the concerts went off without a hitch. The group weren't so lucky in the Philippines, where they found themselves embroiled in yet another scandal and feared for their very safety.

Debacle in
the Philippines

Above and left: The world tour includes two shows in Hamburg — their first return to the city since Christmas 1962. It was to be very different to their humble beginnings at the Star-Club — the motorcade escorting them from the railway station contained eight cars and twelve policemen on motorcycles.

Below: They then fly onto Japan at the end of June and perform five shows at the Nippon Budokan Hall in Tokyo. However, security is very tight and many Japanese people protest against the use of a sacred building to house sumo wrestlers, as a venue for a pop concert.

" One of the nastiest times I have had." George spoke for the entire Beatles retinue in summing up a nerve-shredding 48 hours they spent in the Philippines in early July. Trouble started the moment they landed. The four were confined to a boat in Manila Bay, surrounded by armed heavies and separated from the rest of the crew. Such was their introduction to Ferdinand Marcos's dictatorial regime, and it was about to get a whole lot worse.

The following day the Beatles were told they were due at a pre-show palace reception, an engagement of which they had no knowledge. They glossed over a clear itinerary glitch and played to 80,000 people in two shows staged at the Rizal Memorial Football Stadium. The next morning's headlines focused not on the concert triumph but the slight to the ruling clan. "Beatles Snub First Family" ran the headlines, and they found that the mere charge carried severe consequences. All support was withdrawn, and they effectively had to run the gauntlet to escape. At Manila Airport officials stood idly by as a hostile crowd rained blows on the entourage. Their plane was allowed to leave only after Brian Epstein stumped up a $17,000 exit fee, a trumped up "Beatles tax", which they were glad to pay if it meant leaving the country in one piece.

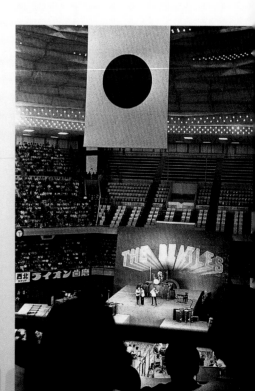

966 1966 1966 1966 1966 1

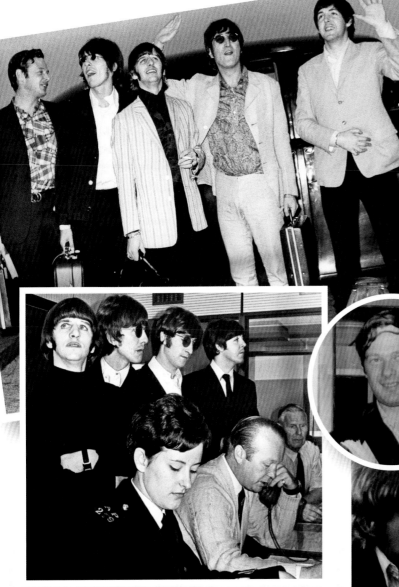

An unholy row

Above left: Relief for the band as they once again stand on British soil.

Below: The band discuss the events in the Phillipines at a press conference back in London.

Circle inset: Brian Epstein arrives in the States to try and undo the damage caused by John's remark.

Below left: On August 11 the boys set off for another tour of the US. Their flight to Boston is delayed so the boys are given a tour of the airport.

Bottom: Fans are once again out in force to bid them farewell. Many feared for their safety in case of reprisals.

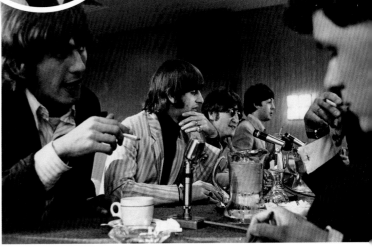

"We're more popular than Jesus now" leads to Beatles ban

In spring 1966 the Evening Standard ran a series of profiles on the four group members. John spoke of his indolence — sex was his sole exertion — and also made remarks on the current state of Christianity. "It will vanish and shrink," he said. "I needn't argue about that. I'm right and I will be proved right. We're more popular than Jesus now." The article raised scarcely a ripple at home, but on July 29, two weeks before the Beatles were due to arrive in the States for their final performance fling, the teen magazine *Datebook* reprinted the piece, and all hell let loose. Beatles songs were banned from playlists, bonfires were fuelled by Fab Four records, Bible Belt zealots leading the tirade against perceived sacrilegious comments. Some church leaders pointed out that Lennon's remarks had an undeniable ring of truth, yet pragmatism dictated that the row's instigator eat humble pie, at least for the manner of his utterances, if not the substance. "If I had said television was more popular than Jesus I might have got away with it," he told reporters. "It wouldn't have got as much publicity though."

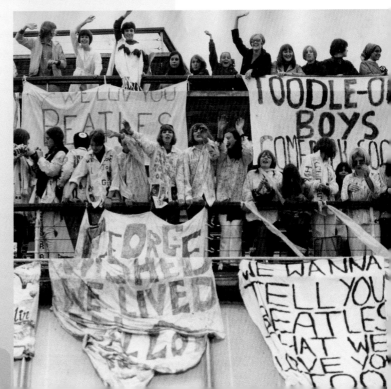

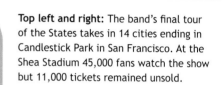

Top left and right: The band's final tour of the States takes in 14 cities ending in Candlestick Park in San Francisco. At the Shea Stadium 45,000 fans watch the show but 11,000 tickets remained unsold.

Above: The band arrive home from the States. By now, they had decided their touring days were behind them. As the amps were finally put away George's famous quote was "That's it, I'm not a Beatle anymore".

Left Inset: "Yellow Submarine"/"Eleanor Rigby" was released in August and spent four weeks at the top of the British charts.

Show's over, folks

When the amps were packed away for the last time, George said his oft-quoted declaration, "That's it, I'm not a Beatle anymore"

Even if the Beatles' third US tour had run like clockwork and been incident-free, they would not have wished to repeat the exercise. The fact that they seemed to be dogged by controversy and misfortune at every turn meant Candlestick Park, the final date, couldn't come soon enough.

It was a successful tour, though by no means a sell-out smash. Had Sid Bernstein underwritten any void seats at Shea Stadium this time round he would have been left with a sizeable bill as it was only 80 per cent full. The fans who turned out were as loyal, passionate and loud as ever; there just weren't quite so many of them on this final lap. By the time they got to Candlestick Park on Monday, August 29, they had had enough of being mannequins rather than musicians. Having upped the ante with *Revolver*, stadium shows featuring *Beatles For Sale* numbers were never going to be satisfying. The opening harmonies of "Paperback Writer" disappeared into the night,

reaching the ears of few if any of the 25,000 present. Paul rang down the curtain with "Long Tall Sally". Even the group's most natural showman and committed performer conceded that he could live without the smell of the greasepaint and roar of a Fab-loving crowd, for now at least. When the amps were packed away for the last time, George made his oft-quoted declaration, "That's it, I'm not a Beatle anymore." The relief was palpable. A quick calculation revealed that they had done around 1,400 gigs. At the beginning it had been fun, notwithstanding the straitened circumstances and gruelling schedules. They had often played intimate venues where they could crack jokes and pass notes or drinks to members of the audience. They had earned their spurs as a tight, working band, chasing success, recognition, fame and fortune. None of those were factors now. Candlestick Park closed the book on touring, but it wasn't the beginning of the end, merely the end of the beginning. The Beatles were now a studio band.

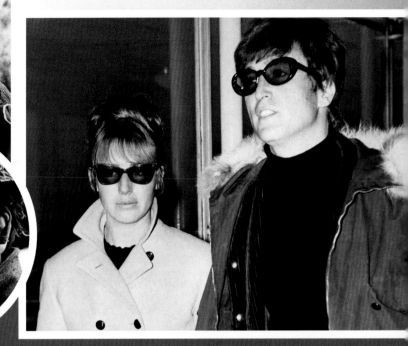

Left and circle inset: John in the role of Private Gripweed in the film *How I Won the War*, with co-star Ronald Lacey, in Spain. While there he wrote "Strawberry Fields Forever".

Below left: Brian Epstein's position with the group is now beginning to look uncertain.

Below right: John and Cynthia pictured just before he becomes involved with Yoko Ono.

Brian Epstein
struggling to manage

A diminished role threatened to remove the main stabilising force in Epstein's life

Much of the responsibility for the Philippines nightmare was laid at Brian Epstein's door. As the plane set a course from Manila to India, the band told their manager in no uncertain terms that the forthcoming American tour was the end of the line. Epstein took it badly, seeing a void opening up in his life. At a stroke he saw a substantial part of his management duties disappear. He didn't attend the Candlestick Park show, overwrought, perhaps, at the prospect of an uncertain future. With a chaotic private life and raft of business interests that afforded him little satisfaction, Epstein gained a sense of purpose as well as pleasure from handling the group's affairs. A diminished role threatened to remove the main stabilising force in his life.

When the existing EMI contract expired mid-1966, Epstein did at least manage to secure substantially better terms, though that wouldn't have been difficult given the Beatles' standing. They were to receive a 10 per cent royalty on sales, a nine-year deal which thus spanned the demise of the group and the birth of their solo careers. Epstein insisted on negotiating with the American market direct. He had talks with the major labels, but not all welcomed him with open arms and a blank cheque. Columbia, maybe with an eye on lower box-office returns, thought they were on the slide. Capitol's Alan Livingston didn't. He matched the EMI percentage and threw in a $2 million bonus for good measure. Even EMI chairman Sir Joseph Lockwood thought the subsidiary would struggle to recoup that outlay. Livingston assured him the company would make it back on the first album. By the end of the year the band had started work on *Sgt. Pepper*; vindication of the Capitol boss's faith lay just around the corner.

Top left and right: George arrives at London Aiport to meet the sitar player Ravi Shankar. Shankar had taught him the instrument during George's recent five-week stay in India and he invited him to London in the hope that the sitar could be used in future work.

Circle inset: Paul sporting a new moustache named by the media as "Viva Zapata".

Below right: John reportedly meets Yoko Ono in November 1966 at one of her art exhibitions. The exhibits include a timeless clock (below left) and a bag in which to hide (inset).

This Page: John plays the part of a doorman of a member's only gentlemen's lavatory for Peter Cook and Dudley Moore's *Not Only ... But Also*.

Below: *A Collection Of Beatles' Oldies* was released in Britain for the Christmas market. It featured one new song "Bad Boy".

66 1966 1966 1966 196

Sergeant Pepper and an anthem exhorting global fraternity put the Beatles at the forefront of psychedelia and the Summer of Love. It was also the year in which they lost their managerial rudder.

As George began looking eastward for spiritual guidance and liberation from the Beatle straitjacket, Paul addressed the same issue by suggesting they assume the personae of a fictitious band for their next album. *Sgt. Pepper* left muso peers and fans alike awestruck, while two early album contenders, Paul's "Penny Lane" and John's "Strawberry Fields Forever", were hived off for a crackerjack single. Amazingly, it broke a run of 11 consecutive UK No 1s. They were soon back on top with "All You Need Is Love", the Lennon-penned contribution to a global televisual hook-up, and "Hello Goodbye". The year-ending "Magical Mystery Tour" was a free-form experiment too far for many critics. The Beatles took the brickbats in their stride as they went into the management business following the death of the man who had steered the commercial ship, Brian Epstein.

Right: The Beatles at Brian Epstein's launch party for the *Sgt. Pepper* album

Inset: The Beatles became interested in Transcendental Meditation and attend a lecture given by the Maharishi Mahesh Yogi at the Park Lane Hilton in London.

Below left: The second edition of *Beatwave*, issued around the time of the release of *Sgt. Pepper*, featured a stylized portrait of Paul on its cover.

Within You, Without You

1967

The landscape
of the past

Sgt. Pepper's Lonely Hearts Club Band was seven hundred hours in the making, at a cost of £25,000

The Abbey Road sessions in late 1966 yielded three new songs that showed John and Paul in reflective mode. McCartney took a jaunty, vaudevillian look at ageing in "When I'm Sixty-Four", and recalled the sensory stimuli of a childhood bus journey in "Penny Lane". Lennon also cast a homeward look with "Strawberry Fields Forever", which took its name from a Woolton orphanage in whose grounds he used to play. The next Beatles album might have developed the theme — the landscape of the past — had the demands for new product not required "Penny Lane" and "Strawberry Fields Forever" to be hived off for the singles market. That decision altered the course of pop history. The idea for an autobiographical album withered, allowing another seed to germinate, one that would bloom in the Summer of Love and forever after be synonymous with that epoch of heady optimism.

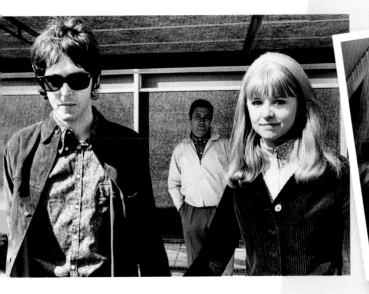

> *The project would be regarded as the Beatles' magnum opus, arguably the most influential album in recording history*

In autumn 1966 Paul loaded up his Aston Martin DB6 and took a solo vacation on the Continent, using a stick-on moustache and glasses so that he could shoot the breeze — and some home movie footage — without being recognised. On one occasion, when he was denied entry to a club, he cast off his disguise and was welcomed with open arms. Paul had always been image conscious; now he considered identity as a concept for a new Beatles project. With their touring days behind them, how better to draw a line under the Fab era than to give the group a completely new persona? How better to liberate themselves from "Beatlemania" than to create a band of alter egos?

Sgt. Pepper's Lonely Hearts Club Band was 700 hours in the making, at a cost of £25,000. These were staggering figures for the ephemeral pop industry, and a significant investment of time and money, even by Beatles' standards. But they had only themselves to please, and "a new way of being, a new way of recording", as Paul put it, was never going to be a quick fix. The album's chief architect described the rationale behind the *Pepper* undertaking: "Instead of looking for catchy singles, it was more like writing your novel," It was a neat analogy for a project that would be regarded as the Beatles' magnum opus, arguably the most influential album in recording history.

This Page: At the beginning of 1967, although Paul and Jane Asher were still seen together regularly, the gaps in their relationship are beginning to emerge. Jane spends much of the first part of the year touring with a theatre company and claims on her return that Paul had changed — which she puts down to the effects of experimenting with LSD.

Creating a
new identity

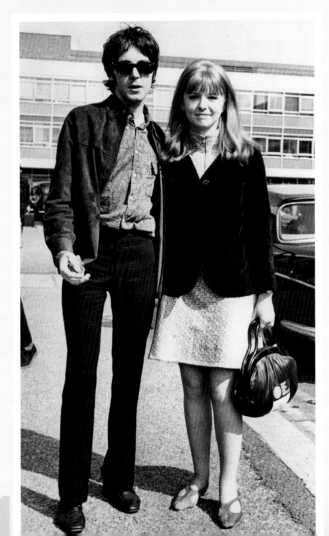

1967 1967 1967 1 19

A Day In **The Life**

THE **BEATLES**
All You Need Is Love
Baby, You're a Rich Man

Above: The Beatles arrive at the launch party for *Sgt. Pepper*.

Below: Pop artist Peter Blake is asked to design the cover for *Sgt. Pepper*. Released at the beginning of June it sells 250,000 copies in the first week in Britain and in the United States has over one million advanced orders.

Above left inset: "All You Need is Love" proves to be another transatlantic chart-topper after its release in July.

John could be scathing about his own songs, but was justly proud of "A Day In The Life", the tour de force that provided *Sgt. Pepper*'s grand encore after the reprise of the title song completed the regular concert performance. When they laid down the basic rhythm/vocal track, two 24-bar gaps were left, an alarm clock signalling the end of the first, where a middle eight was required. Paul had just the thing. "Woke up, fell out of bed..." was a fragment he had squirrelled away, which finally found the perfect home. It was perfect Lennon-McCartney synergy. The former needed a middle section, the latter had a bridge in search of a beginning and end. "It was a good piece of work between Paul and me," said John. "It just sort of happened beautifully."

967 1967 1967 1967 19

Right: The band just before their performance of "All You Need is Love" on the television extravaganza *Our World* — a show broadcast to 400 million people across 24 countries and five continents.

Below: Their placards read "All You Need Is Love" in Italian, French, Spanish and German.

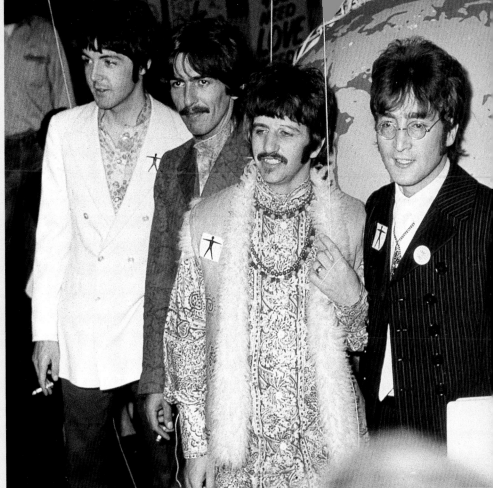

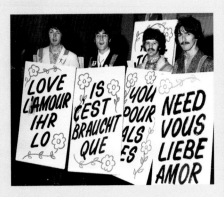

Sgt. Pepper would have a luxurious gatefold sleeve and printed lyrics — but the Beatles, as ever, quickly moved on: Their next long-player would come in a plain white wrapper

Blake's iconic
'Pepper' cover

It became clear that the cover artwork of *Sgt. Pepper* needed to match the theatricality and artistry of the content. Paul was put in touch with Peter Blake, one of the leading lights of the Pop Art world, who set about realising McCartney's vision. The floral clock motif, creating a distinctive "northern" feel, was there from the start, while another early design had the band in alter ego mode posing in front of pictures of their heroes. The idea quickly emerged for a tableau, *Sgt. Pepper's Lonely Hearts Club Band* surrounded by a cult-figure audience after performing in a park bandstand. The Beatles fired off some names, Blake added others to swell the crowd.

Blake spent two weeks in a Chelsea studio arranging the cut-outs and waxwork models borrowed from Madame Tussaud's. The latter included the Fab Four themselves, a fitting addition to a crowd of cult heroes. The photo-shoot took place on March 30, but not everyone was happy with the result. Brian Epstein was concerned that they were walking headlong into another row, following the previous

year's PR disaster over the infamous "Butcher" cover that adorned the US album *Yesterday And Today*. EMI chairman Sir Joseph Lockwood also had misgivings. First, there was a bill tipping the scales at over £2,800, when record companies might typically budget less than £100 for sleeve artwork, even for top-line artists such as the Beatles. However, he was worried that this astronomical figure might be a drop in the ocean if those depicted felt their image rights had been violated and sought legal redress. He relented — as long as Gandhi and Hitler were removed, consents were obtained and EMI indemnified against any legal action.

Still the Beatles weren't finished. *Sgt. Pepper* would have a luxurious gatefold sleeve and printed lyrics — rarities if not firsts. The Grammy award-winning *Sgt. Pepper* cover perfectly complemented the musical content, the eclecticism of the visual conceit dovetailing with the bravura diversity within the groove. Garish psychedelic covers became a cliché, but the Beatles as ever, quickly moved on. Their next long-player would come in a plain white wrapper.

A song that spoke of "people who hide themselves behind a wall of illusion", and "who gain the world and lose their soul", can be seen as Sgt. Pepper's spiritual core.

George & Ringo
have reservations

Sgt. *Pepper* was an epic production and recording landmark, yet there were dissenting voices within the ranks of its creators. John and Ringo pointed out that the "concept" was not carried through, resting on its variety-show feel for coherence. Only on the intro and reprise "Pepper" bookends and "the one and only Billy Shears" — the fictitious band member ushered in to sing "With A Little Help From My Friends" — is the idea really manifest. As Lennon said: "It worked because we said it worked."

John at least could immerse himself in his contributions, whether they fitted an overarching theme or not. George and Ringo were less enamoured with the *Pepper* sessions. Because the songs were constructed in layers, with numerous overdubs, there was little opportunity for whole-group performance. Ringo, more easily mollified than George, accepted his lot, and any tedium that went with the complex recording process. "I felt we were just in the studio to make the next record, and Paul was going on about this idea of some fictitious band. That side of it didn't really interest me."

George's frustration was greater. On top of the fact that guitars didn't feature heavily, he was once again struggling to get any of his material included in the set. From three tracks on *Revolver*, it was back to a single Harrison composition, "Within You Without You". None of the other Beatles performed on the track, which has often been unfairly derided as the seminal album's weak link. In fact, a song that spoke of "people who hide themselves behind a wall of illusion", and "who gain the world and lose their soul", can be seen as *Sgt. Pepper*'s spiritual core.

This page: George, Ringo and 'Magic Alex', a friend introduced to the group by John, and subsequent head of Apple Electronics, set off for a holiday in Greece. They are hoping to buy a Greek Island where they can finally find some peace and quiet.

All You Need Is Love

As well as giving the Beatles another transatlantic number one, "All You Need Is Love" articulated the idealistic hippie-era credo.

No sooner had the Beatles finished work on the defining album of the Summer of Love than they were back in the studio producing the single synonymous with that epochal period. Epstein was approached to see if the Beatles would appear in a live TV extravaganza called *Our World*, a 24-country satellite link-up across five continents. Each participating country had a five-minute slot, and it was revealed that the UK's pop princes would write a song specifically for the occasion. It required a catchy melody and simple lyric that would work for a worldwide audience, a task to which John and Paul applied themselves independently, and with time running alarmingly short. As had been the case when title songs for *A Hard Day's Night* and *Help!* were needed in short order, it was John who delivered the goods.

"All You Need Is Love" was recorded over a 10-day period in the run-up to the June 25 broadcast. The "La Marseillaise" intro set the perfect tone for a supranational composition espousing amity and fellowship across the global village. If the message was serious, the mood was leavened with a swirling, free-for-all coda that included a burst of "She Loves You", a neat Fab-era reprise on the same theme. The party atmosphere was maintained during the transmission, a host of pop luminaries piling into Abbey Road for a memorable sing-along happening.

Days later, it was announced that "All You Need Is Love" would be the Beatles' new single. It would have been against the spirit of the programme to use it as a plugging platform, but it was unarguable that the broadcast gave the song instant worldwide penetration. The vocals and instrumentals were sweetened for the vinyl release, though it was barely distinguishable from the live version. After the mystifying lapse of "Penny Lane"/"Strawberry Fields", normal chart service was resumed. As well as giving the Beatles another transatlantic number one, "All You Need Is Love" articulated perfectly the idealistic, if simplistic, hippie-era credo.

This page: John and Paul soon join the others in Greece although Ringo returns home as Maureen is expecting their second child. However, after technical issues with purchasing the island, all members lose interest in the project and agree to pull out and return to Britain.

A slow start on the
Magical Mystery Tour

Most bands would have rested on their laurels after signing off on a marathon production such as *Sgt. Pepper*. The Beatles were back in the studio within four days, starting work on McCartney's latest pet project: a road trip, English-style. "Mystery" coach tours had long been a part of working-class life, usually involving a jaunt to the seaside. Paul envisioned the band taking off on a madcap ride full of fun and frolics, which would also tick off another film commitment. His scattershot ideas didn't add up to a fully formed concept — and rightly so, for that would have detracted from the mystique of his "Magical Mystery Tour".

The title song, with its *Pepper*-like "Roll up" invitation, was put to bed by the first week of May, but momentum waned during the Summer of Love. It would take Brian Epstein's death to kick-start the idea and get the bus rolling on its surreal journey. Already concerned that fault lines were appearing, Paul knew that without a project to rally round, the Beatles' very survival was in question.

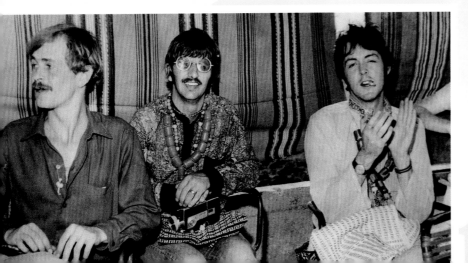

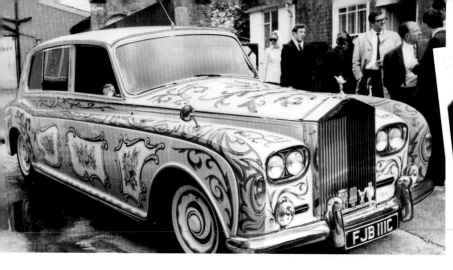

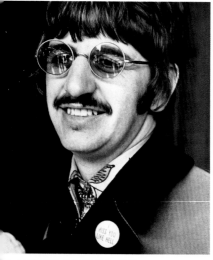

Paul knew that without a project to rally round, the Beatles' very survival was in question.

Opposite below right: Paul and Jane Asher look after Julian Lennon at the airport. In June Paul admits during an interview that he has taken LSD along with the other members of the band.

Opposite far left: Ringo arrives at the hospital with his mother-in-law Florence Cox to visit his new son Jason.

Above and inset: John, Paul and George attend a lecture by the Maharishi Mahesh Yogi at the London Hilton, about Transcendental Meditation. Pattie is the first to become interested in this form of spirituality and encourages the others to come along.

Opposite above right: The Maharishi then invites them to a ten-day course in Bangor where they have the opportunity to meet him privately.

Opposite above left: John reveals a £1,000 paint makeover on his Rolls Royce Phantom V.

All aboard the
Mystical Special

George spoke of the Beatles having a "collective consciousness", forged through years of living cheek by jowl

In summer 1967 George visited the hippie utopia of Haight-Ashbury. Expecting counterculture enrichment, he found squalor and dysfunction, an unnerving episode that saw him turn his back on acid as the gateway to enlightenment. A new "answer" presented itself in the shape of Transcendental Meditation. Pattie Harrison, just as eager to imbue her life with greater meaning, had attended a lecture on Spiritual Regeneration earlier that year. A disciple of Maharishi Mahesh Yogi had led the meeting, and Pattie discovered that the guru himself was delivering a lecture at the London Hilton on August 24. The Harrisons obtained tickets for themselves and the other Beatles, whose minds were ever open to new ideas and experiences, especially if championed by one of their number. George spoke of the Beatles having a "collective consciousness", forged through years of living cheek by jowl, and here was another example of that intuitive connection.

In the event, Ringo missed the lecture, Maureen having just given birth to their second son, Jason. But all four signed up to a seminar in Bangor the following weekend, such was the enthusiasm of the attendees. Here they would learn the principles and practice of TM. George, whose eyes were already looking eastward, was hooked. He believed that it was through reaching a pure level of consciousness that the power of prayer came into its own. The guru believed having the Beatles on board would be very good for business.

Euston Station on Friday, August 25 wasn't quite a throwback to *A Hard Day's Night*, but it was chaotic enough for Cynthia Lennon to find herself embroiled in a platform melee and left behind — in more ways than one. The Beatles took their seats on what the press pack dubbed the Mystical Special.

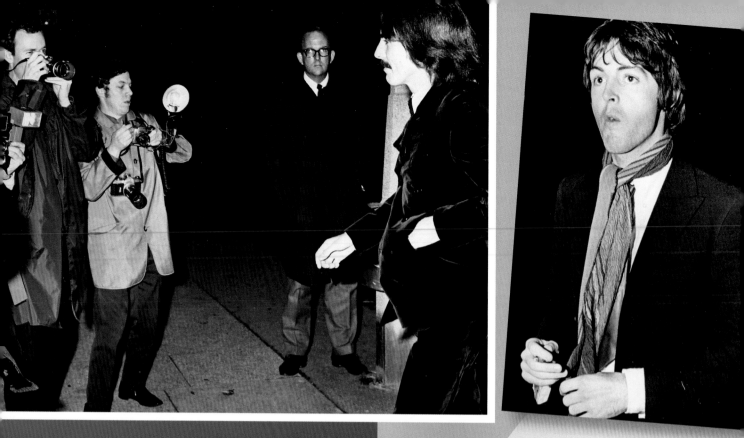

Brian Epstein
found dead

Below: Brian Epstein (pictured with his mother Queenie) is found dead at his home in Chapel Street at the end of August.

Above left and right: George and Paul arrive for Brian's memorial service at the New London Synagogue on Abbey Road.

Opposite above left: Four days after Brian's death Paul encouraged the band to start immediately on the proposed *Magical Mystery Tour* project. The rapidly recruited cast of 33, along with three cameramen and a soundman leave London on the tour bus on September 11 and head for the West Country. However it is not long before the bus becomes wedged on a narrow bridge.

Opposite middle left: Paul during filming on Tregurrian Beach near Newquay.

Opposite below left and opposite above right: Filming scenes while on location in Devon.

Below Right: *Magical Mystery Tour* is released as an EP in Britain containing the six tracks from the film.

Brian Epstein's life was in chaos in 1967. Insecure, depressed and desperately lonely, he had plumbed new drug-fuelled depths as his position in the Beatles empire came under threat. The death of his father did nothing to ease his state of mind, though he reined in his wildly erratic behaviour to play the dutiful son to his distraught mother, Queenie, who had been staying at his Chapel Street home. By the time the Beatles boarded the TM express, Queenie had returned to Liverpool. Epstein planned to spend the weekend partying at his Sussex retreat, returning to London when the hoped-for "fresh meat" failed to turn up.

What happened over the next 24 hours is a matter of conjecture, but by Sunday lunchtime his housekeeper couple were concerned. They contacted Epstein's secretary, who called in physician John Galway and Alistair Taylor, a long-serving Epstein aide from the NEMS days. The two men forced entry into Epstein's room and found his lifeless body. A number of pill bottles lay on the bedside table, but none had been emptied and all had their lids on, suggesting a tragic accident. That didn't prevent speculation that Epstein had taken his own life, and suicide notes did come to light, though these were dated weeks before the fatal event. Shortly before his death, Epstein admitted entertaining such thoughts in a press interview, hoping the self-destructive tendency had been vanquished.

The coroner ruled that "incautious self-overdosage" occurred on the weekend of August 26-27, 1967. Verdict: accidental death.

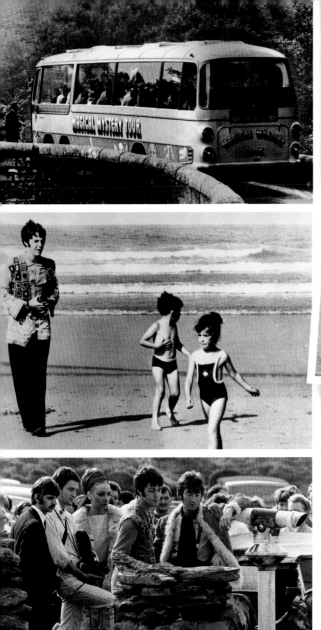

Roll up, roll up!

The bus left on September 11, pursued by the inevitable posse of journalists, intrigued to see where all this was leading

"I knew that we were in trouble," John would say of the uncertainty following the loss of their manager. Notwithstanding the fact that Epstein's role had diminished — the more so following the establishment of The Beatles & Co. in April 1967 — his death created a vacuum that Paul instinctively knew had to be filled. Work was the glue that bound them together. Thus, at a group meeting four days after Epstein's death the decision taken to go full steam ahead with the *Magical Mystery Tour*, which had been in abeyance for four months. A proposed trip to India to further their study of Transcendental Meditation would be deferred to the new year.

A handful of technicians and a 33-strong cast of jobbing actors were recruited, and the bus left the capital on Monday, September 11, pursued by the inevitable posse of journalists, intrigued — quite literally — to see where all this was leading. The answer was the West Country. There were frayed tempers on day two as the bus got stuck on a narrow bridge at Widecombe, forcing the entire caravan to undertake a lengthy reversing manoeuvre and the abandonment of plans to shoot

some footage at the famous annual fair held at the Dartmoor town. It encapsulated the haphazard nature of the entire project. McCartney bullishly thought they could record on film as effortlessly and successfully as they did in sound. Yet the five-day trip didn't produce anywhere near enough usable material, and extra footage had to be shot in France and a disused air base in Kent.

The editing process took 11 weeks, in which 10 hours' worth of material was reduced to 52 minutes. The technician employed to do the cutting found himself caught between two masters, Paul and John often countermanding each other's instructions. Unsurprisingly, the finished print was disjointed. Even six new Beatles numbers couldn't save *Magical Mystery Tour* from a critical mauling when it aired on Boxing Day. Not a kaleidoscopic fun ride but a monochrome mess was the consensus view. NEMS insiders derided it as a £40,000 home movie. Aspiring young filmmaker Steven Spielberg was among those who admired Magical Mystery Tour's surreal set pieces, and over time the Beatles' first venture following Epstein's death came to be seen in a much more favourable light.

This page: The band and their partners attend the premiere of *How I Won the War*. The film, directed by Richard Lester, gave John the opportunity to take on his first solo film role. He shared the top billing with Michael Crawford.

Waiting for
the van to come

Lennon's favourite Beatles song was issued as the flip to McCartney's breezy "Hello Goodbye", giving the group their fourth festive-season number one in five years

From 1966 through to the final split, McCartney was the artistic driver of the Beatles' bandwagon. He had been the prime mover behind *Sgt. Pepper* and *Magical Mystery Tour*. He supplied the focus and direction. To all intents and purposes John had abdicated his role as leader, though he was still capable of stepping up to the mark with a gem such as "I Am The Walrus", his sole contribution to *Magical Mystery Tour*. The unlikely combination of a police siren and Lewis Carroll's "The Walrus and the Carpenter" provided the inspiration for some of the most memorable and evocative imagery in the Lennon canon. He used deliberately impressionistic nonsense to take a sideswipe at pseudo-intellectuals who endowed lyrics with meaning never intended by the composer. "Let them work that one out", he is reported to have said after writing the line that had semolina pilchard climbing up the Eiffel Tower. This pretentiousness-pricking masterpiece, Lennon's favourite Beatles song, was issued as the flip to McCartney's breezy "Hello Goodbye", giving the group their fourth festive-season number one in five years.

1967 1967 1967 1967 196

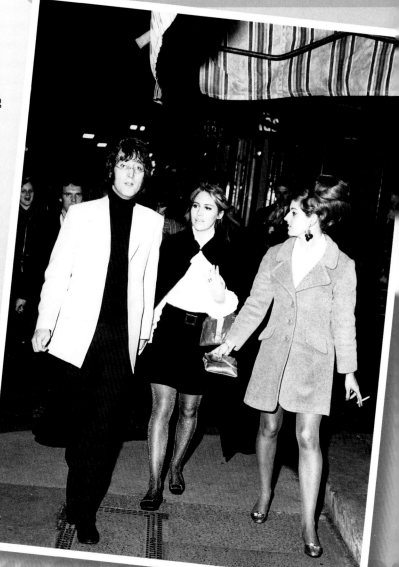

The Beatles would be benign facilitators, more interested in the communal good than the bottom line

Apple launches a new
enterprise

Even prior to Brian Epstein's death, the Beatles had taken their first steps toward self-management and an entrée into the world of corporate responsibility. The punning Apple Corps was founded so that the royalty windfall following their new EMI deal could be invested in a business enterprise instead of being lost to the taxman. They would apply A-is-for-Apple simplicity to their business model, creating hip products for groovy people, while giving creative types the wherewithal to develop their ideas. The Beatles would be benign facilitators, more interested in the communal good than the bottom line.

The Apple tree would have many branches. Music, obviously, would be an important offshoot, nurturing new talent as well as putting out Beatles' records. Fashion, film and electronics also came under the corporate canopy. There were visions of running an Apple school. With the exception of the music division, all the company's offshoots haemorrhaged money over the next year. One by one they folded as it became clear that these well-intentioned enterprises were as misguided as they were quixotic, and even the Beatles couldn't afford to bankroll them indefinitely.

This page: John, Cynthia, George and Pattie attend the official opening of the Apple Boutique in Baker Street. Paul and Ringo are away at the time. It proves to be an expensive blunder which eventually folds after only eight months.

John's top two

"Hello Goodbye" lodged at number one for seven weeks, their biggest home chart success since "She Loves You" four years earlier

The first single of the post-Epstein era was McCartney's "Hello Goodbye", a typically catchy if somewhat lightweight offering born from some word association frippery. Lennon was not best pleased that his contender, "I Am The Walrus", was relegated to the B-side of something he considered insubstantial. The single lodged at number one for seven weeks, their biggest home chart success since "She Loves You" four years earlier. With "Magical Mystery Tour" breathing down its neck at No 2, John had the distinction of seeing "I Am The Walrus" occupy the top two spots over Christmas 1967 — though the "knickers" reference in the lyric was enough to earn it a BBC ban.

This page and opposite top left: Scenes from the official opening of Apple Boutique and the subsequent party.

Opposite top right: John decides to arrive in fancy dress for the launch party of *Magical Mystery Tour* at the Lancaster Hotel.

Opposite middle row: *Magical Mystery Tour* is screened on the BBC on Boxing Day but is heavily criticised. Afterwards Paul is invited onto *The Frost Show* to defend the project.

Opposite bottom row: As all the other band members start to pursue their solo projects, Ringo jumps at the chance to appear in his first solo role in the film *Candy*, alongside many acting greats including Marlon Brando, Richard Burton and James Coburn.

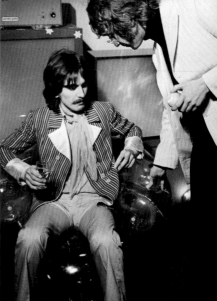

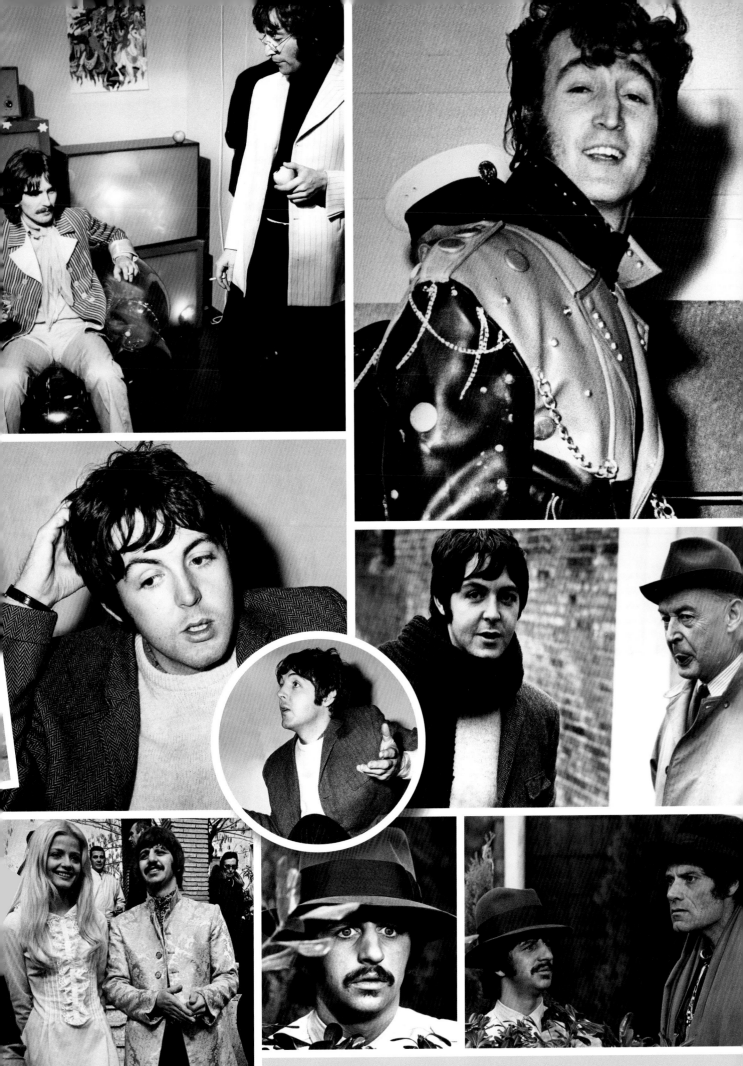

967 1967 1967 1967 19

A lengthy ashram sabbatical brought anything but harmony. Cracks opened wide during the making of the *White Album*, John's new love cutting a divisive figure in the recording studio.

After laying down the rootsy "Lady Madonna", the Beatles headed to India to continue their flirtation with Transcendental Meditation. George apart, it would not develop into an abiding passion. John was much more enamoured with conceptual artist Yoko Ono, her presence at Abbey Road breaking an unwritten recording rule. A Lennon-Ono collaboration drove a further wedge, and had the public decency brigade hot under the collar. The eastern sojourn had, at least, been a fecund period, but committing the eclectic stockpile to vinyl was a fractious, fragmentary experience. This, said George, was when "the rot began to set in". The Beatles double set — more popularly named after its stark white attire — was another transatlantic triumph. The year's other 45rpm offering, "Hey Jude", became the group's biggest Stateside hit. Apple's music division, at least, was flourishing. The Beatles also hit the big screen again, albeit as bit-part players in an animated feature.

Below: In the coming year Paul was to split up from his long-term girlfriend Jane Asher while John and Yoko officially declared their love for each other.

Inset: John and Paul announce the creation of Apple Corps in New York.

Opposite below: In 1968 collectors' editions of the birth certificates of each Beatle, complete with playing card covers went on sale.

Revolution
1968

Lady Madonna

LADY MADONNA by john lennon & paul mccartney

McCartney shrugged off the critical mauling *Magical Mystery Tour* received by reeling off another A-side that also drew a line under the Beatles' year-long dalliance with psychedelia. The boogie-woogie, Fats Domino-style "Lady Madonna", featuring a sax solo from the legendary Ronnie Scott, was completed in just two sessions. It was Paul's hymn to motherhood in general, and his own sainted "Mother Mary" in particular, marvelling at how they managed to juggle parenting and "make ends meet". This rootsy number got the nod over John's ethereally poetic "Across The Universe", with its meditative "Jai Guru Deva Om" refrain. Lennon tinkered incessantly with the song, and perhaps from sheer impatience George's "The Inner Light" took the B-side slot. It was the first time a Harrison composition had featured on a 45, and the first single with no Lennon contribution.

Both John and George's offerings were deeply, dreamily contemplative. "Without looking out of my window, I can know the ways of heaven", ran one line from "The Inner Light". These songs were crafted by men seeking enlightenment in the forthcoming trip to India, though Paul's pared-down, back-to-basics number marked out a different musical path.

"Across The Universe" appeared twice on vinyl, though on neither occasion in its original form. It first saw the light of day on a 1969 compilation album in aid of the World Wildlife Fund, when it was overlaid with animal sound effects. The following year it turned up on *Let It Be*, slowed down and given the "Wall of Sound" treatment by Phil Spector. Unlike Paul, who famously hated Spector's arrangement of "The Long And Winding Road" on the same album, Lennon was happy enough with the result to invite Spector to produce his next three LPs.

Above left: Michael York strums the sitar while George and Rita Tushingham look on.

Left and circle inset: George returns from India after working on the music for the film *Wonderwall*. It was the first solo album project by a Beatle.

Opposite above left and opposite below right: The Beatles along with Brian Jones, Donovan and Cilla Black attend the launch of Grapefuit's initial single, at the Hanover Grand. They were the first group signed to Apple Publishing in the days before Apple Records.

Opposite middle left: Ringo and Paul with Maureen and Jane set off to join George and John in India. The Starrs soon returned home hating the food and the heat. Paul stayed a few weeks longer, but preferred to focus on new compositions.

Opposite below left: Ringo soon returns to his regular lifestyle and dances with Mia Farrow at an official function.

Opposite middle right: Alexis Mardas joins Cynthia and John at a party at Revolution nightclub in Mayfair. Alex loathed the Maharishi and his influence on the Beatles and eventually exposed much of the fraudulent behaviour of the Maharishi.

1968 1968 1968 1968 1968 1968 1

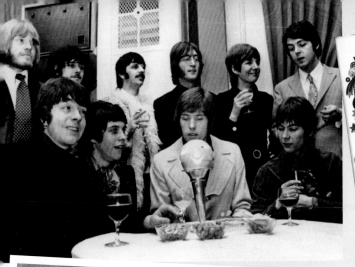

A sojourn in India

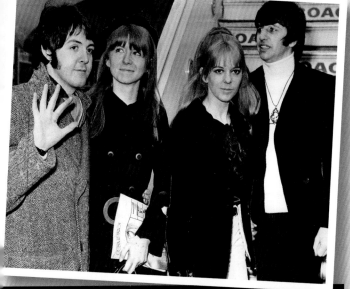

George wanted the trip to be an antidote to Beatle life, not a brainstorming session for a new album

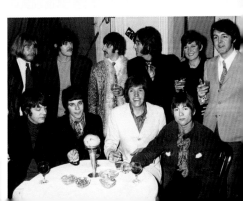

With their 17th single on its way to No 1 at home — No 4 in America — the Beatles were free to embark on the postponed trip to India. It was to be an extended retreat, furthering their TM studies under the tutelage of the Maharishi and drinking in the ego-denying spirituality of the ashram. As they pitched up at Rishikesh, a remote northern outpost, John and George were the most fervent disciples, Paul and Ringo open-minded but less committed to the transcendental cause.

That divide soon revealed itself. Ringo and Maureen lasted barely a week, while Paul was unable to switch off the creative tap. That earned a rebuke from George, who wanted the trip to be an antidote to Beatle life, not a brainstorming session for a new album. Paul lasted five weeks before decamping with Jane Asher, who had never wanted to go half way round the world to find herself in the first place.

John and George carried on, assiduously imbibing the Maharishi's twice-daily lectures, exulting in the simplicity of their existence. The ashram overlooked the Ganges, a magical setting that brought melodies and lyrics flowing through John's head. Unlike Paul, the workaday pragmatist, he was in no hurry to commit them to vinyl.

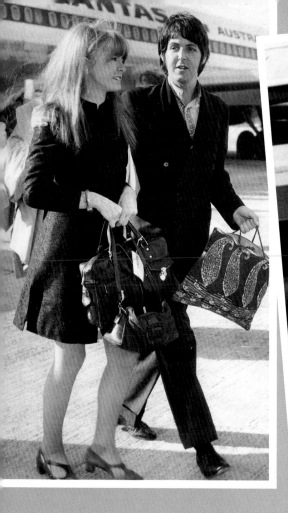

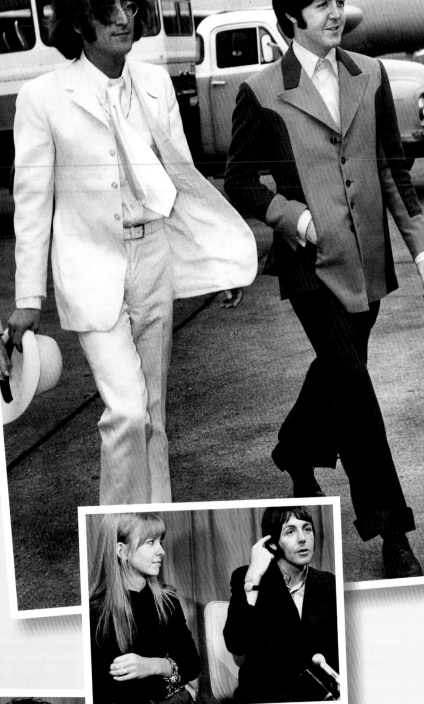

This page: After their return Paul and Jane discuss their visit to India. Paul never found enlightenment, but he learned to meditate, a skill he would later encourage others to try.

Above right and opposite page: John and Paul travel to New York to unveil Apple Corps. They held several press conferences to launch the new venture and also appeared on *The Tonight Show*, hosted by the former baseball player, Joe Garagiola. Apple Records was then created in the summer with James Taylor as the first artist signed to the label.

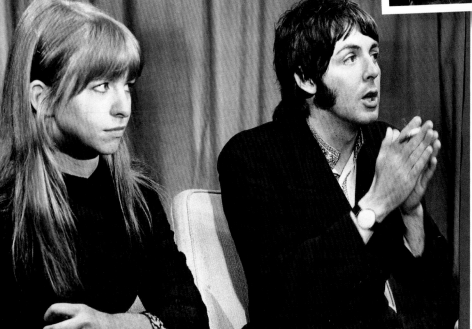

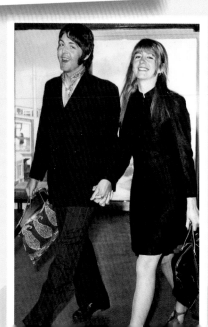

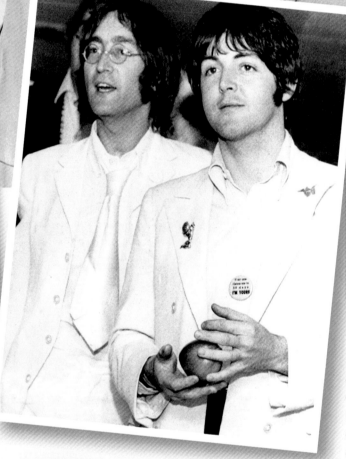

John & Yoko
create their revolution

Revolution was in the air and Lennon caught the mood of the times with his new song

The Prague Spring was but one example of grass-roots unrest that spread like wildfire in 1968, a powder-keg of protest that saw idealistic youth taking to the streets to demonstrate against governments perceived as militaristic and authoritarian. Revolution was in the air, and Lennon caught the mood of the times with a song he had written in India, the first to be recorded when the Beatles returned to Abbey Road at the end of May. Egged on by Yoko Ono — not merely

a silent presence in the studio but active contributor — John enthused about his latest creation, which ran to 10 minutes in its original form. "This is the music of the future … You don't even have to know how to play a musical instrument to do it." Which was just as well, given Yoko's off-the-wall vocal accompaniment.

Lennon was overdue a singles credit, but the length of the song and its slow tempo counted against it. The author headed off those objections by recording a truncated, speeded-up version, and it was this incarnation of "Revolution" that appeared on the B-side of "Hey Jude".

The man who had told us that love was all we needed wrestled with the form political struggle should take. Lennon's ambivalence about wanton destruction as a means to an end surfaced in the lyric, which alternated between wanting to be counted both "in" and "out". That equivocation, along with the bland assurance that "It's gonna be all right", was hardly a rallying call to radicals seeking a new world order.

139

The White Album:
son of Sgt. Pepper

Having ceded supremacy, a newly emboldened John was out to assert his will.

This Page: The Harrisons and the Starrs fly out to France to attend the screening of *Wonderwall* at the Cannes Film Festival. George had written the soundtrack.

The Beatles convened at Abbey Road on May 30 to start work on their ninth studio album, dubbed "Son of Sgt. Pepper" by John. They had just picked up four Grammys for their magnificent 1967 opus. How to follow that? There was no shortage of material; the India trip had left them awash with new songs, enough to fill two albums on day one, with more in the pipeline. The quality was uneven in George Martin's estimation, however, and there was a lack of focus as solid ideas often drifted into loose jamming. The producer favoured serious pruning and a slimmed-down single set to rival any of its predecessors. Had there been a conciliatory mood abroad in the studio, the album might have taken a very different shape. But their group identity was being eroded, their solidarity compromised. Battle lines were drawn, they were defending their own corners. That slow fragmentation was crystallised in Yoko Ono's presence, breaking an unwritten rule and denting the collegiate spirit that had sustained them for almost six years as recording artists. Having ceded supremacy, a newly emboldened John was out to assert his will. The disagreement over "Revolution" was but an early skirmish in a protracted war. Full-blown arguments were largely avoided during the making of the *White Album*, often by the simple medium of physical separation. Indeed there were times when they were in separate countries, let alone studios. When they came together, the simmering tensions were plain for all to see. Including sound engineer Geoff Emerick, who quit midstream. "They were falling apart," he said.

1968 1968 1968 1968

This Page: John stages an exhibition at the Robert Fraser Gallery in Mayfair, London, called "You Are Here". It was here he publicly declared his love for Yoko where her own work was also on display. Yoko was still married to the American film director Antony Cox at the time.

Becoming "Johnandyoko"

John made no effort to conceal his relationship. From that moment nothing could separate them

Yoko Ono had remained on Lennon's radar since their first meeting at the conceptual artist's Indica Gallery exhibition in November 1966. She was everything the house-frau Cynthia wasn't: a creative artist in her own right, an intellectual equal. And a celebrity, her avant-garde happenings making good press copy. She certainly wasn't blonde — conforming to John's early fixation with Brigitte Bardot — but her exotic, gamine appearance added physical appeal to an intriguing character.

Yoko stoked the fire by turning up at the Lennons' home unannounced and bombarding John with letters. He waved it away to Cynthia as the act of another besotted fan, or a creative type looking for a Beatle sponsor. But it was John who was becoming infatuated, to the extent that he angled to try and add Yoko to the Rishikesh party. That was unworkable,

but they were in regular correspondence during the two-month period. John was seduced by missives as enigmatic as their author's artwork. Cynthia may have wanted the trip to India to reinvigorate their relationship; in fact, they were nearing the end of the line.

It was a meeting of minds, and only a matter of time before they were conjoined physically. That happened in May 1968, when Cynthia was holidaying in Greece, still harbouring thoughts of rescuing the marriage. Those evaporated as she returned to Kenwood to find Yoko in situ. John made no effort to conceal his relationship with a woman he would describe as "the ultimate trip". From that moment nothing could separate them. Not the rarefied confines of Abbey Road. Not even the English language: henceforth they considered themselves as Johnandyoko.

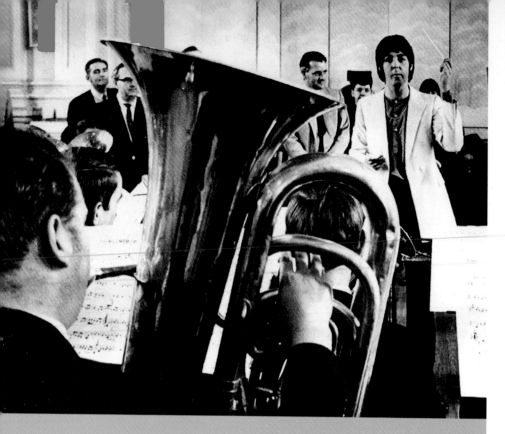

This page: Paul sets himself the challenge of working with a brass band and leads the Black Dyke Mills Band from Shipley. He records his new composition, the theme music written for a television sitcom called *Thingummybob*.

Opposite above right: Now officially a couple, John and Yoko attend the opening night of the stage version of John's *In His Own Write* at the Old Vic Theatre.

Opposite above left: John and Yoko with Victor Spinetti, the play's co-producer.

Opposite below: Most of the summer was spent working on the *White Album*. However, they were still able to persue personal holidays and business trips. George flew to the US to play a cameo role in *Raga*, a documentary about Ravi Shankar. Ringo, Pattie and Maureen joined him.

Opposite above left: Although "Beatlemania" was beginning to wane, the *American Fan Club Magazine* was still in operation.

Working together
but separately

The peace may have been fragile, and the output the fruit of individual contributions rather than collaborative effort, but the yield was still impressive.

U ntil now, when a band member unveiled a new song, it was often jointly burnished. The other Beatles might suggest a new line or bridge, the originator welcoming ideas from the collective. By contrast, the *White Album* was all about individual ownership. The default was for the writer to present a new work as a finished article, using the others as virtual session players. Several McCartney songs, including "Blackbird". "Mother Nature's Son" and "Martha My Dear" had zero contribution from any of the other Beatles. John replied in kind with "Julia", the only Beatles song in which he performed solo. It wasn't hard to see why George described the *White Album* sessions, which ran through to mid-October, as the period when "the rot began to set in".

The peace may have been fragile, and the output the fruit of individual contributions rather than collaborative effort, but the yield was still impressive. The Beatles covered just about every musical genre on the *White Album*: rock, blues, reggae, country and western, folk, electronic, ballads and lullabies. It was flawed — George Martin admitted as much — but the group's first Apple long-player and only double set still topped the UK chart for eight weeks, the *Billboard* listing for nine. Within weeks of its release, Capitol announced that it was the biggest selling album in the company's history. In Sweden it made the Top Ten in the singles chart!

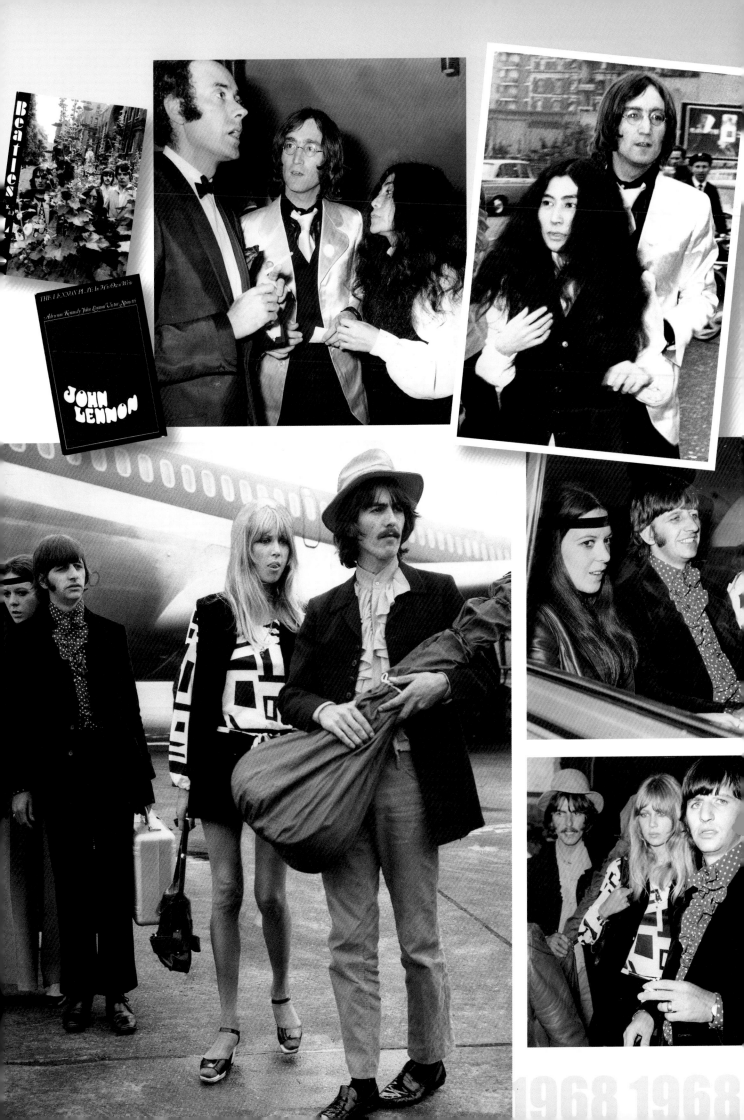

1968 1968

World premiere of
Yellow Submarine

The Beatles were knocked out, belatedly wishing they had contributed more than a walk-on part and a few musical throwaways

The salutary experience of *Help!* and *Magical Mystery Tour* had left the Beatles wary about accepting another film project. None of the ideas pitched to them over the previous two years had gained their approval, but like it or not, they were contracted to appear on the big screen in 1968. A production meeting around the time of *Sgt. Pepper*'s release yielded an idea for an animated adventure, whose main attraction was the lack of input required of the band. That they took little interest in the project can be seen in the material they put forward for the soundtrack. Even the most die-hard fan would have to concede that "All Together Now", "Only A Northern Song", "It's All Too Much" and "Hey Bulldog" were not among the first rank of Beatles songs. The auguries weren't good. Yet this surreal fantasy, in which our heroes are called upon to save the inhabitants of Pepperland from the nasty, music-hating Blue Meanies, is full of charm and wit, a psychedelic-era classic. At its London Pavilion premiere on July 17, 1968, the audience gave it an enthusiastic

endorsement, as did the critics. The Beatles were knocked out, belatedly wishing they had contributed more than a walk-on part and a few musical throwaways. Their hands-off approach gave rise to the tag that it was "the best film the Beatles never made".

The soundtrack album was something of a hotchpotch: two old No 1s — the title song and "All You Need Is Love" — plus the four new tracks, padded out with a swathe of George Martin orchestral pieces. Release was put back to January 1969, but on both sides of the Atlantic the *White Album* still ruled the charts. *Yellow Submarine* thus became the first — and only — Beatles long-player not to reach No 1 in the UK. It still sold a healthy million copies worldwide, demonstrating that the Beatles' name still had a cachet unmatched by any other artist.

Opposite page: The Beatles attend the premiere of Yellow Submarine at the London Pavilion.

Left: Paul and Jane's relationship reaches the end.

Bottom right: Paul speaks to the press outside his father's home in the Wirral soon after Jane reveals their split.

The end for
Paul and Jane

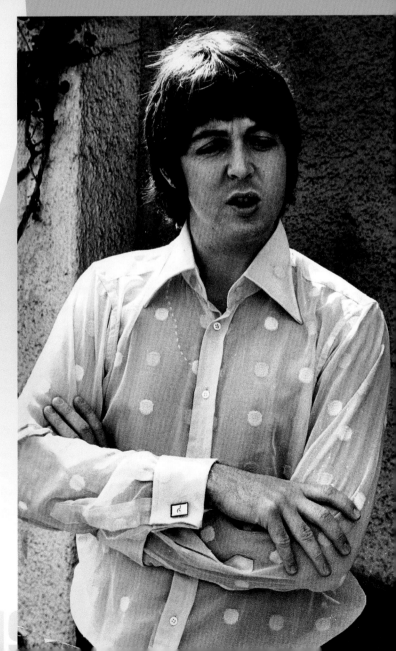

Three days after *Yellow Submarine* received its premiere, Jane Asher guested on the BBC's popular Saturday evening magazine programme *Dee Time*, where she revealed that her engagement to Paul was off. Jane had a work and social diary to rival the Beatles, and of the four Beatle consorts she was the least suited to the role of subservient appendage to a pop superstar. There were other forces at work, too. The fact that Jane had never been interested in the drugs scene was a long-standing wedge between the two. From his standpoint, Paul had been in awe of the cultured, cultivated Asher family when he and Jane first got together. Five years on, the erstwhile rough-edged moptop was a man about town, a member of the cognoscenti who could discourse on a wide range of subjects. The final straw was infidelity. Paul had never signed up to an exclusive relationship, and Jane had arrived at his Cavendish Road home to find him in flagrante delicto with his latest plaything, 24-year-old American Francie Schwartz.

Some maintained Francie was used as a means of provoking the split with Jane. Whatever the case, she, too, was soon off the scene. The field was now clear for a much more serious connection. Paul had renewed his acquaintance with Linda Eastman during the trip to New York to launch Apple in mid-May. A month later they met again in Los Angeles, when Paul was in town to attend the annual Capitol convention.
He invited Linda to London as the finishing touches were being put to the *White Album*, and soon became as besotted as John with his new love. Before the year was out he had asked Linda and daughter Heather to move to England lock, stock and barrel.

Left: Juliet Simpkins, from Madame Tussaud's gives the boys their fifth wardrobe change since they first appeared at the museum in 1964.

Above and below left: Crowds surge into the Apple Boutique in Baker Street. The shop had been a financial catastrophe and closed down on July 31. Shoppers arrived to discover the remaining stock, estimated at more than £10,000, was being given away. There had been no publicity but the news quickly spread by word of mouth. Eventually, the police had to be called to control the crowds trying to get in.

Ringo quits

Circle inset: Ringo's home in Surrey had a room decorated to look exactly like a traditional English pub.

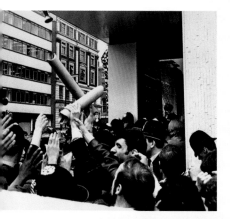

Ringo had been feeling increasingly marginalized, spending long hours kicking his heels

Abbey Road studios might have considered installing a revolving door in the summer of 1968, so numerous were the comings and goings during the *White Album* recording sessions. Some of those were planned, others not. The strained atmosphere took its toll on the backroom team as well as the Beatles themselves. Paul and George Martin had an expletive-filled exchange over the recording of "Ob-La-Di, Ob-La-Da", the producer taking a vacation time-out to defuse the situation. On the same track McCartney put Ringo's nose out of joint by redoing his percussion part, and there was further disharmony between the two during the recording of "Back In the USSR". On August 22, the ever-patient, long-suffering Ringo downed sticks and walked out. He had been feeling increasingly marginalized, spending long hours kicking his heels, waiting to be pressed into service. Even then his efforts occasionally counted for naught.

Ringo spent the next ten days sunning himself in the Mediterranean aboard Peter Sellers' yacht, where he wrote his best known song, "Octopus's Garden". In his absence Paul took over on drums, "Back in the USSR" completed as a three-hander. Ringo was soon welcomed back into the fold, his drum kit festooned with flowers. It was an uneasy truce, a sticking plaster on a gaping, infected wound.

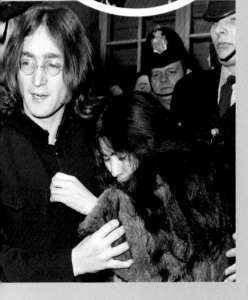

Clapton takes session role on
George's song

Ringo may have beaten George to the punch by a few months in terms of walking out on the group, but the latter felt a similar lack of regard during the making of the *White Album*. It was almost two months into the sessions before a Harrison song got a look in. So when they finally got round to recording "While My Guitar Gently Weeps", written by George during the India trip, he was determined to flex his muscles.

Harrison was riled by the others' indifferent response to the song, which appeared in several guises over time, from a spare acoustic arrangement to a much fuller sound. Then, on a whim, he decided on the boldest of finishing touches.

On September 6, George happened to share a car ride into London with his near neighbour and good friend, Eric Clapton. How would Cream's six-string blues god like to come to Abbey Road and lay down some lead work on his new song? Far from jumping at the chance, Clapton was extremely apprehensive about intruding on a Beatles session. They'd imported brass and string players, but a guitarist? George reassured him. In previous overdubs he had failed to capture the plangent quality he wanted for the solo using backwards tapes. Clapton made his Gibson Les Paul "gently weep" to perfection, and his presence also had a pacifying effect. Peace broke out at Abbey Road the day the Beatles employed their most illustrious session musician.

This Page: After a drugs raid in October, John and Yoko are charged with possession of cannabis and freed on bail until a hearing at Marylebone Court on November 28.

147

Paul had driven to the Lennons' Kenwood home countless times for a writing session, and usually had at least the germ of an idea by the time he arrived. Such was the case once again in June 1968, though on this occasion the object of the visit was to put a consoling arm around a friend whose marriage was in tatters, and cheer up a five-year-old boy caught in the crossfire.

"Hey Jules", ran the comforting appeal of the opening line, addressing Julian Lennon directly. "Don't make it bad, take a sad song and make it better". Deciding "Jude" sounded better, Paul recognized immediately that he had something special on his hands. "Hey Jude" was recorded in the middle of the *White Album* sessions, but quickly marked out as the next Beatles A-side, relegating John's "Revolution" to the flip. Lennon was magnanimous enough to acknowledge "Hey Jude" as Paul's best song. And he seized upon the line "You have found her, now go and get her" — surely a lyrical blessing of his new, all-consuming relationship.

"Hey Jude" rocketed up the American charts at an unprecedented lick, holding top spot for nine weeks. It displaced "I Want To Hold Your Hand" as the group's most successful single Stateside. Apple's debut release hit number one in 11 countries — sales exceeded five million before the year was out — confounding those who thought even the Beatles should think twice about releasing a seven-minute single with a four-minute coda.

Hey Jude

"Hey Jude" was recorded in the middle of the White Album *sessions, but was quickly marked out as the next Beatle A-side*

Above: "Hey Jude" shot into the UK charts at No 1, but was eventually replaced by Apple's "Those Were The Days" by Mary Hopkin. The record produced by Pau spent six weeks at the top of the UK chart.

Right: By now John and Yoko were virtually inseparable. John had even brought her into the studio while the Beatles were recording the *White Album* giving Yoko a microphone to make comments.

1968 1968 1968 1

Above: Five year old Julian Lennon with his father, Yoko and Brian Jones at the Rolling Stones' *Rock and Roll Circus* in December. Julian was the inspiration for Paul's "Hey Jude".

Beatles to play live again?

It was a watershed moment: the first time Lennon had performed in public without any of the other Beatles

The Beatles shot a promo for "Hey Jude" and "Revolution" in the first week of September. Directed by Michael Lindsay-Hogg and filmed at Twickenham Studios, this mimed performance was attended by a 300-strong audience who were invited to sing along to the A-side's extended coda. These lucky few were the first to see the Beatles "perform" since they walked off stage at Candlestick Park two years before. A few weeks later, it seemed that fans would have the chance to see a concert proper, for it was announced that the Beatles would put on three shows at London's Roundhouse in December. Those plans evaporated almost as soon as they were formed. One Beatle did take to the stage in the run-up to Christmas, though. John filmed a sequence for a proposed Rolling Stones TV special, *Rock And Roll Circus*, singing "Yer Blues" with an all-star backing group comprising Eric Clapton, Keith Richards and Jimi Hendrix Experience drummer Mitch Mitchell. Naturally, Yoko was on hand, hidden in a black sack. The Stones weren't happy with the show and pulled the plug on the scheduled broadcast. It was a watershed moment, however: the first time Lennon had performed in public without any of the other Beatles.

1968 1968 1968 1968 1968 1968 19

The "Get Back" sessions that kicked off 1969 revealed a band in its death-throes. The Beatles rallied just long enough for an ebullient rooftop set and magnificent swansong album, but this was a patient in terminal decline.

When they convened at Twickenham Studios in January '69 it was meant to be Beatles redux, a McCartney-led attempt to keep the band's body and soul together. Instead it exposed a deep malaise. Differences were set aside for one final, traffic-stopping live performance, and a last studio album. Paul and John both got hitched, and rolled back the years for the two-handed recording of "The Ballad of John and Yoko", the group's final UK No 1. But it was painfully clear that they couldn't get back to where they once belonged. The legal knives were out. Solo projects weren't simply extra-curricular excursions but signpost to a post-Beatles future. For John it meant bed-ins, bagism and forming a new band. Even Paul knew it was time to let go. By the time the "Get Back" tapes saw the light of day as *Let It Be* in May 1970, the ties were severed, though acrimonious divorce proceedings lay ahead.

19

Below: The Beatles in the studio filmimg *Let It Be*.

Inset left: George discovers new kindred spirits with a Hindu Sect called the Radha Krishna Temple.

Top left: The *Let It Be* album cover, with its four distinctive images, designed by John Kosh.

Inset below: The Plastic Ono Band's *Peace For Christmas* concert given at the Lyceum Ballroom in London on December 15 delivered the message "War is Over".

Get Back

69-70

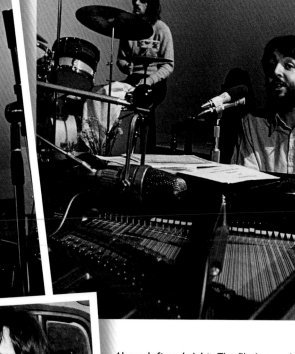

Getting back
to where they belong

Above left and right: The filming sessions take place at Twickenham Studios and the Apple Studios; George had suggested a new venue and a fresh approach.

Inset: At one point George walked out but returned a few days later and new ground rules were agreed. George also invited Billy Preston to join them.

Opposite circle inset: There was much speculation in the media that Paul and Linda Eastman were about to marry.

Opposite right: An impromptu live performance on the roof of the Apple building on January 30 lasts for 42 minutes, until the police are called after complaints about the noise.

There was traffic-stopping chaos as news spread that the Beatles were giving an impromptu concert atop the Apple building

As 1968 drew to a close, relations in the band were seasonably frosty. Paul, ever the most passionate about keeping the show on the road, believed a new project centred on their core business — performing — would strengthen the loosening bond. Thus the Beatles arrived at Twickenham Studios on January 2, putatively to "get back" to their roots: rehearsing for a live show. Cameras would capture the entire process, the resulting TV special neatly dispatching two birds with a single stone.

Exotic locations were mooted as possible venues for the performance. An ocean liner, maybe, or a Roman amphitheatre. But that was getting way ahead of things; instead of reanimating the band, there was the risk of a suffocating expiry before the concert date arrived. Sure enough, scarcely a week into the project, Paul upbraided

George once too often about his guitar work. This, on top of the usual indifference that had greeted his new songs, caused Harrison to pack away his guitar, the second Beatle in six months to quit mid-session. As had been the case with Ringo, he was soon cajoled into returning, but on terms: that they leave the cold, damp Twickenham soundstage and forget the whole idea about putting on some far-flung show.

The sessions continued in the basement of the Apple building, with equipment imported from Abbey Road. Home turf lightened the mood somewhat as the project altered course: the cameras would show them working on a new album. The release of a Beatles record, significant though that was, couldn't match the immediacy and impact of a live performance. Belatedly, the Beatles realized this and decided to give the month-long session a focal point after all.

The final public performance

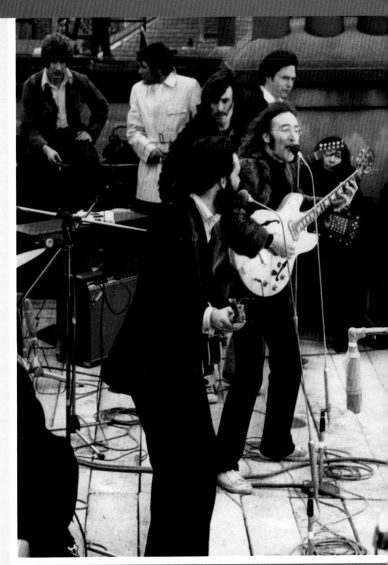

The Beatles had befriended Billy Preston during their Hamburg days, and George — perhaps recalling the mollifying effect of Clapton's presence — suggested the keyboard maestro sit in on the "Get Back" sessions. A new candidate for the "Fifth Beatle" tag entered the frame.

In his 10-day stint as an honorary Beatle, Preston did indeed help lift the gloom that shrouded Apple's basement. It showed in the music, too, which became much tighter. Within days "Get Back" and "Don't Let Me Down" had been buffed up ready for release as the next single, Preston becoming the only musician to get joint billing on a Beatles record.

The sessions had to be wound up at the end of January as Ringo was required on the set of his new movie, *The Magic Christian*. Paul hadn't given up hope of a live performance to provide a final flourish, though it had to be a low-key affair if the others were to be persuaded. Someone mentioned the rooftop space and as soon as it was investigated it had obvious appeal: all the joys of a concert performance without any of the hassle. And it was as groundbreaking as any of the grander schemes that had been floated.

The strains of "Get Back" emanating from atop the Apple building on Thursday, January 30 had the Savile Row passers-by craning their necks and peering into the lunchtime sky. There was traffic-stopping chaos as news spread that the Beatles were giving an impromptu free concert. Over the next 42 minutes they ran through assorted versions of five numbers: "I've Got A Feeling"," One After 909", "Dig A Pony", and both sides of the new single. The police eventually turned up to insist the world's premier band keep the noise down. It was left to John to close the curtain on the Beatles' final public performance: "I'd like to say thanks on behalf of the group and ourselves and I hope we passed the audition."

The album that never was

If Paul thought the exuberant rooftop concert had demonstrated amply that the magic was still there, John's assessment of the "Get Back" sessions brought him down the full six storeys with a resounding bump. "Six weeks of misery," was Lennon's verdict. The patient had rallied, and would do so again, but the wounds were mortal.

As the four headed off in different directions, producer Glyn Johns was left to try and turn miles of tape into a viable album. Johns had been drafted in to replace George Martin, temporarily persona non grata following the bruising *White Album* altercations. The Beatles wanted Johns to get away from Martin's "production shit", as Lennon called it. There was plenty of warts-and-all material to play with, and Johns duly produced a master for a 44-minute album showing the Beatles in the raw. Too raw, apparently, for the plug was pulled before the pressing stage. The entire project was side-lined, the tapes gathering in-tray dust for the best part of a year.

153

Naked truth

John maintained that Phil Spector did a decent job turning the "Get Back" jumble into "Let It Be"

The Beatles had dealt with intrusiveness for years, but the "Get Back" sessions placed them under the microscope as never before. It was unfortunate that the best documented period in the group's history had dissolution as its theme, and that the music — the scorching rooftop set excepted — was somewhat patchy.

John maintained that Phil Spector did a decent job turning the "Get Back" jumble into "Let It Be", the group's 12th and final album release. Paul, George Martin, Glyn Johns and a fair number of fans begged to differ. McCartney felt the original concept had been subverted, and more than three decades later he was finally able to lay the ghost to rest. In 2003 the remixed *Let It Be ... Naked* was issued, the realisation of Paul's vision for the album. It was a cleaning-up exercise, without sacrificing the visceral sound originally intended. The set list was altered, a couple of songs dropped, making way for an excellent new version of "Don't Let Me Down", which had been omitted from the 1970 collection. The banter and out-takes were consigned to a 22-minute "Fly On The Wall" bonus disc.

Opposite above left: Paul works with folk singer Mary Hopkin to record her debut album *Postcard*. As producer he also plays guitar on several tracks and is reponsible for the cover design. He and Linda attend the subsequent album launch at the Post Office Tower where Jimi Hendrix and Donovan are among the invited guests (opposite above right).

Opposite circle inset: Paul is accosted by fans on the day his engagement to Linda is announced.

Opposite below left: The couple arrive at the Odeon in St Martin's Lane for the premiere of *Isadora*.

Opposite middle below: Paul and Linda leave Apple Studios in his Mini.

Opposite below right: After a late night recording session with Jackie Lomax at the Olympic Studios Paul heads for home.

This Page: George and Pattie arrive at Esher and Walton Magistrates' Court. Cannabis resin was found after a raid on their home in Surrey; they are remanded on bail and subsequently fined £250 apiece.

Both Paul and John marry
within eight days

The couple slipped into Marylebone Register Office through a side door. There was a blessing at St John's Church followed by a reception at the Ritz

With the Beatles' business dealings chaotic, artistic bonds frayed and personal relations chilly, John and Paul took a sabbatical from the irksome, multi-faceted bother by marrying the women with whom they had connected so deeply over the previous year.

Paul and Linda — already four months pregnant — tied the knot on March 12 in what was anything but a starry affair. The couple slipped into Marylebone Register Office through a side door, past the dustbins. There was a blessing at St John's Church, followed by a reception at the Ritz Hotel. None of the other Beatles attended. In their business battle, Paul was taking advice from Linda's lawyer father while his band mates were being represented by Allen Klein, a division that soured relations still further.

The competitive edge that existed between John and Paul extended to the marital stakes. On hearing the news of McCartney's wedding, Lennon swiftly proposed that he and Yoko follow suit. Her divorce from second husband Tony Cox had just come through, and although John believed they existed on a higher plane of "total communication", he was content to go through the legal niceties for a second time. Their marriage eight days after the McCartneys was not so much an event as a saga. The nuptials took the form of a private civil ceremony in Gibraltar, a Crown Colony that could expedite matters as speedily as John wanted. Clad in matching white outfits, they were on the island barely an hour, just long enough for the registrar at the British Consulate to perform the ceremony.

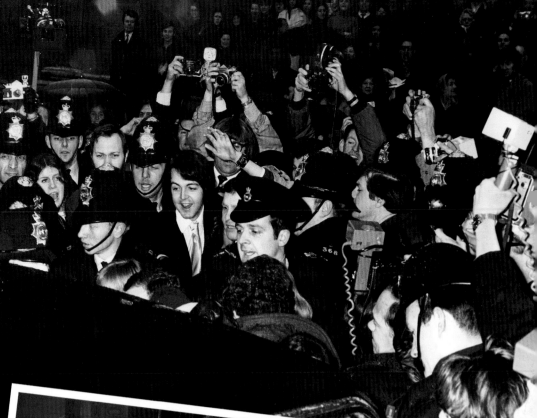

This page and opposite:
On March 12 Paul and Linda negotiate a narrow back alley with Linda's daughter Heather, for their marriage ceremony at Marylebone Register Office. It is very much a last-minute decision with Paul later confessing he had nipped out to buy her £12 wedding ring just before the shops closed. John and Yoko are busy working in the studio and George has just been arrested for the possession of cannabis. Paul's brother Mike carries out the Best Man duties and afterwards the newly-weds have their marriage blessed in private at St John's Wood Parish Church.

Middle right: Distraught fans weep when they learn that the last single Beatle has finally tied the knot.

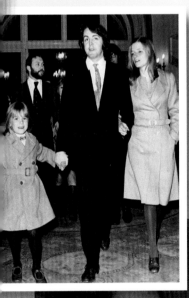

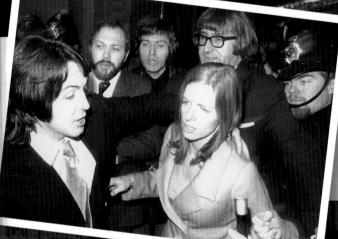

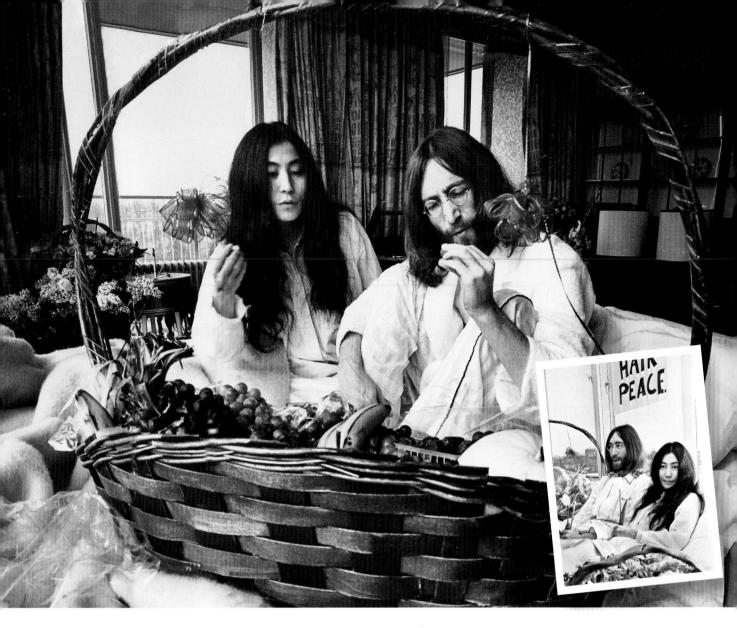

Neither George nor Ringo was available when John was ready to take his travelogue nuptial record to Abbey Road. Paul was on hand though, and it was like the comaraderie of old

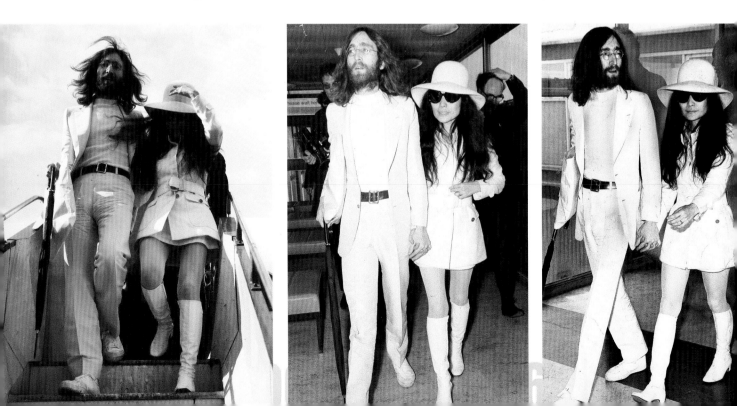

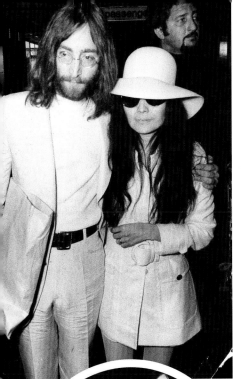

Honeymooning
down by the Seine

The Lennons' post-wedding celebrations were rather more public than the marriage service. First stop was Paris and a little "honeymooning down by the Seine", then it was on to the Amsterdam Hilton and a week-long "Bed-in for Peace". The media were invited, for in the communication age John said he and Yoko would use their profile to sell peace like soapflakes.

In April he ditched his middle name, Winston, legally adopting the moniker John Ono Lennon. Naturally, he also wanted to put his artistic stamp on what he described as "a fantastic happening". In fact, the occasion was marked with two releases. *The Wedding Album*, a confection of matrimonial paraphernalia, bed-in chatter and the happy couple chanting each other's names, made no impact on the charts. John's other vinyl commemoration of the event, "The Ballad Of John And Yoko", gave the Beatles their 17th and final UK number one. Neither George nor Ringo was available when he was ready to take his travelogue nuptial record to Abbey Road. Paul was on hand, though, and it was like the camaraderie of old as the duo completed the song in a single fun-filled session. The "Christ" reference earned it a BBC ban, but it still made top spot, just one week after "Get Back" had been toppled. Restricted airplay in the States had a greater effect and the song stalled at No 8.

This page and opposite: In contrast, John and Yoko's wedding takes place at the British Consulate in Gibraltar. They honeymoon by the Seine in Paris where they have lunch with the artist Salvador Dali. It is then onto Amsterdam where in Room 902 at the Hilton they conduct their very public seven-day bed-in to support world peace, inviting the press into the Presidential Suite to publicise their campaign.

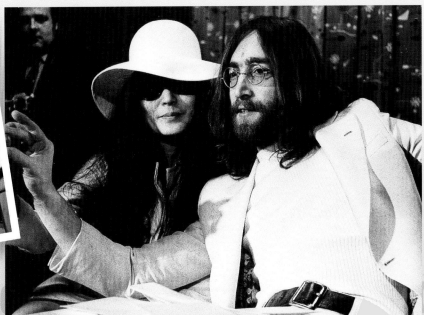

Eastman
versus Klein

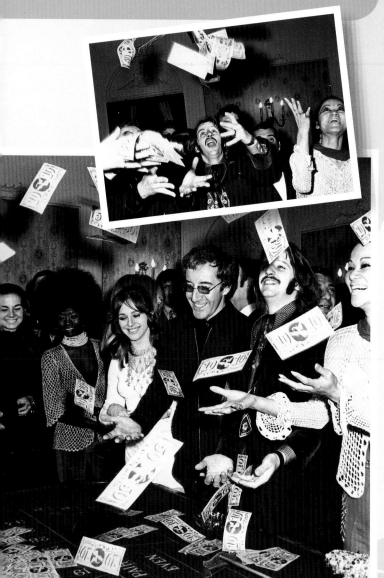

By the beginning of 1969 the Beatles' flirtation with "hip capitalism" had to come to an end. A stream of freeloaders had hopped aboard the Apple gravy train, numerous half-baked ideas had been sanctioned. Savile Row was a virtual drop-out centre. The accountants spelt out that not even Apple Music could prop up the company's loss-making divisions indefinitely. It was one of the few things the Beatles could agree on. There was less accord over who should be tasked with clearing up the mess. Paul favoured Linda's father, Lee Eastman, a top lawyer specializing in the entertainment field. Eastman recommended that the Beatles buy NEMS, which had no management interest in the group by now but did still take a hefty 25 per cent slice of the royalty cake. NEMS was up for sale — Brian Epstein's brother, Clive, needed the money — but there were other interested parties circling. Clive wanted to do business with the Beatles for obvious reasons, and a deal in principle was struck. But John was wary, believing Paul's relationship with Linda would gain him preferential treatment. He had someone else in mind to fight his corner, a brash New York lawyer named Allen Klein. Klein had also forged an impressive track record in the entertainment business, and for years had been angling to add the Beatles to his client roster.

Lennon warmed to the street-smart Klein, who had mugged up on the Beatles' history and catalogue. Even more astute was his wooing of Yoko, Klein making sure he included support for her projects in his pitch. The upshot was a Lennon memo to EMI chairman Sir Joseph Lockwood, informing him "from now on Allen Klein handles all my stuff". George and Ringo also swung behind Klein, who urged that the NEMS deal be put on ice till he could carry out an audit of the group's affairs. It was a major turning point. Until now the Beatles had had a Musketeer philosophy: unanimity was required in decision making, any one person had the right of veto. Not any more. Majority ruled; Paul was out on a limb.

Opposite above: Continuing to pursue his love of acting Ringo co-stars in *The Magic Christian* with Peter Sellers. Cast as the specially created character Youngman Grand he plays the son of Sellers' Sir Guy Grand. Paul wrote the film's theme tune "Come And Get It", performed by Badfinger who had recently been assigned to Apple Records.

Opposite below: This satirical comedy is based on the theme of capitalism and wealth so at the wrap-up party held at a Mayfair gaming club fake money depicting Starr and Sellers' images is thrown around the room. Guests then have the opportunity to use the money at the club casino.

Right and above right; John carries his new step-daughter five-year-old Kyoko Cox, after she arrives in London from the States.

Above: In early July "Give Peace a Chance", written by John and Yoko, is released. John is in hospital at the time after a car accident in Scotland involving Yoko, his son Julian and her daughter Kyoko. All sustained minor injuries and were taken to hospital with John needing to stay in for a few days. The single recorded in Montreal by the Plastic Ono Band, a loose collection of musicians, reaches No 2 in the British charts.

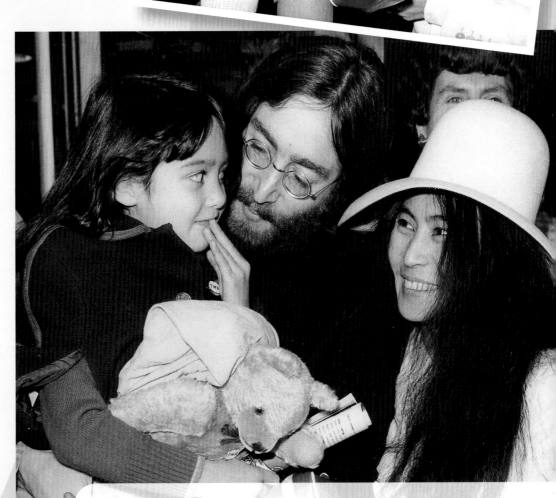

Until now the Beatles had had a Musketeer philosophy: unanimity was required in decision making. Not any more.

Slicing the
Beatles cake

George had finally emerged from John and Paul's shadow, thanks to Abbey Road's two outstanding tracks: the joyous uplifting "Here Comes The Sun" and the sumptuous "Something"

Allen Klein employed his usual tactic when taking on a new client: find ways to slash the existing bills and increase revenues, taking a nice chunk of the profits, in this case 20 percent. The belt-tightening exercise targeted not just the obvious wastefulness and excess but a cull of personnel who in some cases had been with the band for years. Alistair Taylor — the man who accompanied Epstein on that historic first visit to the Cavern — was among the casualties. As each one left, another Apple division closed, another burden lifted from the corporate shoulders. One of the few survivors from the old guard was roadie-factotum Neil Aspinall, who rose to become Apple's CEO and remained with the company until 2007.

As well as stripping away a lot of dead wood, Klein negotiated a much improved royalty deal with EMI, earning grudging praise from Paul. He couldn't prevent the Lennon-McCartney catalogue, which was wrapped up in the publicly quoted company Northern Songs, from falling into the hands of showbusiness mogul Sir Lew Grade.

Above and inset left: After selling Kenwood John and Yoko move into Tittenhurst Park in Ascot. Major alterations are made including the construction of a man-made lake and a recording studio. When they eventually move to America, Ringo buys it from them and moves in.

Below: Paul and Linda attend the premiere of *Alfred the Great* starring David Hemmings. On August 28 Linda gave birth to the couple's first daughter Mary.

Opposite page and above inset: In a continued search for enlightenment, George meets a Hindu Sect called the Radha Krishna Temple. They believe in purification and shun drugs and the eating of meat. Unfortunately George is unable to give up cigarettes and alcohol but is nevertheless attracted to the chanting they use during meditation and introduces this into his music.

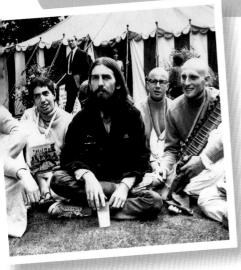

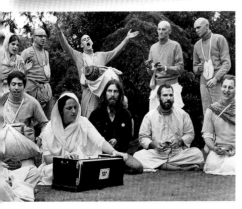

The greatest love song
of the past fifty years

George had never quite shaken off the "kid brother" tag: barely tolerated, often patronised, given the occasional pat on the head. His stockpile of songs was such that the well would take forever to empty at the rate they were being drip-fed on to Lennon-McCartney-dominated records — even if the Beatles stayed together. The band hegemony rankled, and George responded by making plans for a solo LP to be released in the autumn of 1969. Ironically, by then he had finally emerged from John and Paul's shadow, thanks to Abbey Road's two stand-out tracks: the joyously uplifting "Here Comes The Sun" and the sumptuous "Something", hailed by Sinatra as "the greatest love song of the past 50 years".

George's love letter to Pattie dated from the *White Album* sessions. He didn't recognize its quality immediately, for junior-partner status bred faltering diffidence. At long last, with the group in its death-throes, Harrison finally gained the approval he craved. His first A-side made only No 4 in the UK, the first time since "Penny Lane"/"Strawberry Fields" that a Beatles single had missed top spot. But it had already appeared on *Abbey Road*, a departure from normal group protocol that may have cost George his first UK number one.

"Something" was extremely lucrative on a personal level, for George had just set up his own company, Harrisongs, to publish his material. The numerous cover versions earned George plenty of money and an Ivor Novello Award, but doubtless what pleased him most was John and Paul's acknowledgment that he was responsible for *Abbey Road*'s finest song.

Abbey Road

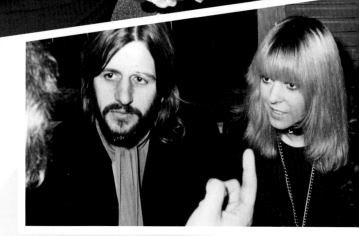

The majority of the songs that featured on the album had surfaced during the "Get Back" sessions

Remarkably, the Beatles were able to set aside their differences in the summer of 1969 just long enough to sustain a final collaborative effort in the studio. No one had the appetite to wade through the "Get Back" tapes, so Paul – who else? – trumpeted the idea of a new, well-crafted, studio album, with George Martin back at the helm. The *Abbey Road* sessions were hardly harmonious, evidenced by John's artistic conceit of lining up his songs on one side and Paul's on the other. But by keeping whole-group involvement to a minimum they managed to produce a magnificent set that in chronological terms was their vinyl swansong.

The majority of the songs that featured on the album had surfaced during the "Get Back" sessions. "Only Come Together", "Here Comes The Sun", "Because", "You Never Give Me Your Money", and "The End" were written specifically for the new project. If the production method was similar to the *White Album* – that is, working separately as often as possible – the new work had a more unified, coherent feel than its predecessor. They weren't "all together now", of course; they were carrying that weight to the bitter end, which was almost upon them.

Opposite top left: Yoko still sports a plaster on her forehead after the car crash in Scotland.

Opposite top right: John, George and Ringo and their respective wives watch Bob Dylan play at the *Isle of Wight Festival*. Afterwards Dylan is invited to John's house and they all return there by helicopter.

Opposite middle: John holds up his letter to Prime Minister Harold Wilson after formally returning his MBE. Amongst many other grievances he includes his dissatisfaction with the gvernment's stance on the conflicts in Vietnam and Nigeria.

Opposite bottom right: Ringo's Octopus's Garden is included in the track listings for the *Abbey Road* album.

John returns MBE

They weren't "all together now", they were carrying that weight to the bitter end, which was almost upon them now

The Beatles' 11th album — or 10th if the bastardized *Yellow Submarine* is discounted — remained untitled for some considerable time. In the end they opted for the same simplicity that had taken them to the roof of the Apple building in January. Keep it low-key and local. And what could be simpler than popping outside for the photo-shoot and naming the long-player after the studio that had been the breeding-ground for so many glittering triumphs?

On the morning of August 8 the Abbey Road traffic was temporarily halted while Iain Macmillan mounted a stepladder and photographed the Beatles filing back and forth over a zebra crossing. This iconic image has been replicated by countless fans on pilgrimage to the sites of special significance in the group's career.

The *Abbey Road* cover gave an unlikely starring role to a VW Beetle. Efforts were made to remove the vehicle from the shot, but as they were once Silver Beetles it made for a nice visual touch. The VW owner discovered that being captured on a Beatles album cover was a mixed blessing. The celebrated number plate became a target for trophy hunters. On the other hand, the 18-year-old vehicle would hardly have fetched £2,300 at Sothebys in 1986 had it not been parked near the Abbey Road zebra crossing that Friday morning in August '69.

John goes
cold turkey

This was a classic Lennon anthem, a direct descendant of "All You Need Is Love". It reached No 2 in the UK chart and top twenty in the States

While Paul still harboured thoughts of a small-scale return to the performance arena, John's commitment to the Beatles cause was rapidly on the slide. Far more meaningful were the events and happenings of his non-Beatle existence: the peace campaign, bed-ins, art exhibitions, sound mosaics — new ventures under the recently formed Bag Productions. In short, his all-consuming passion for Yoko had supplanted his love of being a Beatle.

In the summer of '69, two events made Lennon even more certain that when it came to music there was more to life than being "sidemen for Paul". "Give Peace A Chance", recorded in June during his and Yoko's Montreal bed-in, gave John his first solo hit. There was none of the experimental self-indulgence that went into the making of *Two Virgins* or *The Wedding Album*.

This was a classic Lennon anthem, a direct descendant of "All You Need Is Love". It reached No 2 in the UK chart and was a Top 20 hit in the States, further evidence to support Yoko's belief that John's genius would truly flourish outside the confines of the group.

In accordance with their long-standing agreement, "Give Peace A Chance" was another deposit in the Lennon-McCartney composition bank. But the performer credit went to the Plastic Ono Band. This was a notional concept, with no members as such; deliberately so, for Lennon wanted to escape the hidebound template of a rigid four-piece outfit. It was an emblematic construct, defiantly anti-Beatle even with the Beatles still a going concern. While the finishing touches were being applied to *Abbey Road*, John was having a mainstream success with another group.

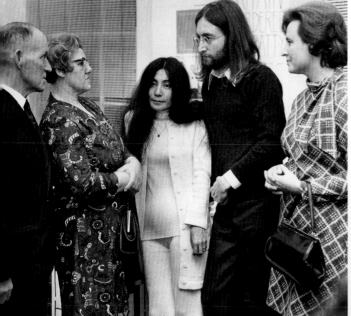

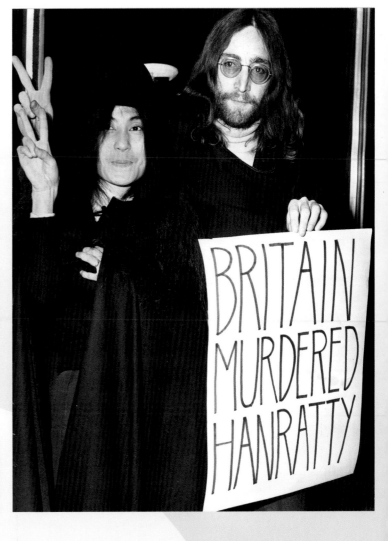

Opposite page and above: John and Yoko publicly support the cause of James Hanratty who was hanged for murder in 1962. Meeting his parents along with fellow campaigner Edith Whicher (top left) they support the growing campaign for the abolition of the death penalty. This penalty for murder was suspended in in 1965 and was due for renewal. At the end of the year it was permanently abolished.

Left and below: John and Yoko promote the concept of Bagism. The principle behind their idea is if all people live permanantely in a bag they will not be able to make pre-conceived judgements about another person's appearance.

SILENT PROTEST
by
John & Yoko

Plastic Ono Band

John found it exhilarating, convinced all the more that his allegiance lay exclusively with the new band

The loose confederation that was the Plastic Ono Band performed in public for the first time on September 13, 1969. Invited to attend a "Rock 'n' Roll Revival" Festival in Toronto, John recruited Eric Clapton, old Hamburg buddy Klaus Voormann and top session drummer Alan White. The set was cobbled together as they jetted across the Atlantic, the lack of rehearsal time showing in a ragged performance of songs such as "Blue Suede Shoes" and "Yer Blues". They also unveiled Lennon's new heroin-withdrawal number "Cold Turkey", which became the Plastic Ono Band's second single.

Despite the musical hiccups and the fumbled lyrics, John found it exhilarating, convinced all the more that his allegiance lay exclusively with the new band. On his return to Britain, John informed Allen Klein that he wanted out. Contract renewal talks with EMI and Capitol were delicately poised, and Klein persuaded him to hold off going public. Klein was buying time, hoping the rift would heal and the golden goose would lay many more eggs. But this was a postponement, not a cancellation. There was just one question left to be answered: who would jump ship first?

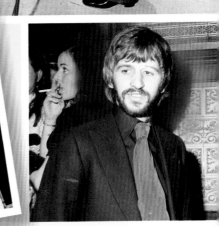

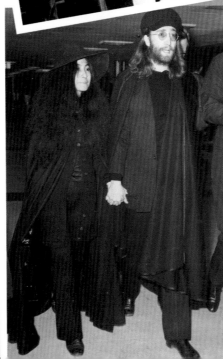

Opposite: The message behind the Plastic Ono's Band's *Peace for Christmas* concert is "War Is Over". Held in aid of UNICEF the band includes George, Eric Clapton and Keith Moon and is recorded by EMI.

Above: In mid-December George Martin's film *With a Little Help From My Friends* is recorded at the Yorkshire Television Studios. Guests include Spike Milligan, Lulu, the Hollies and Dudley Moore.

Right: Cynthia with her son Julian and her new husband, the Italian hotelier Robert Bassanini. They began a relationship soon after she and John separated.

Middle right: Ringo soon starts work on his solo album *Sentimental Journey*.

Below: John and Yoko leave London for Canada where they plan to pass on their peace message to the Canadian Prime Minister Pierre Trudeau while on holiday.

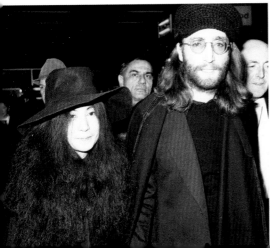

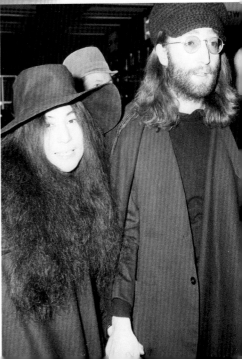

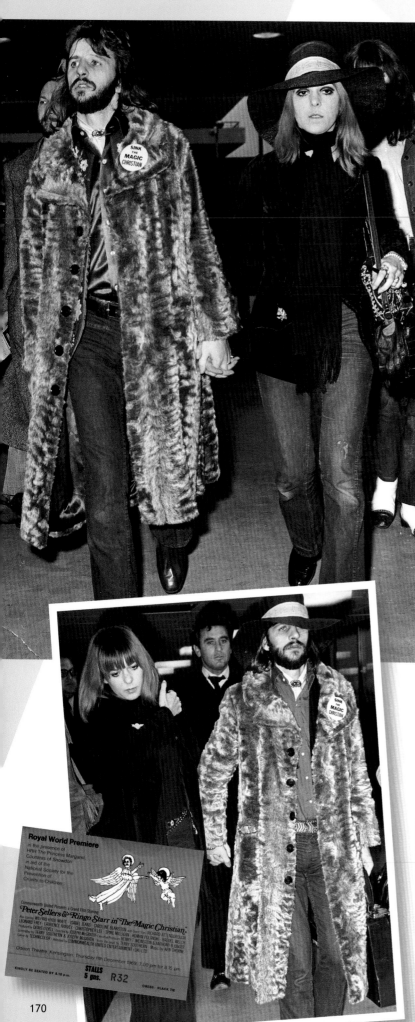

Left and below left: Ringo and Maureen return from watching the world charity premiere of *The Magic Christian*. Outside the theatre John and Yoko protest about James Hanratty's murder. Ringo had recently completed his first solo album *Sentimental Journey* in collaboration with several artists including Paul and Bee Gees' member and good friend, Maurice Gibb.

Below: On April 10 reports in the media carry Paul's statement that the Beatles will never work together again.

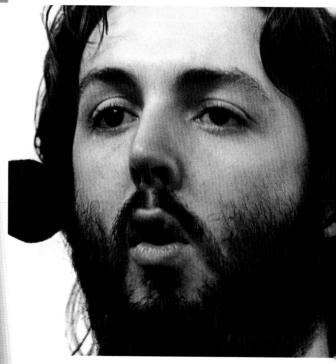

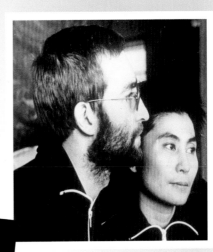

Left and Above: John and Yoko with their matching short haircuts. In March 1970 John revealed the band had smoked cannabis in the toilets of Buckingham Palace when they received their MBEs.

In times of trouble:
Let it be

This was, self-evidently, no temporary suspension of the band fraternity to concentrate on lone pursuits. Even Paul thought it was now time to admit the Beatles were no more

Paul McCartney — multi-instrumentalist, outstanding vocalist, master tunesmith — was undoubtedly the best equipped of the four to succeed on his own. Having focused his efforts on keeping the "great little band" together, even as the others turned their thoughts towards solo projects, Paul finally bowed to the inevitable. He spent the last weeks of the year teetering on the brink of depression, before taking up cudgels and starting work on his own first non-Beatle album.

This was, self-evidently, no temporary suspension of band fraternity to concentrate on lone pursuits. Even Paul thought it was now time to admit the Beatles were no more, and early in 1970 he called John to say he was leaving the group. "Good," came the reply, "that makes two of us who have accepted it mentally." A further sting was to follow. Phil Spector had been given free rein to salvage a record from the wreckage of the "Get Back" sessions. Klein wanted an album out in the spring of 1970, and a film too, cutting a deal with United Artists to give the Lindsay-Hogg footage a theatrical release.

McCartney was incandescent at the thought of a third party riding roughshod over his work, and insult was added to injury when he was told the release date for *McCartney* would have to be put back to avoid clashing with *Let It Be*, Ringo's solo album, *Sentimental Journey*, adding to the congestion. A fulminating McCartney insisted that EMI stick to the original release date, and put together a Q & A insert for the album, which was released three weeks before *Let It Be*. In it he stated that he had no plans to record or perform with John, George or Ringo. "Paul quits the Beatles" was front-page news, the news John in particular wanted to hear. It gave added moment to the appearance of the new album in May: the Beatles signing off not quite eight years after first setting foot into EMI's Abbey Road studios.

George Harrison

George had the honour of being the first solo Beatle to notch up a solo number one single with "My Sweet Lord"

George had accumulated a mountain of material deemed unworthy of inclusion on a Beatles record, and he wasted little time pouring a number of these stockpiled songs into the chart-topping triple album *All Things Must Pass*. He also had the honour of being the first solo Beatle to notch a number one single, but the melody to "My Sweet Lord" was rather too close to the Chiffons' 1963 hit "He's So Fine"; close enough to embroil him in a legal wrangle for subcon-scious plagiarism. In a strange twist, while the case went through due process, none other than Allen Klein acquired the music publishing company whose copyright had allegedly been infringed, setting Harrison against his former manager. To settle the case Harrison was required to purchase the company from Klein for the $587,000 the latter paid when he switched horses from being advocate to plaintiff.

Harrison was the prime mover behind the 1971 *Concert For Bangladesh*, the first major rock event for charity. The concert spawned a single that brought him another Top 10 hit, but beyond the middle of the decade artistic triumphs were few and far between. One exception was "All Those Years Ago", his tribute to Lennon released in the wake of the latter's death. Paul and Ringo played on the song, the nearest thing to a Beatles reunion since the *Let It Be* sessions.

There was personal upheaval as his marriage ended, quite amicably, Pattie taking up with his good friend Eric Clapton. Harrison met his second wife, Olivia Arias, when she was an employee at A&M Records. Olivia came to work at Dark Horse, the label George set up in 1974. They married in 1978, shortly after the birth of their son, Dhani.

Away from music, George was a motor racing enthusiast and keen gardener. He also moved into film production on the back of his friendship with the Python team, particularly Eric Idle, co-creator of the The Rutles, which parodied the Beatles' story. HandMade Films provided backing for *Monty Python's Life Of Brian* — in which George took a cameo role — and the company enjoyed commercial success with movies such as *Time Bandits* an *Withnail And I*.

He ended a six-year barren spell with the 1987 hit single "Got My Mind Set On You", a cover of James Ray's 1962 release from his acclaimed *Cloud Nine* album. The Beatlesque follow-up, "When We Was Fab" was co-written with Jeff Lynne, with whom he formed supergroup The Travelling Wilburys in 1988. The other members were Roy Orbison, Bob Dylan and Tom Petty, who had initially hooked up with Harrison and Lynne merely to knock out a B-side filler to George's single "This Is Love".

In the mid-90s Harrison reunited with the two surviving Beatles for the *Anthology* project, three double albums' worth of Beatles retrospective, with a documentary to boot. There was also fresh material, the three fleshing out Lennon demos "Free As A Bird" and "Real Love", both of which made the UK Top Five.

George was diagnosed with throat cancer in 1997. During his lengthy battle with the disease, which eventually spread to his lungs, he sustained serious injuries at the hands of a knife-wielding intruder who broke into the Harrisons' Henley-on-Thame home. Knowing the illness was terminal, he began work on a final album, *Brainwashed*. It was still in production when he died on November 29 2001, aged 58, completed by co-producers Dhani an Jeff Lynne and released posthumously.

John Lennon

The album's release coincided with John and Yoko's departure to America; he would never return to the land of his birth

John's solo career overlapped the death-throes of the band he had formed in the mid-50s. "Give Peace A Chance", "Cold Turkey" and "Instant Karma!" were all released before Paul informed the world that the Beatles were no more. In his first album, *John Lennon/Plastic Ono Band*, Lennon unpacked a lot of emotional baggage. He had been a disciple of Arthur Janov and undertaken a course of Primal Scream therapy, and he vented many pent-up feelings on this unvarnished album, not least concerning the death of his mother, Julia.

"Imagine", his most enduringly popular solo work, appeared in September 1971, the last record he made in England. It was more melodic than its raw predecessor — crowd-pleasingly "sugar-coated" Lennon himself would say. The Utopian sentiment of the title track contrasted with a stinging attack on Paul in "How Do You Sleep?" The album's release coincided with John and Yoko's departure to America; he would never return to the land of his birth. As the Lennons made New York their home, the authorities cast a watchful eye on potential undesirables. John's drugs record counted heavily against him, as did his active interest in radical left-wing politics. It was ironic that John felt a great affinity with the land of the free, yet he faced a deportation battle that rumbled on until a Supreme Court ruling in his favour in 1975.

The politically-themed "Some Time in New York City" was issued in 1972, and in August of that year John played his last ever concert at Madison Square Garden. The following year he and Yoko moved in to the Dakota Building, taking an apartment overlooking Central Park. But by the time "Mind Games" hit the shops at the end of the year, John had decamped to the West Coast on a 15-month bender he described as his "lost weekend". In tow was May Pang, who had been the family's general factotum for some three years. It was an affair conducted, apparently, with Yoko's blessing.

Lennon hit the bottle hard during his Californian sojourn. He teamed up again with Phil Spector with the aim of making a rock 'n' roll album, but it was so chaotic that he set it aside in favour of *Walls and Bridges* (1974). From this set came the single "Whatever Gets You Thru the Night", which topped the *Billboard* chart, John's first post-Beatles number one on 45rpm. Elton John played on the record and had championed the commercial merit of a song its composer thought was not up to singles standard. Elton's judgment was vindicated and John "paid" the agreed forfeit: to guest on his collaborator's Madison Square Garden show. That November 28, 1974 concert was Lennon's last stage appearance.

He then returned to the abandoned rootsy album, which featured covers of 50s classics by artists such as Chuck Berry and Little Richard. Pictorially, it was also a return to the past, the cover photograph showing 1961-vintage Lennon framed in a Hamburg doorway.

John and Yoko reunited early in 1975, and were soon expecting parents. In June John appeared on stage for the last time, in a TV tribute to entertainment mogul Lew Grade. Following the birth of Sean on October 9 — John's 35th birthday — he went into self-imposed retirement, embracing fatherhood second time round and leaving Yoko to run their business affairs.

By 1980 he was ready to return to the public arena. He had made a number of home demos — including "Free As A Bird" and "Real Love", which his erstwhile bandmates would complete in the mid-1990s — and a trip to Bermuda yielded more material for his long awaited return to recording. Plans for a new joint album with Yoko deterred some labels, but David Geffen was keen to release Lennon's first LP for five years. *Double Fantasy* sold reasonably well, the lead single "(Just Like) Starting Over" hitting the Top 10 on both sides of the Atlantic. Both were propelled to the top when on December 8, three weeks after the album's release, John was shot five times by deranged fan Mark Chapman outside his Dakota Building home. He was returning from a recording session when he encountered Chapman for a second, fatal, time, having signed a copy of *Double Fantasy* for him earlier that day.

The outpouring was extraordinary. Vigils were held, Lennon songs filled the airwaves, and, in 1985, a patch of Central Park opposite his and Yoko's apartment was renamed Strawberry Fields, a fitting memorial connecting the cities that played such a pivotal role in Lennon's life story.

Paul McCartney

Venus and Mars was a transatlantic number one and the group released a steady stream of hit singles and albums

Notwithstanding the tepid reception accorded McCartney's eponymous debut album, it was he, quite predictably, who went on to enjoy the greatest solo success. After releasing *Ram* in 1971 — which featured his first American chart-topper in his own right, "Uncle Albert"/"Admiral Halsey" — Paul formed Wings, recruiting drummer Denny Seiwell and ex-Moody Blues guitarist-vocalist Denny Laine. The four-piece debuted with the album *Wild Life* at the end of the year. Guitarist Henry McCullough joined for the making of *Red Rose Speedway* (1973), whose lead single "My Love" added to the McCartney hit list. McCullough departed prior to the making of the blockbusting *Band on the Run* (1973), as did Seiwell, setting a revolving-door trend of supporting players. Laine was a fixture for the entire decade of Wings' existence — in recording terms the group endured longer than the Beatles. Linda, the butt of much unkind comment for her musicianship, was the only other band member to stay the course. As well as playing keyboards and providing back-up vocals, Linda also added to the McCartney clan by giving birth to Stella (1971) and James (1977).

The Wings era brought a steady stream of hit singles and albums. *Venus and Mars* (1975) was a transatlantic No 1, and the group released three more studio albums, plus the live triple set *Wings Over America*, compiled from the phenomenally successful 1976 tour of that country. In that period Paul and Linda visited the Lennons at their New York home in what was a short-lived reconciliation. The former bandmates would not see each other in the flesh again.

The singles haul of this period included the Bond theme "Live and Let Die" (1973) and "Mull of Kintyre" (1977), the latter named after the Scottish headland on the west coast, where Paul had owned an estate since the mid-60s. It topped the UK chart for nine weeks and replaced "She Loves You" as the best-selling British 45 in history, a record it held until the Band Aid single eight years later.

He returned to solo work before Wings officially split, releasing *McCartney II* the year before his second band signed off in 1981. He was working on the follow-up, the George Martin-produced *Tug of War* (1982), when he learned of Lennon's death. The title track described the competitive spirit that existed between them, while "Here Today" was a direct address to former close confederate. Paul was "holding back the tears no more", setting the record straight after the flippant remark made in the aftermath of the shooting that it was "a drag".

Tug of War included the chart-topping Stevie Wonder duet "Ebony and Ivory". Another superstar collaboration, with Michael Jackson on "Say Say Say", provided him with the second biggest Stateside hit of the Beatles in toto or any of their solo cuts. Only "Hey Jude" sold more copies. His 1984 film *Give My Regards to Broad Street* was widely panned, though a soundtrack album including "No More Lonely Nights" did brisk business. After the disappointing *Press to Play* (1986), there was a return to form with the Elvis Costello collaboration *Flowers in the Dirt* (1989).

In the next decade he showed his diverse talent by moving into the classical sphere with *Liverpool Oratorio* and *Standing Stone*. Over time the man who gave us the "Frog Chorus" effortlessly switched from mainstream pop to film scores to classical and experimental works; he even flirted, unwisely, with punk. His live shows included many Beatles songs, and he added two more to the pile when he joined up with George and Ringo to embellish Lennon's "Free As A Bird" and "Real Love". On completion of the *Anthology* project, McCartney scored well with Grammy-nominated *Flaming Pie* (1997) and received an overdue knighthood. His personal life was shattered a year later when Linda succumbed to cancer, aged 56.

The new millennium saw the Guinness-recognised artist as productive as ever: *Back In The World* live album and tour in 2003, Glasto headliner in 2004, Live 8 concert in 2005. He remains as big a draw as they come. The man who closed Live Aid with "Let It Be" remained the obvious choice for the grand finale of Queen Elizabeth II's Diamond Jubilee concert and the Olympic Opening Ceremony in 2012.

On the domestic front, his 2002 marriage to former glamour model Heather Mills, which produced daughter Beatrice, soon hit the buffers. In October 2011 he married American heiress Nancy Shevell in the same Marylebone Register Office where he and Linda tied the knot in 1969.

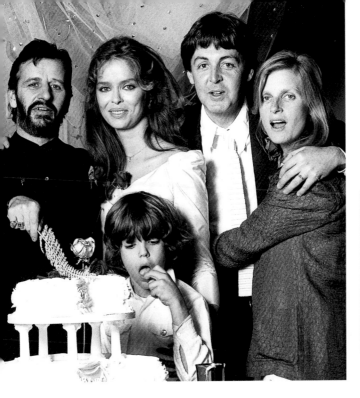

Ringo Starr

Ringo built on his Beatles-era acting successes in films such as 200 Motels *and* That'll Be The Day, *and tried his hand on the other side of the camera with* Born to Boogie

On the surface, Ringo appeared the least equipped of the four to thrive as a solo performer. In fact, he hurtled out of the blocks, the platinum-certified *Ringo* (1973) — featuring separate contributions from the other three Beatles — matching the golden-oldie set *Sentimental Journey* in reaching the UK Top 10, and *Goodnight Vienna* (1974) also charting. A flurry of hit singles included "It Don't Come Easy" and "Back Off Boogaloo", while "Photograph" — co-written with George — and a cover of the old Johnny Burnette number "You're Sixteen" both made number one in America.

Ringo built on his Beatles-era acting successes in films such as *200 Motels* (1971) and *That'll Be The Day* (1973), and tried his hand on the other side of the camera with *Born to Boogie* (1972). In the mid-70s his career stalled. With the vinyl releases less well received and acting work sporadic, Starr kicked back and enjoyed the Monte Carlo-based, jet-set lifestyle, with a string of beautiful women on his arm following the collapse of his marriage to Maureen. High living took its toll a few years later when he needed treatment for a drink problem.

Starr was back on the big screen in 1981 comedy *Caveman*, during the making of which he met his second wife, former Bond girl Barbara Bach. In the mid-80s Ringo branched into children's TV as the narrative voice of the *Thomas the Tank Engine* series. He also kept his hand in musically, even when the hits dried up. Starr played with Paul and George at the 1979 wedding of Eric Clapton and Pattie Harrison; Paul and George contributed to his 1981 album *Stop and Smell the*

Roses; Ringo returned the favour on McCartney's *Tug of War* long-player. He also guested in his former bandmate's 1984 film *Give My Regards to Broad Street* and played on the soundtrack album. A decade later saw the first McCartney-Starr writing credit, for "Really Love You", which appeared on Paul's 1997 album *Flaming Pie*. There was also a collaboration with George on the video for the latter's 1988 hit "When We Was Fab".

By the end of the 80s, Ringo had formed his All-Starr Band, whose rolling line-up has included son Zak, and stars such as Nils Lofgren, Joe Walsh and Jack Bruce. The 2012 tour was the 13th incarnation of the band. As well as touring successfully, Ringo also continued to record, issuing a number of studio and live albums. *Liverpool 8* (2008) was his first EMI/Capitol release since *Goodnight Vienna* 34 years earlier. The recipient of countless awards as a member of the Fab Four, Ringo was also honoured with a place in the Percussive Arts Society's Hall of Fame in 2002.

Each Beatle had his share of creative highpoints, not to mention healthy commercial successes. Speaking of the twin artistic giants that he worked with for so long, Sir George Martin said, "the talents were equal ... Different but equal." Many Beatles fans would concur with that, and with Martin's estimation that "John did a lot of good stuff, and Paul did too, but it wasn't as good as when they were together."

175

Acknowledgements

The photographs in this book are from the archives of Associated Newspapers. Particular thanks to Alan Pinnock.

Thanks to the following contributing authors: Duncan Hill, Alison Gauntlett, Gareth Thomas and Jane Benn.

Unless otherwise stated, memorabilia shown in this book is taken from the private collections of Pete Nash (www.britishbeatlesfanclub.co.uk) and used with his kind permisssion.

Additional photographs/images:

Gettyimages: Front cover, Pages 7, 9, 13, 15(top right), 16(top left), 17(top & middle left), 27(bottom left & right), 28(middle right), 30(top), 33(middle left and right),42(top & middle), 44(middle right), 78(middle & bottom), 82(top left), 84(top left), 98/99(top), 153(right)

Corbis: Pages 3, 6, 18(top), 25(below right), 37(top right), 41(top), 41(bottom right), 80(bottom), 81(top left), 146(circle inset)

Every effort has been made to trace copyright holders but if there are any omissions the publisher will be happy to rectify such omissions or errors in future reprints and/or new editions.

Thanks also to Cliff Salter, Alice Hill, and Sarah Rickayzen.

Design and layout: Richard McHale

Atlantic World
38 Copthorne Road, Croxley Green, Hertfordshire, UK

First published in 2012

Photographs © Associated Newspapers Archive (except where listed above)
Text © Atlantic Publishing

A catalogue record for this book is available from the British Library.

ISBN 978-1-909242-01-2

Printed in the United Kingdom